Nexus Network Journal

GEOMETRIES OF RHETORIC

Robert Kirkbride, Guest Editor

VOLUME 12, NUMBER 3

Winter 2010

KWB

KIM WILLIAMS BOOKS

Nexus Network Journal

GEOMETRIES OF RHETORIC

Robert Kirkbride, Guest Editor

VOLUME 12 NUMBER 3
Winter 2010

Nexus Network Journal
Vol. 12
No. 3
Pp. 363-536
ISSN 1590-5896

CONTENTS

Robert Kirkbride

Parsons The New School for Design
School of Constructed Environments
25 East 13th, Room 201
New York, NY 10003 USA
kirkbrir@newschool.edu

Keywords: geometry, rhetoric,
cognition, memory, ornament

Letter from the Guest Editor

Geometries of Rhetoric: An Introduction

Abstract. Guest editor Robert Kirkbride introduces Nexus Network Journal vol. 12 no. 3 devoted to "Geometries of Rhetoric".

We grasp and transform the world through interplays of quantification and qualification.

Although these modes of analysis and expression are often placed in contrast, for example as the mathematical and verbal arts, human inventions manifest a weave of alphanumerics. Mythic parables, geometric proofs, memory arts, poems, algorithms, buildings and cities emerge from the intercourse of measure and explication. This special issue of the *Nexus Network Journal* considers architectonic examples of past, present and potential geometries of rhetoric.

Several themes emerge across the collection that illuminate architecture's multifaceted role in nourishing thought, memory and identity.

The cross pollination of geometric and literary figures is deeply embedded in our cognitive habits, instruments of inquiry and the constructed environment. Through time, thought has reflected on the visible processes and products of material craft to explain and train the invisible workings of the mind.[2] Recursively, material craft embodies a tradition of splitting ideas into categorical parts and compositional units for reassembly. Buildings, mosaics, tapestries, and inlays are assembled from bits of information according to a larger composition, imbuing everyday experience with a deep-seated appreciation of the fragment within a larger whole.

Conic sections, explored in ancient Greece by Menaechmus and Apollonius and re-examined in Renaissance Italy by Federico Commandino, among others, generated literary figures of speech that allude to their geometric principles; in addition to circular logic, the *parabola* invited the "comparative" allegory of *parable*, the *hyperbola* inspired the "exaggeration" of *hyperbole*, and the "omissions" of the ellipse characterized *ellipsis*. These tropes informed rhetorical structures in philosophy[1] and popular forms of literary and designed ornament, colored by such hybrid media as *emblemata*.

Consequently, the mutual influence of splitting and joining in mental and material craft is engrained in language and our methods of investigation.[3]

It is precisely for this reason that, according to Dan Rose, "nothing is docile," and the human passion and prowess for manipulating the stuff of the world, including the peoples who produce and consume that stuff, demands reconsideration. In "A Strange Catalogue of Things," Rose brings an anthropologist's eye to "the expanse of consumer stuff that threatens to engulf us and causes severe environmental and social degradation." Over the past three centuries, he argues, the human sciences have failed to generate theoretical ballast to the exuberant explosion of applied research in the natural sciences, with direct consequences for the design professions. Put simply, our technological

Nexus Network Journal 12 (2010) 363–366 NEXUS NETWORK JOURNAL – VOL.12, No. 3, 2010 **363**
DOI 10.1007/s00004-010-0049-x; *published online* 15 September 2010
© 2010 Kim Williams Books, Turin

capacity to make has outpaced ethical questions about *why* we make, resulting in the devaluation of natural resources as mere raw materials for human use. Several ideas in this article reappear elsewhere in the volume.

In "Chiasmus, Artificial Memory, and the Arts of Arrangement" Donald Kunze traces a "'deep structural' axis of metaphor and metonymy" from Simonides's foundational myth of the memory arts, through Giulio Camillo's memory theater, to Jacques Lacan's *mid-speak* (*mi-dire*). In this legacy of elliptical logic, truth is understood as partial rather than monolithic, with memory playing an inventive rather than recapitulative role: "artificial memory was from very early times regarded as a kind of machine that actively created meaning rather than passively stored facts." To this end, architecture has offered mental and material prosthetics for dissecting and reconciling the inner workings of the imagination and the facts "out there, in the world," holding the promise that "every project is but a fragment of other possible projects."

An overlapping vein of inquiry distills architecture's capacity, as palpable artefact and generative process, to weave one's personal, sensuous experience of the world with broader institutional and historic narratives. In "Geometries of Reading, Light of Learning," Shannon Mattern asks: "What geometries express and foster the kinds of encounters and qualities of presence that define *Library*?" Through a close reading of Louis Kahn's Phillips Exeter Library and users' experiences, Mattern scrutinizes how the elementary geometries embodied institutional rhetoric about knowledge and learning, and their impact on multi-sensorial modes of "reading" and non-geometric, non-linear forms of media.

> The anatomical theaters used by Andreas Vesalius to produce his De humani corporis fabrica (On the workings of the Human Body: 1543), and Giulio Camillo's memory theater (1540's), which expounded on the workings of the imagination, facilitated complementary activities. The former revealed empirical truths through dissection of the human (worldly) body; the latter expanded the realm of metaphoric truth and meaning, as a combinatorial device for rhetorical composition. Camillo's theater has found an echo in the literary stratagems of the Oulipo, a group of writers who explore narrative structures produced with rigorous mathematical constraints and playful anti-constraints (see, for example, "Queneleyev's Table").

Similarly, in "Encountering the Geometry and Gesturality of Andrew Lambe's House," Dorian Wiszniewski investigates the dimension of time and seriality in architectural research and production. Drawing on "methodological artefacts" produced during a recent project in Leith, Scotland, he unfolds a building's narratives as experienced and reinterpreted through the speculative process of design development and construction, noting: "We never experience architecture as a whole; we experience it a bit at a time, and the same can be said of geometry and narrative."

Through the images and footnotes in her photographic essay, "From Circle to Ellipse," Angela Grauerholz offers that "spaces are measurable, but the experience is not." Reflecting on fountains, monuments, and sculptures – commonplace figures in urban planning that are often circular in plan but never to the eye – she observes: "Photography tells us about our experience, enabling verification of discrepancies between the real and the perceived." It is within this discrepancy, or gap, or *ellipsis*, "that our imagination steps in to fully inhabit the space to be comprehended."

What imaginative architectural interventions might enhance the beauty and ecological commonsense of human habitats? In "Friendly and Beautiful: Environmental Aesthetics in Twenty-First-Century Architecture," Sherine Mohy El Dine Wahba echoes Rose's call for a more balanced valuation of aesthetics and ethics, offering a method of comparative analysis to promote "formal geometry as qualitative criteria for a more integrated approach to conceiving environmental control systems in buildings." Her contribution is among a cluster of articles that propose new research and design methodologies, including several that seize upon recent advances in digital technologies.

In his essay on tenth-century Hindu temples, Sambit Datta highlights how their form and ornament materialized at the intersection of text canons and astronomical mandala geometries. Noting that "computational modeling provides a robust methodology for researching the genesis and evolution of geometry in temple architecture," he speculates that virtual reconstructions would allow greater insight into the temple builders' concepts of nothingness and infinity.

In "Computational Organicism," Brian Holland advocates the exploration of algorithms and biomorphology in tandem with the theorization of an evolutionary architecture, noting: "'Breeding' buildings in virtual environments presents a radical reconfiguration of the architectural design process." Meanwhile, in pursuit of "a language for the narrativization of urban development," Matt Demers draws on Rene Thom's morphologies of catastrophe theory and Michel Serres's model for applying them to narrative processes, proposing that "the confluence of narrative and topology could yield a qualitative yet stable spatial representation of the dynamic development of the human environment." Foreshadowing further investigation, he includes a brief case study for Chandigarh, India.

As a bookend to the inquiries of Rose and Kunze, and a fitting conclusion to the volume, Jack Rees tackles the "conflict between what I believe and what I know." Carefully, he distinguishes between the brain's subsymbolic, tactical responses to localized sensorial experience, and the mind's capacity for symbolic, strategic planning. While unpacking the differences between thinking in text and thinking in images, he underscores the sophistication of human cognition and its byproducts, noting that "early robots did not so much navigate through a space as bump their way through an obstacle course," and acknowledging that "what is remarkable [about good search engines] is not how relatively poorly they currently function, *but that they work at all.*"

Where is the limit between the individual imagination and the world of facts "out there," beyond the self? Whether manifest through a laptop held in our hands or the city borne in our minds, architecture designates that threshold explicitly, as sites of shared inquiry, and implicitly, as the experiential materials of self-edification. Between our perceptions and the perceived, we bump our way from place to place, from day to day, trying to not hurt ourselves and others too badly.

Notes

1. See [Saiber 2005: 25] for analysis of these structures in the works of Giordano Bruno (1548-1600).
2. See [Kirkbride 2008: ch. 3, §27].
3. "Tectonics [and techne] deals with the arrangement of 'distinct units' that the tecton [Homer's shipbuilder/housebuilder] first shapes with his tools and then places and joins together. This dual, seemingly antithetical, activity is what defines tectonics. Since tectonics is literally at the

root of architecture (*archi-tektonike*), this dual mode of operation is also at the core of architecture" [Karvouni 1999: 106].

References

KARVOUNI, Maria. 1999. Demas: The Human Body as a Tectonic Construct. in *Chora Three: Intervals in the Philosophy of Architecture*, ed. S. Parcell and A. Pérez-Gómez, (Montreal: McGill-Queen's University Press, 1999)

KIRKBRIDE, Robert. 2008. Architecture and Memory. New York: Columbia University Press. http://www.gutenberg-e.org/kirkbride/

SAIBER, Arielle. 2005. *Giordano Bruno's Geometry of Language*. Burlington, VT: Ashgate.

About the guest editor

Robert Kirkbride is director of studio 'patafisico and associate professor at Parsons The New School for Design. He has been a visiting scholar at the Canadian Centre for Architecture, architect-in-residence at the Bogliasco Foundation in Genoa, Italy, and is an editorial board member of the *Nexus Network Journal* (Birkhäuser Verlag) and commissioning editor for Alphabet City (MIT Press). His multimedia book, *Architecture and Memory: the Renaissance Studioli of Federico da Montefeltro* (Columbia University Press: 2008), received the Gutenberg-e Prize from the American Historical Association, and is openly navigable at: http://www.gutenberg-e.org/kirkbride/.

Dan Rose

718 Main Road
Stamford, VT 05352 USA
drdanrose@aol.com

Keywords: theory, nature and culture, animism, evolution, unification of sciences

Research

"A Strange Catalogue of Things"

Abstract. The universe has evolved humans who in their turn act as natural-cultural agents to intensify the acceleration of evolutionary processes. The human sciences, whose growth severely trailed that of the physical sciences, failed to theorize the objects that we invent and make. Professions such as architecture that exist in both the realm of naturally occurring substances and human activities have suffered without the intellectual resources for adequate reflection on the world we have made, and about whose consequences we remain all too unaware. Naturally occurring substances and humans must be framed together within a single idea. Further, "the strange catalogue" of contemporary production and billions of individual consumer products must be understood as having relationships within human society. As an integrating discipline that composes with physical materials and cultural life, architecture benefits from a theoretical unification too long neglected by the human sciences.

For 'tis not barely the ploughman's pains, the reaper's and thresher's toil, and the baker's sweat is to be counted into the bread we eat; the labour of those who broke the oxen, who digged and wrought the iron and stones, who felled and framed the timber employed about the plough, mill, oven, or any other utensils, which are a vast number, requisite to this corn, from its being seed to be sown to its being made bread, must all be charged on the account of labour, and received as an effect of that; nature and the earth furnished only the almost worthless materials, as in themselves. 'Twould be a strange catalogue of things that industry provided and made use of about every loaf of bread before it came to our use, if we could trace them: iron, wood, leather, bark, timber, stone, bricks, coals, lime, cloth, dying-drugs, pitch, tar, masts, ropes, and all the materials made use of in the ship that brought any of the commodities made use of by any of the workmen to any part of the work, all which 'twould be almost impossible, at least too long, to reckon up.

John Locke, *The Second Treatise of Government*, [1681: 242 (Ch. 5, §43)]

Introduction

A little more than three hundred years ago, in Locke's account, diligent human labor applied systematically to the "almost worthless materials" of nature furnished a world of things: we see men sweating in the fields and the women over a wood fired stove in a division of difficult labor. Today, that graphic image gives way to automated harvesting machines and robotic factories and the processes from extraction through manufacturing and consumption, all managed by computational hardware and software; and the software handles all sorts of mathematical calculations necessary for production.

Critique

There was trouble in Locke's world that we have inherited, trouble which lurks behind contemporary retail and architectural surfaces. We carry with us the dismissive, self-deluding notion of an "almost worthless nature." That is to say, much of human endeavor in the past three centuries has centered on a belief system where the "natural environment" possesses no inherent value, except as "raw materials" to be transformed by human intervention.

Nexus Network Journal 12 (2010) 367–376 NEXUS NETWORK JOURNAL – VOL.12, No. 3, 2010 **367**
DOI 10.1007/s00004-010-0043-3; *published online* 15 September 2010

In Locke's formulation we witness one of those bifurcation points in the history of human thought whose effects play out over centuries. Locke released a possible knowledge of nature and rallied human society around the concept of human labor that creates wealth and value.

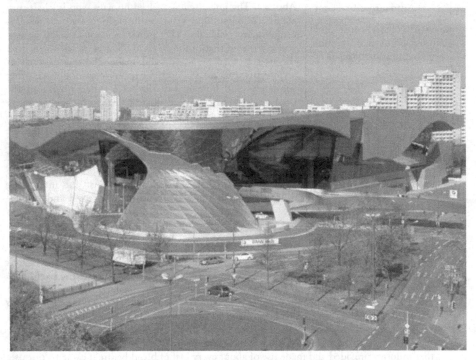

Fig. 1. BMW headquarters, designed by CoopHimmelblau.
© Marcus Buck. Reproduced by permission

Yes, naturally occurring elements can now be priced precisely by resource economists, but from the standpoint of the other human sciences, even today, such as anthropology, history, political theory, and sociology, nature has little standing. Branches of the physical sciences designate, theorize, simulate, and experiment on their particular slices of nature, but neither the physical sciences nor their collective objects of nature have been theorized as wholly human-natural phenomena by the cultural sciences.

More importantly, physical scientists have not adequately accounted for how the biological human brain in communication with others can identify and simulate nature. That is, we do not really explain theoretically how a biological creature can know itself and act so effectively on the natural world. The incorporation of nature into *culture*, the vast realm that apprehends and processes the ingredients of the "strange catalogue," is no more adequately theorized today than it was 329 years ago. In the present era consumer goods with little roughness and a great deal of lay ignorance enter cultural life as fully socialized quasi-beings. The domestic Chihuahua is no longer a wolf and the lithium in a battery no longer resembles unconsolidated lithium carbonate found 3,000 meters below the earth's surface in a hot stew of brine and other trace metals. Most humans don't know the physical bases and could care less, whether it lights our paths or lightens our moods.

As a result of this incomprehensible theoretical omission not only has the planet suffered for centuries from a false invisibility but so have the design professions for a simple reason: alternative ideas, beliefs, and values have not been made available because they are inadequate or absent. Or, when they have been voiced, they have been discredited, marginalized, and dismissed as being contrary to progress.

Locke's words give a particular historical picture of nature and the human efforts that release seeds and soil from their natural state for human use. This has bestowed value on the world's largesse, offering a rationale for ownership that has displaced native peoples, worldwide. Humans who tilled the soil invested things with value and provided the basis for ownership of the goods they produced. It is an easy route to trace this labor theory of value from Locke through Smith and Marx into twentieth-century economics and social thought – the organization of society through the division of labor, the structure and function of the social order, the value added to things in their manufacture and distribution, and the resulting unequal distribution of power and access to it.

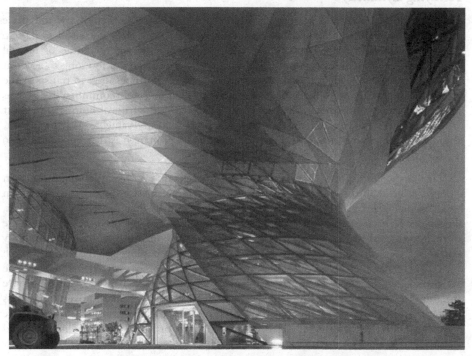

Fig. 2. Detail of BMW headquarters, designed by CoopHimmelblau.
© Hélène Binet. Reproduced by permission

Surfaces

Today, a glossy seam of highly finished surfaces very nearly runs across the entire interface of material goods, where nature has become fabricated for use in cultural settings. The protective and branded surfaces of handheld devices or the plastic wrapped consumer items, from bread to memory storage devices, indicate an exterior below which no one need peer into any natural substance or process. The world of nature – mapped, measured, weighed, and then mined, pumped or harvested – moves from numerically denominated substances through research and development at the hands of scientists,

engineers, and technicians into the tight fit of retail packaging that often presents on their shells instruction sets for the consumer. The didactic texts of ingredients, warnings, how-to's and subsequent product reviews, further socialize the now highly finished stuff of nature. Humans welcome into consumer society products that are remote from their natural origins, imbuing their concealed ingredients with human characteristics and animating them with what in some respects resemble human activities, like speaking and singing. The ubiquitous seam of glossed surfaces, although but a dream for Locke's world, includes the built structures housing work, play, and domestic dwelling. The face of nature that urban dwellers presently see has been brought to them by designers of buildings, commercial signage, autos, and packaging. Built structures of great complexity, designed by architects, affect global society and present readily visible facades along an infinitely extended and unconsciously accepted juncture, easily straddling nature and culture.

Terrifying asymmetry

A worthless nature and a laboring society offer an extreme asymmetry and place nearly the entire source of abundance on human work. *Locke gives no power to natural things, only to humans.* While labor can be catalogued, the sheer volume of natural resources and commodities engaged in delivering a loaf of bread are too long to account for. Nature, ever embedded in iron, timber, cloth, masts and ropes used to transport the ingredients for bread, not only eludes accounting but has no single commonality, such as labor, which serves for society. The singularity in society is the fruit of human effort, but for Locke nature has no comparable unity. He finds it nearly valueless as it lies about, untouched by human hands; once touched by the hand of man, it is then too complex to reckon up.

This tragic bifurcation of nature and culture remains an essential assumption in thought more than three centuries later with only the feeblest efforts to theorize them back together again. Even in Locke's account nature and its ingredients appear as silent, almost docile necessities. Without dozens, perhaps hundreds of physical resources, the journey from seed to bread could not be made. If nature in this picture is economically worthless, then the objects made from nature (like the plow or the bread, which obviously retain their physicality despite the application of labor), remain in the background, untheorized, mute, taken-for-granted, and in an odd way, partaking more of nature's invisibility than of human sociality. It is as if plow, mill and oven, much less all the machinery on the grain ship, inhabited an unnamed, unconsidered third space between a fallow earth and a fully realized human social order. Even technology assumed the invisible cloak of nature.

Wealth

What is so deeply disturbing about Locke's insistence, is that the substances in the strange catalogue are the whole starting place of capitalist development of planetary resources, the location of such exuberant wealth production, the very resource base that humans have enlarged for themselves in service of an expanding population in order to stave off human poverty. The rapidly growing global market pulls endless natural resources into manufactories that produce creature comforts found in all parts of the world, none more so than in the affluent portions of Asia, Europe, and the Americas. By contrast to the seventeenth century, the explosive arrays and volumes of goods today appear beyond enumeration. This expansion of stuff has burst forth such that in advanced consumer society it threatens to engulf us.

Theory

How do we theorize nature so that it is no longer "almost worthless materials," and with that, also re-theorize this vast zone – the extensive assembly line from the mine to the shelves at Wal-Mart – in order to grasp them for thought and more effective action? How do we address this challenge from within the standpoint of the human sciences rather than from within physics or biology, as some physical scientists have proposed? The first order of business is to alter the agenda of the human sciences. The great challenge is to incorporate both nature and humanity within a single framework with as much clarity as either one side or the other musters to explain its own domains. For example, the physical energy of a planet receiving solar radiation and promoting human life could be unified under studies of energy flows, but would need massive rethinking in order to unify meaningfully the sciences of humans and nature [Smil 2008: 380].

It is necessary to reframe humans as having evolved entirely out of nature, partaking of the same energy and matter as all else. Humans and human culture are naturally occurring in response to Darwinian challenges that any animal species faces. Humans with their cultural abilities and the entire empire of nature evolve simultaneously. Beginning long before Locke, humans have evolved various branches of the sciences of nature, but physics and biology are not disciplines to which the explanation for humanity ought to be reduced. Rather these divisions of learning are, in all their splendor, simulations, experiments and commercialization, the sum product of humans engaging with the whole range of stuff available in the world. This position provides the initial formulation for a unified theory.

Powers

The natural sciences, historically at work in their disciplinary silos, have defined and cut out pieces of nature and experimented with them on site and in the laboratory in order to achieve an understanding of naturally occurring substances. The findings are turned into property through patenting; communicated to other scientists by means of scholarly articles in journals; and down the value-added process, elements are fabricated into retail products for the consumer. Human scientists have no more theorized what has happened to the pieces of nature – coal, oil or gas, for example – than petroleum scientists have theorized the effects of large carbon molecules on human adaptation in cold climates, or global air, land and sea transportation and its effects on human linguistic interaction. The phenomenal successes of the natural sciences and their productive laboratories may have simply swamped the world with knowledge gained in specific disciplines and the potential for products. Even if human scientists have noticed the exponential increase of such riches over the last three centuries, they have turned away from explaining how the advances in science impacted social phenomena.

Animism

Our ancestors intuited our relationship with natural objects and local places. For roughly 45,000 years or 2,250 human generations before the rise of the major religions, our hunting and gathering ancestors tended to believe that everything had an animating spirit and was in some sense alive, even stones. This animism is today dismissed as incapable of providing any meaningful approach to the world, and even those who are said to practice it tend to be migrating to cities where engines and pharmaceutical substances replace spirits and the other powers of the unseen world. But there is a clue here, developed elaborately in the myths of our ancestors, that the theorist cannot afford

to ignore: that things not only contain something lively within – essence, substance, activity, hidden abilities – but things also affect humans (who are themselves animated things) and all can interact with one another. Everything has powers. Everything effects.

Unification

Powers of A affect the powers of B as they are brought into proximity by natural events or at the hands and machines of humans. The animist understands with some humility that these relations contain some danger and that it is not a given that events will go smoothly or painlessly. All of this is to say that the world landscape is an array of powers distributed over a large sphere; it is a busy collection of tangible substances, all of which – including the human – have real powers of effect. These powers are increasingly patented, owned and transacted, precipitating an array of incidents, accumulating in catastrophic eruptions and collapses. And each feature of this landscape, visible or not, accounted for or not, is made up of myriad elements with their powers to affect. It is not turtles all the way down, it is powers upon powers all the way down. Brilliant effects and effects upon effects. Nothing is docile. Our theory of the planetary landscape, then, is a theory of the powers of things engaging one another; of humans engaging this engagement with their own powers; of the experimental uncertainty that results from humans encountering the other powers; and, of human powers using the powers derived from nature and amplified by human fabrication. All these things are potentially melded and made useful by means of the global market. The entire landscape is a distribution of remarkable powers. Herein we express our answer to Locke's omission.

First Formulation. All ingredients of the physical universe are active and have evolving combinations of powers that are exerted on other things within the processes of evolution – whether the nuclei of atoms or human beings. The unifying science of humans takes this as the first formulation, which is a kind of democratization of all the substantive elements and their potential relationships in the universe.

Second formulation. As natural objects of great effectiveness, humans amplify and accelerate the processes of cultural and natural evolution; for example, inventing genetically modified seeds and animals and exponentially speeding up computational potential. Phrased another way, the universe has evolved humans that in turn, acting as natural-cultural agents, intensify the acceleration of evolutionary processes.

Acceleration

If the evolving universe has evolved humans who then loop back to accelerate natural evolution, so too it becomes more understandable that humans through experimental science use fabricated nature for tools in order to dig deeper into nature and to engineer even more energized products, in a spiral heaping upward of things used to construct more and other things. This references the Law of Accelerating Returns.

Two axes

Think of two axes, X and Y (fig. 3). The X axis moves from X to X^1 and the Y axis from Y to Y^1.

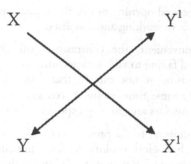

Fig. 3. Two axes

The *X* axis indicates the ingredients of the Strange Catalogue, where physical and biological materials, i.e., the "nearly worthless things of nature," *X*, are transformed through human industry by means of science, math, and engineering and inducted into human society, at X^1.

The *Y* axis represents two effects of the processes moving along the *X* axis; one is entropic and the other is accelerating. By amplifying evolutionary processes, recent human activities produce both disorder and an increasing, higher order. *Y* can be represented as "entropy production," and Y^1 as "order production," innovations that recursively amplify human innovation – for example, the internal combustion engine, nuclear energy, genomics, or supercomputing.

The *Y* axis

In the middle of the nineteenth century, as the steam powered engine underwent rapid development, Rudolph Clausius formulated the second law of thermodynamics to explain why, during a process, quantities of energy became unavailable for work. He named this quantity "entropy," designating it with an *S*. The point here is that although the earth is not a closed system, as were nineteenth-century energy efficiency experiments, the entire transformation of the materials of nature under capitalism have created high quantities of entropy on the earth.

Y, then, captures the notion of the costs that nearly seven billion humans incur as they do business, and injure major ecosystems. Nearly one-half of the surfaces of the earth has been dramatically changed through human habitation, and not for the better. Biologists point to one-quarter of the bird species having been driven to extinction, more than half of all fresh water being put to use and degraded, more nitrogen fixation by humans than all natural terrestrial processes combined, and a thirty percent increase in carbon dioxide production in less than two hundred years – massive changes that result from the great expansion of the catalogue resulting from human ingenuity and commerce and the necessity to feed and service an expanding populace [Vitousek, et al 1997: 494-499].

If *Y* indicates the Second Law, then Y^1 points toward the very nearly opposite, an increase in order. Carbon emissions from U.S. power plants contribute to entropy, but the electricity generated has contributed to air conditioning for residential, commercial, and manufacturing sites inviting a large in-migration to the American southern tier from Florida to California. Such expansions of human habitation, by no means restricted to

America, underscore the general opening out of the human species into eco-zones of the planet formerly inhospitable to working and dwelling.

While dialectically convenient, the contrastive pair of disorder and order are nonetheless misleading, and failing to take into account the increasing speed and range of human innovation. The issue is not merely that humans create higher order and environmental chaos at the same time, as the Y axis suggests, it is that at Y^1 the actual velocity and the things themselves are growing exponentially in power and effectiveness.

From the birth of the universe to the present some scientists consider that the pace of physical evolution, then biological evolution, then human technological evolution, experience exponential augmentation periods that alter the dynamics of the entire system. Termed *The Law of Accelerating Returns*, a phrase coined by Ray Kurzweil, the fundamental idea is that acceleration is inherent in the history of evolution up to the present and that biological evolution continues within the exponential growth rate of human inventions, particularly in computation, genomics, and nanotechnology. To put it somewhat differently, by increasing computational power and applying it to genomics and nanotechnology, whole sectors of innovation explode exponentially, including the potential to radically transform the human brain and body. For example, it is believed by computer scientists that within a few years computer intelligence will not only outstrip the human biological brain in effectiveness, but fuse with it [Kurzweil 2005: 7-14]. In the picture provided by computer scientists, human labor and computational resources tend to blend into an almost seamless human-machine work environment. Locke could not have envisioned such entries into the Strange Catalogue.

Architecture and design

The design disciplines, none more so than architecture, can be located on the nature to culture/entropy + accelerating returns axes. I would place the architect at the crossroads where X and Y lines intersect. The weight of the world bears down here and future thinking must accept the responsibilities of the pressure and step up to the opportunities.

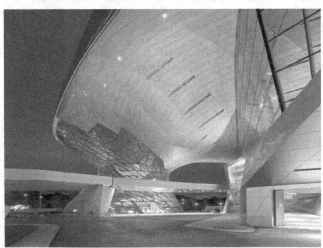

Fig. 4. Detail of BMW headquarters, designed by CoopHimmelblau.
© Ari Marcopoulos. Reproduced by permission

Curious thoughts

Curious thoughts flow from the formulations:

1. Since humans are naturally evolving creatures that amplify the processes of nature, this suggests that the universe sends us to itself as accelerators of evolutionary potential.
2. If this is so, then what ought we to consider about where we and the earth and the universe can possibly be going?
3. How should we imagine the ever-transformative human role in the unfolding universe of the future?
4. How ought we to imagine accelerating the evolution of our own bodies and minds, as well as our practices and living and working?
5. Where ought our ethical considerations be focused and by whom? A century ago, Nietzsche asserted that humans had entered the halfway point, noon in the temporal moment of a solar day. The early morning was over, the afternoon not yet begun. The childhood of dawn had not yet given way to the afternoon of sophistication and maturity. It was a turning point. Call it a search, in the fullest light of day, for the right path forward. He writes:

> My task, to prepare a moment of supreme coming-to-oneself on the part of mankind, *a great noontide* when it looks back and looks forward, when it steps out from the dominion of chance and the priesthood and poses the question why? To what end? For the first time as a *whole*—this task follows of necessity from the insight that mankind is *not* of itself on the right path, that it is absolutely *not* divinely directed, that under precisely its holiest value-concepts rather the instinct of denial, of decay, the *décadence* instinct has seductively ruled. The question of the origin of moral values is therefore for me a question of the *first rank* because it conditions the future of mankind. The demand that one ought to *believe* that fundamentally everything is in the best hands, that a book, the Bible, will set one's mind finally at rest as to divine governance and wisdom in the destiny of mankind, is translated back into reality, the will to suppress the truth as the pitiable opposite of this, namely that hitherto mankind has been in the *worst* hands, that it has been directed by the under-privileged, the cunningly revengeful, the so-called 'saints', those world-calumniators and desecraters of man [Nietzsche 1908: 66].

In this paper we have advanced 217 years from Locke to Nietzsche. However, where Nietzsche's paragraph ends, we must pick up by using the scientific advances of today fused in a moment of supreme coming-to-ourselves. Lunch is over. It is time to bend the trajectory of line Y so that Y and Y^1 are joined, forming a circle. Our accelerating returns from successful innovations, on the Y^1 side, must begin to intervene far more conscientiously on the entropic disorder from the Y side that we have unleashed on the planet, and ourselves (fig. 5).

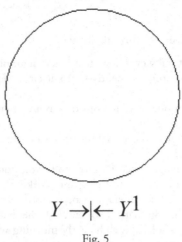

$$Y \rightarrow | \leftarrow Y^1$$

Fig. 5

References

KURZWEIL, Ray. 2005. *The Singularity is Near: When Humans Transcend Biology*. New York: Penguin Books.

LOCKE, John. 1681. *The Second Treatise of Government*. http://files.libertyfund.org/files/222/0057_Bk.pdf. Accessed 15 July 2010.

NIETZSCHE, Frederich 1979. *Ecce Homo: How One Becomes What One Is*. Trans. R. J. Hollingdale. London: Penguin.

ROSE, Dan. 2001. Pass the Salt: How Language Moves Matter. Pp. 44-59 in *The Consumption of Mass*, Nick Lee and Rolland Munro, eds. Oxford: Blackwell.

SMIL, Vaclav. 2008. *Energy in Nature and Society: General Energetics of Complex Systems*. Cambridge: MIT Press.

VITOUSEK, Peter M., Harold A. MOONEY, Jane LUBCHENCO, and Jerry M. MELILLO. 1997. Human Domination of Earth's Ecosystems. *Science* 277, 5325 (25 July 1997): 494-499.

About the author

Dan Rose is Professor Emeritus in the Department of Landscape Architecture, School of Design, University of Pennsylvania. An anthropologist, designer and artist, Dan Rose began making and showing art work in 1995, including seventy-five one-of-a-kind artist books and a year-long project of writing while building twenty-five machines for a three-dimensional novel, *The DNA-Photon Project: 1925-1995*. In addition to showing art he has collaborated on installations and performances, most notably with actors and with couture composer and sonic designer, Melissa Grey. Rose has redesigned and built a facsimile of America's most famous race car, the Shelby American Racing Team, Daytona Cobra Coupe. He has an office and a studio, Pure Theory (Formerly Bob's Used Furniture and Appliances) in Adams, Massachusetts. He has lectured and taught at universities in the United States and Europe and is the author of a number of scholarly articles and books.

Donald Kunze

Department of Architecture
Penn State University
121 Stuckeman Family Building
University Park, PA 16802 USA
dek4@psu.edu

Keywords: acoustics, allegory,
Giulio Camillo, chiasmus, design
theory, Kabbala, Jacques Lacan,
meaning, memory theaters,
metonymy, psychoanalysis,
Simonides, topology, symmetry

Research

Chiasmus, Artificial Memory, and the Arts of Arrangement

Abstract. Few figures of classical rhetoric can claim more spatial relevance than "chiasmus," the figure of symmetrical convergence used by poets, novelists, rhetoricians, mnemonicists and others. Is chiasmus a tool of literati who appropriate spatial forms to pull their plots to closure, or is there an independent architectural tradition of chiasmus? If one pulls together the clues about metonymy, the logic of arrangement, one can discover an intriguing link to Jacques Lacan's similar design of the human psyche and his topological investigations. The Vitruvian sequence of *venustas*, *utilitas* and *firmatas* may suggest to some nothing more than an arbitrary division of architectural interests. Ritually, however, the relation of *firmitas* not just to material stability but to the traditional rituals required to secure buildings from both collapse and curse, even if figurative, offers connections to the chiastic design of foundation rites, where sacrifice secures the life and security of structure.

Two lines of thought: metonymy and metaphor

When the French psychoanalyst and theorist Jacques Lacan read the news about the sensational murder case of the Papin sisters, he was fascinated, and continued to be fascinated, with the way the sisters spoke.[1] In another case, a school teacher who had gone insane began to speak in fragmentary sentences that were luminous and prophetic. These instances of female paranoia led him, in explicating the "mirror stage," to develop a more general theory of truth that confronted the Gödelian set-theory limitation of how theory can include itself.[2] Because discourse must be subject to the rules it explicates as universal, the phenomenon of *mi-dire*, of "saying half," became for Lacan both a style and a method. This style was evident in Lacan's spontaneous use of puns, alliteration, abrupt breaks (aposiopoiesis), and prosopopoeia. Lacan's knowledge of classical and Biblical literature undoubtedly fueled his conviction that *mi-dire* was not simply a method or presentational mode but a means of thinking and discovery.

Catherine Clément, the French philosopher-novelist-artist and one-time student of Lacan's, wrote:

> Mid-speak (*Mi-dire*). Not the whole truth. A treatise on the correct usage of reserve in literary style: Lacan's style is such a treatise – it is unceasingly reserved. His formulae, figures, and tropes are allied with negation, with the negation of negation, and with all resources of grammar that turn plain assertion around and stand it on its head. 'I tell the truth – not the whole truth'. When the truth is conceived 'whole', it cannot be anything but the complement of the man. But the truth is not 'the whole truth', it eludes the grasp of man, his culture, and his language [Clément 1983: 63].

Rhetorically, the essence of *mi-dire* is metonymy: speech broken into parts that, in relation to other parts, achieve "meaning effects" (rather than direct, signified meaning) from incompleteness. Lacan's interest in types of metaphor was partly a response to the

prevailing linguistic interests of the day in the "metaphoric" nature of semblance and the "metonymic" quality of contiguity. Semblance and contiguity had been identified, in the famous analyses of neurophysiologists Gelb and Goldstein of brain-damaged veterans of World War I, as the typological structure of aphasia.[3] Reasoning backwards, semblance aphasia (blindness to semblance relationships) and contiguity aphasia (inability to conceive of tangent relationships) pointed to a "deep structural" axis of metaphor and metonymy, lying beneath language and thought. Roman Jacobson readily associated metaphor with poetic thought and metonymy with rational functions. This led many to conclude that metaphor was developmentally primary and that metonymical rationality later "overtook" it both in personal development and cultural genesis.

Lacan's reversal of this view of metaphor as primary was related closely to his interest in the mirror stage, the event through which the young child, encountering his/her reflection in a mirror, achieves a self-conception of mastery and unity, at the expense of recognizing that this mastery is based on the externalized view of the Other ("Other-ness" is a better translation of Lacan's *l'Autre*), a mastery which had to be reinforced and defended by the ego's constant attention to appearances and defending the subject's place in the networks of symbolic relations.[4] Commentary on the mirror stage often misses two subtleties of Lacan's idea. The first is that it is the *imaginary* realm that holds the key to the subject's unity, but the treasure this key unlocks lies in the *symbolic* realm, where the subject is assigned roles to play. The second subtlety is that the reversed mirror image is that it is *not quite* what others see. The stereo reflection and the public image are separated by a *minimal difference*, a small gap that operates like a micro-force between two atomic particles, a case of "difference in itself." Left and right are also a matter of what makes a face out of what is otherwise just one side of an object. And, as we know from folklore, the left hand will accumulate a reputation for evil, the right will be the side of light, origins, the good, and the Law.

This small gap between the mirror image and the externalized self that the ego uses as a "marker" in the game played in the social world is a mark of the subject's authenticity as well as the dimension that allows it to stand outside of the three-sided game played by the Lacanian trio of domains: imaginary, the symbolic, and the Real. The marker-image will be used by others *to stand in place of* the subject and will always be a locus of misrecognition. Others will create personalities for the subject that the subject will discover only gradually and imperfectly. In contrast, the mirror image belongs to the subject "directly," through a logic of touch. The gap between the "nothing" of the marker-image and the subject's unique possession of the mirror image will constitute a mark of authenticity, to be punched into every situation. The subject will feel that, although no one could literally stand in his/her shoes, others *could and should* see the same thing, feel the same thing, think the same thing. The recognition of impossibility is the mirror image, the rhetorical demand is the marker image, the subject's social mask. The coupling that links the two is the mark of the certain and is a kind of action of certification, a making.

Truth, in terms of *mi-dire*, is not just a combination of the two powers of the mind, semblance-metaphor and contiguity-metonym. Metonymy's partial nature stands for the process of truth – "truth by halves" – and goes to the heart of the mirror stage's primal condition of its own truth told in halves, and halves of a half. After the mirror stage, the normative meanings of the two kinds of metaphor are turned on their heads. Semblance will always involve *mis*recognition, contiguity will always involve *cutting* space, time,

and logic so that half of the matter is hidden. This strange state of affairs calls for some further understanding of metonymy.

The mi-Dire of Simonides (and beyond)

When Lacan took on the matter of the five drives he had constructed from Freud's three (anal, oral, phallic, plus the scopic gaze and acousmatic voice), he made a point of saying that they were all partial. That is, the object or aim (*but*) of the drive was not directly achievable. "No food will ever satisfy the oral drive, except by circumventing the eternally lacking object" [Lacan 1998: 180]. The image of the drive was a line circling around a gap or, in some cases, a line moving up through a rim representing the goal that the aim had "overshot." Metonymy made sure the gap would be there. The gap allows for an escape, a place where the Real can set up shop, a funhouse and smuggling emporium. But, there are two kinds of franchise locations for this Real. Ed Pluth describes:

> There is a first real (real$_1$) ... and there is another 'second-order' real (real$_2$), which is an effect of the symbolic order itself. Real$_1$ sounds like a typically 'realist' notion: the real consists of stuff 'out there' that language tries to symbolize. Real$_2$, however is not outside the symbolic, as real$_1$ seems to be. This second-order real 'is characterized by impasses and impossibilities' that occur in the symbolic order itself. In what I think is his best definition of this understanding of the real, Lacan said that 'the real can only be inscribed on the basis of an impasse of formalization'. Instead of being a field of referents that language aims at, this version of the real is a stumbling block in the field of signification itself.[5]

Real$_2$, like a defect, is the aspect of the gap that makes the circling drive seem like a machine encountering, over and over, some programming error that sends it back to the beginning.[6] Interestingly, we have all encountered this as a comic device commonly employed in popular culture: the inane and irritating exchange between the comedy team Abbott and Costello, "Who's on First?" Because the first baseman's name is actually "Who," the confusion circles around the question as the pronoun and the proper name vie for dominance. In the Cyclops Episode, Odysseus uses the same trick, telling the giant he has just blinded that his name is Ousis, "Nobody." "Who has blinded you?" the other Cyclopes ask when he calls for help as the Greeks escape beneath the sheep. "Nobody, that's Who!"[7]

Metonymy always puts off the meaning question, but this indefinite future involves the present and the past as well. Lacan used the future anterior tense, the "will have already happened" time sense, to define the subject not as a past or future but as a future in which "What is realised in my history is not the past definite of what was, since it is no more, or even the present perfect of what has been in what I am, but the future anterior of what I shall have been for what I am in the process of becoming."[8] This simultaneous forward and backward motion is the point of the Real – Real$_1$ – where we can really exit to some exterior. The two varieties of Real are related to the partial object, generalized as the famous Lacanian *objet petit a* (the otherwise untranslatable "object-cause of desire"). The "matheme," or condensed expression, that Lacan used for fantasy was:

$$\$ \Diamond a$$

The \diamondsuit is the *poinçon*, or punch, the mark of authenticity because, although it is different for every subject, it is authentic for each. Thus, $Real_1$ and $Real_2$ structured a space that lies between them, the "inner" and "outer" versions of the Real; just so, the *poinçon* can also be written as the scale dysfunction, <>, "both smaller and larger than." The inner $Real_2$ is an "internal" (dys)function of the symbolic order itself, while the outer $Real_1$ is the point at which what seemed to be the container turns out to be itself contained and escapable. In the Arena Chapel in Padova, Italy, Giotto shows the angel of the Apocalypse rolling up the human world as a geographer might roll up a map to put it away.

Where is the payoff in extending the *mi-dire*, and other Lacanian ideas such as the mirror stage and the metonymical vs. the metaphorical "reals" to the classical art of memory? One area was mapped by Lacan himself, by his interest in ancient philosophy and classical literature. Clément comments that his appreciation stemmed from first-hand knowledge of primary texts. Like Freud, Lacan saw in antiquity, and especially in the products of ancient art and literature, a proving ground, if not a battle-ground, of the psyche. The complementary benefit of Lacanifying the memory lore is to rescue its real magic. Why, in fact, was the popular study of Llullism (the art of memory created by the thirteenth-century Catalonian mystic Ramon Llull) completely eradicated at the University of Paris? According to Ivan Illich, it was the Church's conviction that such arts were magic – and they were correct.[9] Looking for the origins of the invention of artificial memory should not end with the Simonides story, for the arts of memory were ancient by his time. His story, apocryphal in many ways, shows that space and memory already ruled over an uncanny playing field, each sharing media and method with the other. The most famous "theater of memory" was invented by Giulio Camillo, who made no secret of his use of the Kabbalah and other "esoteric" lore. In short, artificial memory was from very early times regarded as a kind of machine that actively created meaning rather than passively stored facts. Modern misunderstanding has bracketed artificial memory – along with its engagement of profound philosophical issues – within the categories of antiquarian curiosities. The case of Simonides provides more than enough evidence to correct this situation, and it is probable that Camillo capitalized on this apocryphal story.

The story of the invention of artificial memory comes to us from several classical sources. Most modern readers will have encountered it in Frances Yates's popular book, *The Art of Memory* [Yates 1966: 1-4]. The poet Simonides is invited by a local celebrity and politico, Scopas, to entertain his guests with a poem commemorating his victory at a wrestling meet. The guests are assembled in the banquet hall, and Simonides memorizes their names using the method of place, by which he associates each guest's name with a mentally pre-constructed memory place. He delivers his poem but Scopas is not pleased by Simonides' insertion of a passage in honor of the twin gods, Castor and Pollux, a gesture of piety to protect the host from the evil eye, which a poem filled completely with congratulatory braggadocio would surely have done. The impious Scopas withholds half Simonides' fee, telling the poet, rudely, that he can go to the gods (i. e., "go to Hell") for the rest. Simonides returns to the banquet but is called outside by "two youths" who, it is said, wish to speak to him. When he gets outside, the two are not anywhere to be seen, but before Simonides can return to his unfinished meal, the banquet hall collapses. All inside are crushed, Simonides has been saved by this spurious interruption. Before he can leave the scene of disaster, relatives anxious to identify the victims beg him to stay and help. Thanks to his employment of the art of spatial memory, he is able to name each

corpse on the basis of its location amidst the rubble. The relatives, whose religious scruples can now be satisfied with the proper burial of their kin, reward Simonides generously, making up for his lost fee. With true poetic justice, it is the braggart Scopas who, in the end, goes to the gods for his reward.

Yates makes no special analysis of the story; in an earlier study, I described the clear chiasmus used to preserve the symmetry of the story's two main parts.[10] Scopas, a wrestler, is one half of a pair, and this is the clue that sets the pace. Simonides divides his poem in two, and the second half is, like Scopas, a matter of twins. Scopas withholds half of the fee, suggesting that the gods pay the rest. Simonides is called out by two men. At this point, the chiasmus reaches a turning point where the narrative folds back on itself to "correct" the divisions-by-two. Where the system of memory places was used to store names, the places now yield the names back, for burial's sake. Grateful relatives restore the withheld fee. The "poem" is realized, now as a funeral encomium, and Scopas himself goes to the gods.

Taking into consideration the *mi-dire* sheds new light on this chiastic structure. The presence of an internal $Real_2$ and external $Real_1$ make us able to see how the narrative of memory is a space "held open," collapsed, and then re-opened. True to the *mi-dire*'s tradition of juxtaposing the living and the dead but restricting their communications to reverberations and whispers, the first part of the chiastic story is dedicated to the living, the second to the dead, and the clues connecting them can be intuited but not spoken out loud. With the false request to see two mysterious men outside (the Dioscuri appearing in person to thank Simonides for including them in his poem?), we have the Real of salvation. The living turmoil of the contentious banquet and the lethal turmoil of the collapsed building are hinged by a momentary breath of fresh air outside the space of memory. When Simonides returns inside, it is to the second kind of Real: the "partial objects" created by the art of memory, composites of names and places. No one has made the comparison of the memory object to the partial object, or of the system of memory places to the *mi-dire* of the oracle or prophet, but there are clear advantages to do so. These do not take us away from the original practice of artificial memory but, rather return it to an origin that has so far remained obscure.

The Topology of X

In language, metonymy has to do with the meaning effect generated by a partial string of signifiers, where the signified (referent) as such is *postponed*. For example, the crown, one element of the king's symbolic paraphernalia, "stands for" the king. Detached from the king (absence of the referent, the signified), it still has a certain uncanny power, as if to say that the order of cause and effect has been reversed: "whoever wears the crown is the king." The crown as metonymy postpones the matter of who is king, by creating a "meaning effect," an essence, that is *missing*. The king, in Lacan's terms, is "castrated by the symbol" of his power, and this is the meaning of castration in Lacan. The price of joining the network of symbolic relationships in the social order is precisely this castration (by the metonymic symbol of the location of one's place within the network).

Metonymy in architecture has to do with how boundaries are drawn to make parts that have this representative magic. In this sense, every project is but a fragment of other possible projects, and the house implies the city: the "meaning effect" of the utopian microcosm. Because every built project is a "partial object" – a fragment in comparison to a larger whole that it specifies by asserting itself as an example of "how things should be done" – the boundary is significant because it relates to the "reality out there," what is

in popular terms "the solid world of facts." But, there are also "inside frames" that refer to a kernel of the Real that, in every architectural project, works as the gambler's "tell," or truth-revealing detail. This can be an internal unintended inconsistency, a hidden flaw; or, as in the work of Carlo Scarpa, it can be a detail that reveals the entire idea of the building. In ancient building practices, this kernel would be addressed by sacrificing a victim and burying it with ritual that secured its place as the guarantee of the building's solidity and security.

The story of Simonides' invention of artificial memory is a link between these primary architectural practices and the metonymy of the signifier that is common to all human thought. In a sense, it is architecture's interpretant, its central enigmatic key. The chiasmus of the story shows the relationships. In Lacan's theory of metaphor-metonymy, which is by extension his theory of language and the structure of the unconscious, the formula for metaphor is:

$$F(S'/S)S \cong S (+) s$$

The signified effect (s) is created by the substitution of one signifier for another (S'/S). Lacan's is a "purist" definition of metaphor, one that precedes the more literary versions. One of the signifiers in this replacement process becomes the stand-in for the effect itself, S (+) s. The signifier is "charged" ("pulsated") with the signified; it exceeds any particular signifier, and is the means of incarnating the meaning effect. Lacan's formula for metonymy is quite different:

$$f(S \ldots S')S \cong S (\text{---}) s$$

The Ss are signifiers, and the 's' is the signified *effect* (in place of the illusory "signified"). S . . . S' is a chain of signifiers, each succeeding the other in the temporal sequence. The movement from one signifier to another creates the idea that there is a signified somewhere, beyond the signifiers. "S (—) s" means both "signifiers in absence of a signified effect" and signifiers and signifieds separated by a barrier, across which we can experience meaning only as a *resonance* or echo. The bar is important, not in its usual mathematical sense but as something that *cannot be crossed*. In metonymy, the line between meaning effects and the signifiers that produce them is prohibitive. It represents a gap (like the gap separating the subject's mirror image and the image stand-in that Others will use) that can't be crossed. The meaning effect of metonymy is sensed as a resonance or sympathetic vibration. Because of the bar, there will always be a here and a there, and an echo or specter that, if it makes it to the other side, can do so only as a kind of ectoplasm or, more benevolently, the distant, haunting call of some wild bird or beast.

The bar is evident in the Simonides story through the chiastic structure, which divides the tale into two halves. It is across this bar that we have only suggestions of an uncanny connection between, for example, the half of the poem dedicated to the twin gods, the Dioscuri; the half of the fee "made up" both by the grateful relatives of the crushed guests and by the gods themselves, who seem to have some connection to the mysterious youths who called Simonides out of the banquet hall just before its collapse; and the half-and-half structure of the memory place itself, a place that holds a name, the system of spatial memory. These halves call out to each other across a bar they will not cross without destroying the "signified effect." Spookily, they are epitomized by the crushed bodies, about which two points should be noted: the bodies cannot be identified (semblance dysfunction), and proper burial depends wholly on determining their

location according to the system Simonides had used to recall their names (contiguity). Contiguity, too, is "dysfunctional" in the sense that Simonides' method was to place the names into *his* memory place, not the literal space of the banquet hall. The story depends on this central irony: that Simonides could not have discovered his method by means of this disaster without having already employed it before the collapse. Even if Simonides' "memory place" had been the banquet hall itself, it would have been re-shaped by a symmetry of counting required by the method.

The issue of contiguity points to an important Lacanian theme. When Lacan discovered the centrality of the mirror stage, it was Melanie Klein's theory of the importance of metonymy in early childhood development that served as a guide. The child's relation to the mother is one of parts. Not-all of the mother can be perceived, and this "not-all" quality itself becomes the key component in the child's relation to the mother as the model of all subsequent Others. The other is a treasury of signifiers; a seemingly endless source of signified "effects"; but these effects are conditioned by absence – missing signifiers or components that become the very essence of the Other. The Other *is*, if anything, this lack; this missing part. The subject's relation to the other is radically metonymical.

In the Simonides story, thanks to chiasmus we have an exceedingly vivid picture of the treasury as signifieds and the Other as lack: the banquet hall with its guests, in its proper erect form and, then, in collapsed ruin. Chiasmus tells us the relationship between the two. There are two roles for the "bar" that separates the signifiers from the signified effects, or "meaning effects." One is the boundary of the doorway. When Simonides is called outside, it is to the kind of Real that constructs a dimension of escape, a position that will afford him the ability to interpret the disaster, R_1. The other role of the bar is miniature and internal. It is the dividing line that manages the economy of halves that dominate the story. The split poem, the divided fee, the name of each guest and the memory place that Simonides employs to retain it. These amount to "internal dysfunctions in the operation of causality" that are R_2, the second type of Real. The portability of R_2 allows any segment of the signifying chain within the "treasury" of the banquet hall to resonate. Places echo names, missing fees resonate with the idea of two youths who call Simonides outside, the prophecy of Scopas will be, spookily, fulfilled. These *loci* of the "inner real" create an echo chamber that works, like a sea-shell, with any wind that blows across it. The seemingly visual method of memory places turns out to be an acousmatic voice, Lacan's fifth "partial object."

The coupling of gaze and voice, where both deploy a metonymical-dysfunctional logic within a form that could be called a "treasury" is found in the second most famous example of artificial memory, Giulio Camillo's *theatro della memoria*. Whether or not this *theatro* existed as an actual structure or only as an *idea* described in the book Camillo wrote under the sponsorship of Francis I has never been determined. If it was a structure, as some eye-witnesses claim, it was lost shortly after Camillo's death in 1544. The main features are described in Camillo's 86-page book, *L'Idea del Theatro* (1550).[11] The single user of the theater occupied a small area comparable to a stage. Around this area, was an "auditorium" whose seven rows and columns defined a set of forty-nine (7x7, a perfect number in the lore of number magic) memory places.[12] Each place was defined by a crisscross logic set in motion by a bottom row of "seats," the planets. The seven tiers stood for the generation of the world from these archaic planetary qualities: the uppermost tier described human institutions, tools, and arts. The horizontal program

followed the logic of the planets, as a generational series beginning with Saturn and ending with Luna.

Like Simonides' banquet hall, this "treasury" was filled with "partial objects." Each of the items Camillo specified to fill the forty-nine compartments was conceived in the "emblem tradition." This was the art related to the "military device" used to identify the soldier, his rank, clan, and deeds. With the rise of printing, emblem books became the obsessions of the literate classes. Rebus-like images were accompanied by poetic riddles that challenged the reader to guess the hidden mysteries of each of the topics: "wisdom," "virtue," "prudence," etc. The emblem books were perfect examples of Lacanian *mi-dire*. They spoke the truth, but only a part of it. The metonymy of text was the riddle form, akin to the genre of children's riddles in the style of "What am I?"; qualities were enumerated through personifications of abstract ideas.

Camillo's memory theater was not the classical memory place where things to be remembered were stored for later recall. It was a place that demonstrated the idea, later expressed by Giambattista Vico, that memory was the same thing as imagination [Vico 1984]; see also [Bayer and Verene 2009]. The user of Camillo's theater would "remember" the whole of human wisdom by imagining it. In a sense, Camillo (and Vico) defined wisdom in a very Lacanian way: it could not be lost because it had never been possessed, but because it was not lost it could be imagined through the fiction of loss. The treasury of the Other was, precisely, its defectiveness. This defect manifested itself first in the rebus-like objects Camillo placed in the compartments of the auditorium. Each was "partial" in the same sense that Simonides' banquet-hall guests were composite monsters of place and name. The linkages holding the theater together as a whole were also defective. The user was required to reason from the position of God rather than man. The mnemonicist was, as in the tradition of *mi-dire*, to become the shaman, the prophet, the mystic.

Another defect in the "string of signifiers" called the memory theater could be found in the first row. Six of the "seats" are, according to the general design, planets. The middle position however is not Apollo, who is found in the row above. On the first row, he is eclipsed by the "banquet of the Breadth of Being, which is the image of the Divinity," and banquet is the name given to the entire second tier. What is the meaning of the banquet and why does this internal chiasmus, which exchanges the place of Apollo and pulls the second row down to the first, occur? Camillo explains – but only in part — in ways that make him seem to be a sixteenth-century precursor of Lacan: "Two have been the productions which God has made, the one from within his essence of His divinity, the other from without" [Wenneker 1970: 217 (*L'Idea del Theatro*, p. 17)]. Do the two Reals of the Banquet also establish, as they do in the Simonides story, a space, a "treasury"? The production from within, Camillo explains, was the word that initiated the world. This was guided by the number 7, a composite of 6 and 1, and 6 was a "chiastic" number, both the product and sum of its parts. The external Real was a matter of formation from *prima materia*. This, too, was dominated by the number 6. In the Pythagorean tradition, all things proceed from the "Gamone," six entities that progress from God (as father) to God as son, to angelic mind, to the "soul of the world," or Chaos, to the breath of the soul, to generation. These steps were represented by the thermodynamic sequence of sun, light, flame, brilliance, heat, and generation. The "Banquet of the Gods" may have a correspondingly climatological origin. The story goes that Okeanos invites the gods to the banquet, in what is now Libya. The meaning of this has to do with the belief that the sun drew up moisture by its heat and, at the spring

equinox, drew the gods from their home on Mount Olympus to the south. Just as the seasons begin in spring, the material world begins at this point where the northern hemisphere's elements are warmed by the moist breath of Okeanos, who, Camillo notes, existed before creation.

With an internal Real$_2$ of emblems and external, oceanic Real$_1$, it is easier to see how the bar of metonymy gives rise to memory as *mi-dire*. The missing signifier of the Other will not be symbolized, but as the ultimate partial object, it will be the voice of the mnemonicist; the gaze embodied by the cabinets of the theater will become, literally, the *audi*-torium where vision gives way to an "acousmatic" resonance afforded by chiasmus. Is this the answer to the ancient riddle of the meaning of the letter E inscribed on the omphalos-stone at Delphi? On the final row of the theater, in the place of the Banquet, Camillo describes the "most noble" image of Hercules (*Ercole*), as a sign of "all the sciences pertaining to things celestial, to this world and the abyss" (the three parts of creation).

> Since the symbolic Theologians wish Hercules to denote the human spirit, which like the arrow of three points, can penetrate with one the celestial secrets, with another, those of this world, and with the third, those of the abyss. Therefore, it shall contain a very distinguished volume, in which shall be seen organized without exception all the sciences with all the 'links' pertaining to their particular 'chains'. And finally, eloquence as the shelter and ornament of all, eloquence, I say, relating to prose expression, in all its kinds, since poetry is solar, and it shall go to the image of Apollo among the muses. ... This image, therefore, shall include a volume pertaining to design, architecture, painting, to perspective, modeling, to sculpture, and all their appurtenances. And the division shall be of such small categories, that the disposition shall appear marvelous.[13]

Recent excavations at Annapolis, Maryland, have uncovered the first intact example of the Yoruba practice of "cosmogram."[14] In short, this is the creation of a design within a building through the concealment of objects inside door jambs, beneath floor tiles, and so on, so that curses and blessings could be reinforced by delivering curses/blessing at the precise moment when the subject-victim stood in the proper location. In this "treasury," like Camillo's and Simonides', there is the partial object, the guest and the magic name with the power to kill or bestow eternal life. There is the bar in its internal and external forms: the internal logic of halves, of pairs with a missing twin; the external dimension that affords the *magus* control and agency. There is the metonymy of parts, and the meaning effect. In short, there is the *mi-dire*, the only way to speak the truth. In this African practice that gave American slaves some sense of mastery in a world where they themselves were the misrecognized subjects "castrated" by the symbols of their servitude, we can hear the echoes of all foundation rites, all magical practices by which buildings, cities, and graves were secured.[15] Chiasmus, the logic of halves, the 'E' of the oracle, suggests that Vitruvius's conception of the architectural virtues of *venustas* (the celestial), *utilitas* (the world), and *firmitas* (the abyss, the place of sacrifice, of the part that resonates the whole) were not far off the mark.

Notes

1. In February 1933, all France was horrified over the news of the savage double murder committed in the town of Le Mans. "Two respectable, middle-class women, mother and daughter, had been murdered by their maids, two sisters who lived in the house. The maids had not simply killed the women, but had gouged their eyes out with their fingers while they were alive and had then used a hammer and knife to reduce both women to a bloody pulp. In both cases, there were no wounds to the body. Apart from some gashes to the daughter's legs, the full force of the attack was directed at the heads and the victims were left literally unrecognisable." http://www.geocities.com/neil404bc/crime.htm, last accessed January 12, 2009.

2. Popular culture's view of Kurt Gödel's observations on the subject of recursiveness does little more than scratch the surface of his revolutionary 1931 paper in response to Alfred North Whitehead and Bertrand Russell's *Principia Methematica*. See [Nagel and Newman 1958].

3. For a comprehensive review of this issue, see [Cassirer 1957: 205-278].

4. The theme of the "armored" ego was emphasized by Hal Foster in his treatment of the mirror stage; see [Foster 1996: 208-211].

5. [Pluth 2007: 17]. Pluth's citations have been omitted for the sake of clarity. I thank Nadir Lahiji for pointing out this very important contribution to Lacanian studies.

6. For those not familiar with Lacan's theory of the drive, demand (asking for) contains two components, one that can be symbolized and a "silent" vector that, because of its resistance to symbolization, removes the goal from the aim of demand. The result is a motion that circles around a missing/silent object that is the "object cause of desire," what Lacan called *l'objet petit a*, the "small other," a material cause that functions primarily through absence.

7. Richard Ellmann reports that the extremely name-conscious James Joyce considered Odysseus's name to be a composite of *outis* and Zeus — "Outiszeus" — and, hence, a "divine nobody." This illuminates his use of the Greek letter E to represent Giambattista Vico as "Earwicker" throughout *Finnegans Wake*. The E is related to the ε found on the omphalos stone at Delphi. See [Ellmann 1977: 13].

8. Lacan's interest in the future anterior stemmed from Freud's account of regression in terms of the analysand's future discovery of where the id was. "*Wo Es war, soll Ich werden*" is the phrase so often used in reference to this. "Where it [the Id?] was, there I [the Ego?] shall be." Ellie Ragland-Sullivan discusses this phrase at length and points to Lacan's own interpretation of this motto of regression to mean something substantially different from the traditional id/ego translation: "It is one's duty to emerge from a place of unconsciousness being to recognize the truth, that one's being derives from having been an object of unconscious and alien principles. Only in the movement of seeing oneself emerge from the unconscious can knowledge become truth" [Ragland-Sullivan 1986: 12]. Ragland-Sullivan further observes that the famous misinterpretations of this Freudian phrase (Jung, Bachelard, Jones) have exactly inverted its meaning, making the unconscious a matter of myth and symbol. In his attempt to restore the Freudian meaning, "Lacan takes the dream quite literally as a 'discourse' spoken by an unconscious subject and, what is more, in the language of everyday discourse. The dream discourse becomes a rebus or enigma, however, because it is formed and reorganized by the primary-process laws of condensation and displacement and, thus, is distorted by the time it surfaces to the conscious level" [1986: 13]. In other words, the dream is the metonymy of a (metaphoric) consciousness, a form of (female) "paranoiac discourse." The significance of this view is heightened by the fact that Lacan saw regression primarily as a *topographical*, not a temporal, process. In Seminar XI, Lacan notes that the *Ich* of Freud's phrase is the subject, and "where the subject was" was, precisely, the dream. "The subject is there to rediscover *where it was* – I anticipate – the real ... *The gods belong to the field of the real*" [Lacan 1998: 44-45].

9. Ivan Illich, personal communication, October 1989.

10. Yates can be forgiven, since none of the primary sources for this story (Cicero, Quintilian) refer to it other than a curious anecdote. The earliest claim of the story's chiasmus is my own; see [Kunze and Wei 1986: 65].

11. My resource for Camillo's theater is a doctoral dissertation [Wenneker 1970], which includes a translation of *L'Idea del Theatro* and an extensive analysis.
12. The reader will note both the "chiasmus-like" effect of 7x7, two sets of lines crossing at right angles, and the chiasmus of the aliquot number 6 (1x2x3, also 1+2+3) which makes 6+1 such a good choice for a theater, whose space must include and then "disavow" a dimension based on hearing. In the '6', the single user of the memory theater is both in on stage (6+1) and in the auditorium (in the 6's).
13. [Wenneker 1970: 348-349 (*L'Idea del Theatro*, pp. 82-83)]. The three-pointed arrow is, we conjecture, the E of Delphi. This makes Joyce's appropriation of it as the 'E' of Earwicker, his nickname for Giambattista Vico, and the coincidental role of the ear in psychoanalysis, even more provocative. In both cases, understanding ("science") is based on the resonance afforded by accumulated detail and the role, in all "treasuries" of the Other, the missing signifier.
14. [Wheeler 2000]. This article cites the work of University of Maryland Prof. Mark Leone and archaeologist Jessica Neuwirth, of the Historic Annapolis Foundation, on the Brice House.
15. The Yoruba practice of constructing cosmograms is not so unusual if one includes, in this family of sympathetic magic practices, Hopi mandalas, therapeutic circular dances of the choruses in ancient Greek theater, or even the geometry of the Federal Mall in Washington, D.C.

References

BAYER, Thora Ilin and Donald Phillip VERENE, eds. 2009. *Giambattista Vico: Keys to the New Science, Translations, Commentaries, and Essays*. Ithaca, NY: Cornell University Press.

CASSIRER, Ernst. 1957. Towards a Pathology of the Symbolic Consciousness. Part 2, Chapter 6 in *The Philosophy of Symbolic Forms*, Vol. 3, *The Phenomenology of Knowledge*, trans. Ralph Manheim. New Haven and London: Yale University Press.

CLÉMENT, Catherine. 1983. *The Lives and Legends of Jacques Lacan*, trans. Arthur Goldhammer. New York: Columbia University Press.

ELLMANN, Richard. 1977. *The Consciousness of Joyce*. Toronto and New York: Oxford University Press.

FOSTER, Hal. 1996. *The Return of the Real: The Avant-Garde at the End of the Century*. Cambridge, MA and London: MIT Press.

KUNZE, Donald and Wesley WEI. 1986. The Vanity of Architecture: Topical Thinking and the Practice of Discontinuity. *VIA* **8**: 54-69.

LACAN, Jacques. 1998. *The Four Fundamental Concepts of Psychoanalysis, The Seminar of Jacques Lacan*, Book XI, trans. Alan Sheridan. New York and London: W. W. Norton & Company.

NAGEL, Ernest and James R. NEWMAN. 1958. *Gödel's Proof*. New York: New York University Press.

PLUTH, Ed. 2007. *Signifiers and Acts: Freedom in Lacan's Theory of the Subject*. Albany, NY: State University of New York Press.

RAGLAND-SULLIVAN, Ellie. 1986. *Jacques Lacan and the Philosophy of Psychoanalysis*. London: Routledge.

VICO, Giambattista. 1984. *The New Science of Giambattista Vico*. Max Harold Fisch and Thomas Godard Bergin, trans. Ithaca, NY: Cornell University Press.

WENNEKER, Lu Beery. 1970. An Examination of *L'Idea del Theatro* of Giulio Camillo, including an Annotated Translation, with Special Attention to His Influence on Emblem Literature and Iconography. Ph.D. dissertation, University of Pittsburgh.

WHEELER, Linda. 2000. Common Objects Are an Uncommon Find; Extensive Collection of African American Hoodoo Artifacts Uncovered in Annapolis. *The Washington Post*, Metro Edition (February 16, 2000): B03.

YATES, Frances. 1966. *The Art of Memory*. London: Routledge and Kegan Paul.

About the author

Donald Kunze has taught architecture theory and general arts criticism at Penn State University since 1984. He studied architecture at N. C. State University (B.Arch.) and received his Ph.D. in cultural geography in 1983. His articles and lectures have engaged a range of topics dealing with the "poetic" dimensions of experience. His book *Thought and Place: The Architecture of Eternal Places in the Philosophy of Giambattista Vico* (New York, Peter Lang, 1987) studied the operation of metaphoric imagination and memory in landscape, architecture, and art. As a Shogren Foundation Fellow, he developed a system of dynamic notation that adopted the non-numerical calculus of George Spencer Brown. As the 2003 Reyner Banham Fellow at the Department of Architecture at the University at Buffalo, he extended the calculus to a "screen theory," a graphical approach to problems of the boundary in art, architecture, film, and geographical imagination. As the 2008 Nadine Carter Russell Visiting Chair at Robert Reich School of Landscape Architecture at LSU, he applied boundary language theory to the problem of the surrealist garden, involving film theory, topography, and the phenomenon of the death narrative.

Shannon Mattern

Dept. of Media Studies and Film
The New School
2 West 13th Street, 12th Floor
New York, NY 10011 USA
matterns@newschool.edu

Keywords: Louis Kahn,
acoustics, libraries, design
analysis, meaning, symbolism,
geometry

Research

Geometries of Reading, Light of Learning: Louis I. Kahn's Library at Phillips Exeter

Abstract. In Louis I. Kahn's library at Phillips Exeter Academy geometries of architecture and media function as parallel rhetorical systems, sometimes complementing, sometimes contradicting one another. This present paper examines how the geometric forms of the library shape patrons' relationships to media in the collection, and how Kahn's elementary geometries have accommodated new media characterized by non-geometric, non-linear forms.

Introduction

Sarah Williams Goldhagen describes Louis I. Kahn's library at Phillips Exeter Academy as a "great brick packing crate of a building that is dominated inside by geometries of circles inscribed in squares; natural light pours in around an improbably heavy X-shaped cross high above" [2001: 1]. Kahn himself uses a different geometrical language to describe his design:

> I made the outer depth of the building like a brick doughnut.... I made the inner depth of the building like a concrete doughnut, where the books are stored away from the light. The central area is a result of these two contiguous doughnuts; it's just the entrance where books are visible all around you through the big circular openings. So you feel the building has the invitation of books [quoted in *Architectural Forum* 1972: 77].

Designed from the outside in, as a box within a box, the library's outermost volume features rows of private reading carrels along its exterior walls, while the intermediate ring houses the book stacks, and the ceremonial hall in the center offers a place to meet and be inspired by views of the library's collection.

In the nearly forty years since Kahn's library began welcoming students at this exclusive prep school in southern New Hampshire, countless critics and historians have addressed the functionality and symbolism of the library's exterior and interior geometries, how that geometry filters light and directs the flow of visitors; and how Kahn's design manifests his interpretation of the essential Form of the library-as-institution. In that same period, and for decades prior, some of those same critics and historians have searched for material evidence, throughout Kahn's entire oeuvre, of his "knowledge of architectural history, transformed by his fascination with geometry, and placed at the service of his ideas about the nature" of human institutions [Wickersham 1989: 140]. Using several of Kahn's buildings as examples, Robert McCarter, author of one of the many monographs on the architect, explains how Kahn made "the archaic...architectural through engaging the most fundamental of geometries and eternal ordering principles" [2005: 446]. William Jordy [1974], Hisao Koyama [1983], Vincent Scully [1989], Jay Wickersham [1989], Peter Kohane [1990], and McCarter [2005] have all examined the influence of Kahn's Beaux Arts training and his complex relation to Modernism and the International Style on his practice, and the impress of particular

Nexus Network Journal 12 (2010) 389–420 NEXUS NETWORK JOURNAL – VOL.12, No. 3, 2010 **389**
DOI 10.1007/s00004-010-0042-4; *published online* 15 September 2010

historical precedents – the medieval monastic library, the monastery cloister of Bramante's S. Maria della Pace, the Renaissance palazzo, Étienne Louis Boullée's drawing of a "Library Hall," Frank Lloyd Wright's Unity Temple – on Exeter, in particular. At Exeter, Vincent Scully argues, Kahn found "a diagrammatic realization of the Neoplatonic order indestructible within the ruin" [2003: 317]. "Kahn sought to reduce the [library] to the simplest possible statement of pure geometric shapes," Jay Wickersham writes, "a sphere within the cube of the central hall, within the larger cube of the building's exterior mass" [1989: 148-149].

Yet Goldhagen, in *Louis Kahn's Situated Modernisms*, strives to dispel the myth that Kahn was a "conservative mystical thinker who sought to discover or create geometric archetypes of universal significance" – that Kahn, a "latter-day neo-Platonist, ...believed it was the architect's job to 'discover' ideal forms and then re-embody these archetypes in a new architectural language" [2001: 2]. She argues that

> Kahn himself encouraged this vision of his agenda, particularly toward the end of his life when, under the influence of spiritually minded architects, mostly from the Indian subcontinent, he retroactively described his architectural agenda in the obfuscatory and transcendentalizing terms for which he is well known [Goldhagen 2001: 2].

Much ink has already been spilt in this debate, and it is not my intention to resolve it here. The focus on biographical histories of Kahn's design and this *auteur*-ish approach to design analysis, I think, steal attention from the *social* and *experiential* aspects of Kahn's buildings – an oversight that is particularly unfortunate when examining his institutional designs. As we know, Kahn was interested in the "existence will," the "spirit," of institutions, and how that spirit might be embodied in an architectural form (see [Kahn 1961, 1970]). We cannot forget that institutions are *social* constructions; they are, as Libero Andreotti says in his study of the Exeter library, "the social expressions of the order of human nature" [1984: 160]. We therefore have to wonder how Kahn realizes a "Form reflective of [the library's] order" – how he translates that Form into a design, a geometric assemblage, that represents "the accumulated wisdom [the library] stewards;...the spontaneous encounters it allows;...the needs of people who may, because of its presence, gain presence" [Andreotti 1984; Marlin 1973: 34]. What geometries express, and foster, the kinds of encounters and qualities of presence that define *Library*?

A few critics and scholars – particularly Andreotti, Jordy, Kohane, Scully, and Wickersham – have addressed the symbolic functions of the Library's geometric forms. I will reassess much of this literature through a rhetorical lens: I will revisit the Phillips Exeter Academy Library (which, since 1996, has been known as the Class of 1945 Library) as a rhetorical space, in the sense that, through its form and materiality, it argues for a pedagogy and an "existence will" that defines the library and the Academy as institutions. There is plenty of precedent for regarding architecture *as* a form of communication or rhetoric; anthropologist Edward T. Hall [1959] calls human spatial practices one of the "primary message systems" of culture, while semiotician Umberto Eco [1997] reads architecture as a system of signs, and McLuhan [1994] proposes that housing is a medium. Adrian Forty [2000] and Jonathan Hale [2000] identify several other architectural and communication theorists who regard architecture as a system of meaning or rhetoric. Kahn might have denied that his architecture had any rhetorical purpose; according to Goldhagen, "[h]e claimed that even his geometries, which in their Euclidean simplicity so invited symbolic interpretation, were abstract" [2001: 152]. "I

use the square to begin my solutions because the square is a non-choice," he claimed (quoted in [Goldhagen 2001: 152]). Yet "the monumental imageability of Kahn's buildings, together with the public nature of the institutions they house," Goldhagen says, "nearly insist that members of a community appropriate them as symbols. They stand as physical embodiments of the social values ... that their institutions represent" [2001: 209]. Scully agrees: "The signs and symbols are certainly there in Kahn's buildings, all emphatically embodied in solid matter. They are intrinsic to the structural forms ..." [1989: 40].

The first and second sections of this essay will focus on the macro-scale exterior and interior geometric forms – the "packing crate" constructed of brick planes, the doughnut plan, and the circles, squares, and triangles defining the central hall. I examine how these forms function as a medium for "institutional rhetoric," defining the values of Phillips Exeter Academy and of the library as an institution. I aim in these two sections to address an over-emphasis in current scholarship on Kahn's personal design philosophy and his own relationship to architectural history – an emphasis that leads to a bracketing out of the *institution's* historical context. Much of this existing work ignores the relationship between Kahn's design and other libraries designed in the same time period, and it disregards the influence of Phillips Exeter Academy's (PEA) 200-year history and entrenched pedagogical mission on the purpose and program of its Academy library. Kahn's own professed disregard for the client's influence may foster a similar disregard within the scholarship on his work. He claimed that "[t]here are few clients who can understand philosophically the institution they are creating," and thus the architect must take it upon himself to act as "philosopher for the client"; the architect must, as Jordy puts, it, "reconstitut[e]...the programme in light of what the institution primarily *is* with respect to the cumulative human experience of using it" (quoted in [McCarter 2005: 223; Jordy 1974: 330]). While acknowledging the innovation of Kahn's design, we must also read through his conceit to appreciate the significant influence on the design of both the Academy's tradition, and the insightful and progressive library program created in 1966 by a PEA faculty committee.

The third section examines how the building houses the collection, and how Kahn's more micro-scaled architectural geometries and furnishings – and their connections to light – create a *habitus* that structures the way patrons interact with books and with the building. In order to examine visitors' experiences of these interior spaces, I draw on published letters from Exeter alums, many of who eventually served in the Friends of the Academy Library. I then look, in the fourth section, at how the building, which literally places "orality" at its core, in the form of a large, public central hall, integrates formal expressions of both literacy and orality. Drawing on the work of Walter Ong, I examine the place of orality and literacy in Exeter's signature pedagogies, and address how the library functions as a pedagogical space. Finally, in the fifth section, we look how the Library has accommodated the technologies of what Ong calls "secondary orality": how new media forms – film, video, audiocassettes, CDs, word processors, wirelessly networked computers – have been integrated into the library. Drawing on McLuhan's distinction between "light-on" and "light-through" media to address these media formats' varying relationships to light and their spatial demands, I examine whether Kahn's architectural geometry, which took the rectangular book as its module – and which made those books, displayed in linear stacks, its *ornament* – might resonate differently for a new generation of media and library users.

Ultimately, analyzing the myriad rhetorical registers on which Kahn's library operates, we find several breaches – between media and architectural forms, between institutional ideologies and the ideologies embodied in material form. The building's timeless architectural form is rooted in the light of the Enlightenment – a light that is in no way diminished, but has, within the past several decades, been joined by other sources of illumination. The Library as a whole is based on the geometry of the book – a geometry that, in the end, is unable to represent the non-Euclidean nature of new media and the seeming disorder of nonlinear, networked modes of learning.

The institutional rhetoric of the brick box

The Phillips Exeter Academy was founded in 1781 by Dr. John Phillips, Harvard graduate and Exeter local, to teach its students "not only in the English and Latin grammar, writing, arithmetic, and those sciences wherein they are commonly taught, but more especially to learn them the great end and real business of living" – a way of life based on the belief that "goodness without knowledge is weak and feeble, yet knowledge without goodness is dangerous" [Phillips Exeter Academy, Academy Archives]. In 1930 a gift from oil magnate Edward S. Harkness provided for the implementation of a new pedagogy and pedagogical "architecture": the Harkness table. "What I have in mind," Harkness said, "is [a classroom] where [students] could sit around a table with a teacher who would talk with them and instruct them by a sort of tutorial or conference method, where [each student] would feel encouraged to speak up. This would be a real revolution in methods" [Phillips Exeter Academy, The History of Harkness Teaching]. The design of the table evolved until it comfortably fit a group of students, typically 12, and their teacher, such that everyone was able to make eye contact with one another. "As the physical table itself implies, learning at Exeter is a cooperative enterprise in which the students and teacher work together as partners" [Phillips Exeter Academy, The Harkness Table]. Some of the original tables were too large to fit through the classroom's doorways, according to the Academy's website, so "builders brought their materials to the classrooms and constructed the tables inside. This means that Harkness Tables really are part of the rooms in which Exeter's community learns, teaches, discusses, and collaborates" [Phillips Exeter Academy, The History of Harkness Teaching].

The room, we might say, grows out from the table, its physical, pedagogical, and symbolic center. Harkness's vision thus shaped the institution's teaching and learning philosophies – philosophies that, in turn, impacted the arrangement and use of spaces in which teaching and learning were to take place, including the Library. In a 1984 letter to the Friends of the Academy Library, the group's secretary Robert N. Shapiro notes that "[i]t was the Harkness Plan in the 1930s that really changed the role of the Library at Exeter":

> Recitations were no longer the norm, texts were no longer the only books used in class. Supplemental reading, independent research, short selections from many books held on reserve – all these brought students into the Library. Not surprisingly, the collections grew quickly, and soon displaced the English classes that had originally been held in the rooms on the first floor. A periodicals room was created, and across the hall the librarian's office. That, too, was eventually crowded with old and rare books, microform machines – and a model of the *new* library [Shapiro 1984c].

In the meantime, as these new technologies began appearing in the old Davis library, other curricular changes incited changes in the use of pedagogical space. In the 1950s,

the history department began assigning more research papers, driving more students to the Library, which had made the once-closed stacks open to students [Shapiro, June 1985]. The geometric regularity of bookstacks, a newly inhabitable space, thus became a new spatial form shaping students' learning experiences. Exeter's pedagogy therefore had multiple geometric expressions: It was an oval table; it was the linear bookstacks; and, eventually, when Davis proved insufficient to handle these new patterns of use, it was Kahn's circle-in-a-square.

A committee composed of librarian Rodney Alexander, French teacher Elliott Fish, and history teacher Albert Ganley were charged with developing a program – "no more than a guide...[with] general proposals which might shape [the architect's] mental image" of the new library [Phillips Exeter Academy 1966: 1]. Most buildings on the campus are red brick, neo-Georgian structures, so the faculty committee asked that the library be made of brick, too, and that it be "unpretentious, though in a handsome, contemporary style" [Phillips Exeter Academy 1966: 2]. Yet Kahn, ultimately chosen for the project from among a list of prominent architects, claimed to design as if no library had existed before and as if the client's program was disposable. He seemed to take credit for the Library's brick exterior: "Brick was the most friendly material in this environment. I didn't want the library to be shockingly different in any way" (quoted in [Wiggins 1997: 12]).[1] Regardless of where the idea originated, brick tied Kahn's new structure into its context aesthetically and symbolically, expressing traditional values, yet in a contemporary form.

There are five rows of openings in the building's brick facades: the openings at the ground level reveal a "deeply shadowed arcade" leading into the main entrance, while the top-level openings, framing views of the sky, partly obscure a rooftop terrace [McCarter 2005: 309].[2] In between, there are three rows of windows ringing the building, suggesting that these three floors, plus the ground level, make for a four-story structure. Yet each of those windows is double-height, and there are "shed-roofed mini-buildings" set back from the building perimeter on the upper level; thus, there are actually eight floors sitting above ground. Judging by fenestration alone, the building seems smaller than it actually is. Yet Annette LeCuyer notes that the facade's bricks are smaller than standard size, which makes the library appear *larger* than it actually is [1985: 76]. Kahn had planned to include stair towers at each corner of the building, but, for the final design, stripped those towers away to create re-entrant corners, and thereby "under[cut]...what might have been an off-putting monumentality" [Russell 1997: 94]. The cut-away corners reveal the full depth of the outer brick doughnut, which appears to be faced with freestanding screens detached from the concrete structure behind.

Beneath each of the large windows, recessed into the brick wall on floors one through three, are unfinished teak panels with a pair of tiny inset windows positioned flush with the wall. Behind each of these small windows is a pair of carrels, while the large windows above illuminate mezzanine-level carrels in the double-height arcades. These "different window patterns," Wickersham says, "temper the uniformity of the brick walls and offer the only clue to the different activities that take place within" [1989: 148]; we'll discuss these interior spaces later. Kohane notes that on one of Kahn's fenestration studies, a human figure was "used to fix the size and proportion of each fenestration unit"; this "body-centered approach" to design suggests that "the reader will always be sheltered within an architectural environment that is given intimacy and human warmth by proportional concordance with his own body" [1990: 117]. The teak panels, too, seemed a fitting representation of the intimate relationship between reader and book that was

being cultivated at the individual carrels behind the panels. The windows are thus both literally and symbolically transparent; they are instructive about the library's internal layout, and their materials and scale link them to different qualities of activities inside.

In between those windows are brick piers that are equally instructive about their structural function. They become progressively narrower toward the top, as the load they bear decreases, and as the windows become wider. "Kahn intended that the inhabitant empathetically read the building's structure," McCarter says, by imagining through the changing widths how the piers are "dancing like angels" above and "grunting" from the weight down below [McCarter 2005: 309; Kahn, quoted in Brownlee and DeLong 1991: 355]. Wickersham refers explicitly to the exterior skin as "rhetorical": it is "used to dramatize the structural forces within the building" [1989: 147]. In addition to providing a "lesson on construction logic," the brick walls also serve rhetorically to convey in part the "spirit" of the library: Kohane argues that the narrowing piers suggest "a feeling of ascension that was surely relevant to Kahn's idea of the library as a place where readers strove to attain higher realms of knowledge" [LeCuyer 1985: 76; Kohane 1990: 118]. This transparent expression of structure, combined with the literal transparency of the windows, reflects the institution's mission to provide a sound education in which the ascension to enlightenment is rationally structured. In addition, the simultaneous application of maximizing and minimizing optical illusions plays on both the microsocial and the macrosocial roles of the library; fenestration and brick work together suggest that the institution within provides a learning environment for the individual *as part of* a community. Kohane agrees that Kahn, having thought about the nature of *Library* since his 1956 competition entry for the library at Washington University in St. Louis, acknowledged at Exeter the "importance of an individual's private and public life, the interconnections between each realm, and the relationship of both to a spiritual existence" [1990: 99].

Instead of being sited at the center of campus – a position that would have reinforced the importance of structural logic and the ascension "spirit" to the Academy's identity and mission – the library sits along the side of the quad, "protruding into the green space without respect for the existing building line ... Thus, the library – like a boulder in a stream – disrupts the movement of students along the edges of the quad, forcing them to walk around the structure and drawing them into the ground floor colonnade" [LuCuyer 1985: 76]. One can enter the shady brick arcade from any direction – "[f]rom all sides ... there is an entrance," Kahn said (quoted in [Wurman 1986: 178]) – but depending on what direction that is, he or she might have to circle the building to find the entrance, a glass vestibule on the north side of the building. "Perverse as the hidden entrance may seem," Jordy acknowledges, "it emphatically reinforces Kahn's statement that his design begins on the periphery ..." [1974: 333]. We might read this entrance sequence as a symbolic rite-of-passage to enlightenment – which seems to be how Peter Greer, Exeter alum, experienced it. In a January 1991 letter to the Friends of the Academy Library, he recalled what it felt like to approach the building:

> As I walk up the path toward the north-east corner of that building, I saw again what I love to see: that even as it soars over me, diminishing me in a sense, I see myself reflected in the corner window, and my reflection, of course, grows larger as I come closer. That growing reflection suggests to me that the Library, far from something that diminishes me, is nothing more than a reflection of my own potential for intellectual and cultural growth [Greer 1991].

Although we might find within the play of scale, transparency, and structural rationalism of the facade a generally coherent rhetoric conveying the core values of Library and School, we will soon see that there is a physical and rhetorical breach between this façade and what awaits us inside.

Circle, square, seduction, and ceremony

Once the visitor has located the glass vestibule, he walks through the door to find a rather pedestrian message board with announcements of upcoming Academy events and two display cases angled to direct one toward a glass entrance into the ground-level Periodicals Rooms. Yet, on an initial visit to the library, one rarely notices these quotidian elements. Instead, the visitor's eye and body are drawn toward a grand double circular staircase whose "ceremonial function is explicitly denoted by its white travertine marble facing" [Kohane 1990: 110]. As the visitor approaches and climbs the stair to the central hall (fig. 1), one flight up, massive concrete beams obscure his view.

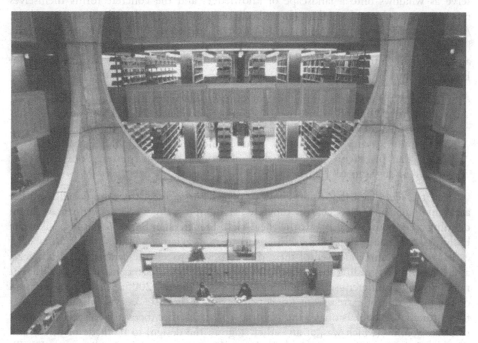

Fig. 1. Rockefeller Hall. Photo courtesy of Dennis Waters

This "gradual unfolding of the central space creates a strong sense of anticipation" for the ascent "into the realm of ideas" [Kohane 1990: 112]. "Having traversed the intricate entrance sequence, one responds with all the more intensity to the perfectly ordered geometries of the light-filled hall" [Kohane 1990: 110]. Kahn likely borrowed this idea of a large central space, which was not called for in the library program, from seventeenth-, eighteenth-, and nineteenth-century libraries, which used the central hall to "impress upon the reader the accumulated knowledge of centuries available for study. ... It is a place to pause, to reflect upon the knowledge, history, and tradition embedded in the books" [Jordy 1974]. Kahn's central hall, a monumental room rising the full height of the building, is likewise where one receives the "invitation of books." Much has been made of the centrality of the book to Kahn's design; he regarded the book as "an offering

of the mind," and the library "tells you of this offering" (Kahn, quoted in [Wurman 1986: 202]). He saw the library as a "place where the librarian can lay out the books, open especially to selected pages to seduce the readers" (Kahn, quoted in [Brownlee and DeLong 1991: 309]). As Glenn Wiggins suggests, the Library itself "participates in [this] seduction of the user"; the building functions rhetorically to entice the reader to "take the books and go to the light" [Wiggins 1997: 16].

Large circular openings in the walls of ceremonial Rockefeller Hall, reminiscent of Kahn's Bangladesh National Capital at Dhaka, stretch so that their 30-foot diameter is roughly the full width of the wall, suggesting that their purpose is not to provide mere "glimpses" of the books behind, but rather to envelop the collection and tie the stacks and the communal space of the central hall together into a comprehensive expression of "*Library* spirit." It is what Kahn might call an "architecture of connection." The circles serve as windows onto a landscape of knowledge, and the concrete forms themselves represent the order and stability of that body of knowledge, and of the library's and the Academy's tradition. At the American Institute of Architects' 1997 conference, where the library received the AIA's 25 Year Award, a panelist called the library's geometry "tough and thoroughly humane" [Shapiro 1997]. Just a few years before, Sally Murray James, an Exeter alumnus, recalled her experience of the space in similar terms:

> The huge concrete forms of the inner space continued their endless, weighty round of tic-tac toe. The quick interplay of spaces perpetually celebrated the sheer joy of learning, rather than the mere heft of work. The infinite views up, down, across, around, and through the building remind me that persistent curiosity yields answers far beyond the questions we have thought to ask [James 1993].

Yet it is significant that Kahn chose to detach the walls of the central hall from the adjacent floors in the concentric concrete "doughnut"; the circle and square volumes defining the boundaries of Rockefeller Hall are freestanding – seeming, like the building's external brick façade, to float away from its external volumes (fig. 2). McCarter explains that "Kahn conceived of these three types of spaces [the central hall, the stacks, and the perimeter reading spaces] as if they were three buildings, constructed of different materials and at different scales, buildings-within-buildings" [2005: 306]. The separation of the outer ring of carrels from the concrete ring of bookstacks symbolically distances these functions: book storage and reading. The distance between the central hall's concrete volume (which was, at an earlier stage in the design, to be made of brick) and the oak-clad terraces and metal stacks beyond, seems to emphasize the central hall's framing of the bookstacks. Kohane and Gast suggest, tellingly, that the circular frames present the books as "the ornament of the interior," as the building's "treasure" [Kohane 1990: 110; Gast 1999: 132]. Kahn puts the books on display, but at the same time protects them behind concrete from damaging sunlight. What is the significance, though, of presenting books as both the library's currency and its treasure – both as something to be used, and something to be displayed? How do we reconcile this "exhibition" of books with the library program's declaration that "the emphasis should not be on housing books but on housing readers using books"? [Phillips Exeter Academy 1966: 6].

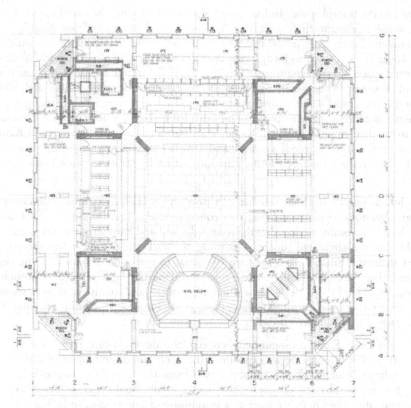

Fig. 2. Detail of plan of first floor. Louis I. Kahn Collection, University of Pennsylvania and the
Pennsylvania Historical and Museum Commission

Several critics have addressed the rhetorical functions of Rockefeller Hall's geometric
forms and their material realization. Jordy examines how the "semi-circle of the entrance
stair, set off as a geometrical shape by its travertine lining against the concrete finishes all
around, ... plays with the circles in elevation," and how "this circularity alternates with
the angularity of the stack-supporting girders" [1974: 334]. He regards these geometric
systems as "architectonic supergraphics," perhaps communicating the structural integrity
of the hall and demonstrating how it is to be used and what qualities of presence it
fosters. Goldhagen argues that through these formal graphics, "highly abstracted allusions
to historic monuments," Kahn "encourages a community to transform a building from a
landmark into what he called a 'people mark,' an architectural vehicle that situates people
in their community" [2001: 209]. For Wickersham, the library's rhetorical structures get
at the "spirit" of the institution: they "*dramatize* the nature of the library as a storehouse
of learning, and...provide a central focus for the Academy's campus" [1989: 141; italics
mine]. The Library committee, of course, recognized this representative potential, too:

> The quality of a library, by inspiring superior faculty and attracting
> superior students, determines the effectiveness of a school. No longer a
> mere depository of books and periodicals, the modern library becomes a
> laboratory for research and experimentation, a quiet retreat for study,
> reading and reflection, the intellectual center of the community [Phillips
> Exeter Academy 1966: 1].

Gast sees in the floorplan the "Indian image of contemplation," the mandala [Gast 1999: 132], while Andreotti finds that the "centrality and symmetry" of Kahn's design represents the library as "a public institution, symbol of the life of the mind" [Andreotti 1984: 162]. Yet according to Jordy, some critics find fault with the "*rhetorical flourish* of the central space," for its extravagance [1974: 335; italics mine]. Goldhagen suggests that, "instead of seeing in the library at Exeter idealist geometries recalling past architectural traditions, one could better…contemplate the social vision implied in placing a grand and richly detailed common space at the heart of building where privileged teenagers come to do their math" [2001: 2]. Rather than being taken in by the mystical Kahnian theories of timeless, universal symbols and institutional "existence wills," one might consider how Kahn's rhetorical forms function within Exeter's particular socioeconomic context.[3]

Light also plays a symbolic role here. In Rockefeller Hall, light shines from overhead through clerestory windows and past two concrete beams that intersect to form a large "X." These cross beams tie together the four walls and add another geometric form – the triangle – to the circle and square. According to Wickersham, the beams serve only a limited structural function, but they are "essential to the visual stability" of the central hall, and they "act as a baffle, to screen and diffuse the light" entering through the overhead windows [1989: 145]. These different qualities and intensities of light represent the different forms of learning, different stages of knowledge acquisition, that Kahn found integral to the library's meaning. Wickersham explains:

> At Exeter, Kahn distinguished between the direct "white light" which streams in through the windows onto the study carrels and tables, and the indirect "blue light" which filters down from the top of the central hall. Just as the physical display of the books in the bookstacks is meant to dramatize the library's nature as a storehouse of knowledge, so in Kahn's mind the descent of the blue light dramatizes the student's encounter with knowledge and truth – not in the collective setting of a classroom, but as an individual, who would set foot in the hall alone [1989: 142].

Geometries of books and reading spaces

After the visitor accepts the "invitation of books" and moves into the stacks (fig. 3), he maintains contact with the central hall through continuous balconies overlooking the hall. Each balcony features an oak bookshelf around the central perimeter. The shelves offer inclined surfaces for the display or perusal of books, "allow[ing] readers to be at once in the stacks, separated, and also to be brought together around the central room" [McCarter 2005: 316]. The central hall thus functions as an "architecture of connection" from both on the ground and up in the stacks. The stacks, by the way, are standard institutional metal shelves, with a capacity for 250,000 volumes, and are lit by fluorescent lights, although daylight from the large exterior windows and the clerestory windows does reach this area.

After selecting his materials from the stacks, the reader then moves toward the study areas along the building's perimeter (fig. 3), toward "the more prosaic white light" [Wickersham 1090: 142], where he finds a band of two-story high brick arcades circling the building. This is where we see the large windows that clouded our judgment of the building's exterior scale. These windows provide light for the interior reading areas and mezzanine-level study carrels. Light is of course a central metaphor in Kahn's designs, but here in the library it is critical both symbolically and functionally. Architect Brook

Muller suggests that Kahn's "patterns of spatio-luminous organization" at Exeter represent more than just a "high modernist's deployment of an enlightenment notion of humankind's privileged access to the light of knowledge" [2008: 189]. A more "experiential interpretation" of enlightenment acknowledges that finding and reading books are activities "'threaded with'…tactility, view, footfall, passage, etc. Knowledge is a journey and light calls forward" [Muller 2008: 189]. We saw how "passage" into the building and central hall informed the rhetoric and process of "enlightenment"; we will now examine how enlightenment is embodied in the library's book storage and reading spaces.

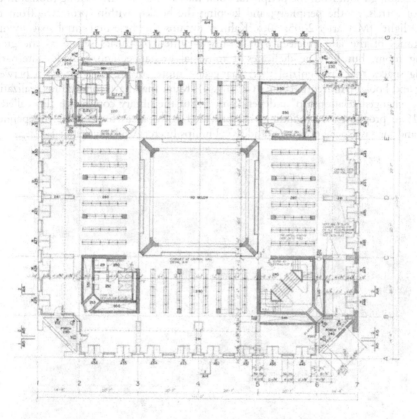

Fig. 3. Detail of plan of second floor. Louis I. Kahn Collection, University of Pennsylvania and the Pennsylvania Historical and Museum Commission

The arcades mark the transition to a new stage of knowledge acquisition – a stage physically separated from the selection of reading material: the act of reading itself. Kahn was inspired by the organization of medieval libraries as described in Russell Sturgis's *A Dictionary of Architecture and Buildings*; in his essay "Space Form Use" Kahn references Sturgis's description of the library at Durham, with its windowed carrels that "grew out of the monk's desire to read and learn" [Kohane 1990: 105]. This spatial organization of the monastic library was later discarded in favor of the "rational separation of functions" [Kohane 1990: 130].

A space order for a library which encompasses many possible relationships between books, people and services could possess a universal quality of

adjusting to changing human needs, translatable into an architecture. A library designed around the incipient influences of standardized book storage and reading devices could lead to a form with two distinct space characteristics – one for people, one for books. Books and the reader do not relate in a static way [Kahn 1965: 43].

Kahn proposed that at Exeter he would give new shape to the fundamental desires of reading and learning. McCarter commends Kahn's "literal inversion of the traditional library programme and plan type" by turning inside out "the habitual separation of the central reading room from the peripheral book stacks"; placing the reading rooms, in the form of carrels, at the periphery; and keeping the books "within, protected from the natural light" [McCarter 2005: 306]. Kahn maintains the majestic central space, which in libraries of the late nineteenth and early twentieth centuries served as the grand reading room, but here he dedicates it to social exchange, and provides alternative reading spaces that "recogniz[e] the...changed – more private – relationship between reader and book" [Andreotti 1984: 162] (fig. 4). Kahn may have come to his realization of this "changed relationship" independently – but the library committee also called in their 1966 program for a building that provided both "areas for creative independent study and for easy social exchange of ideas" [Phillips Exeter Academy 1966: 1-2].

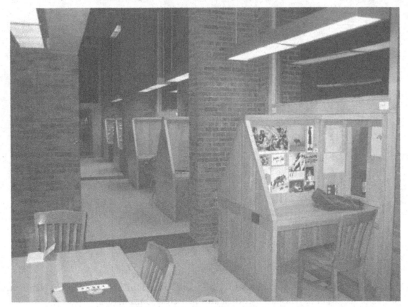

Fig. 4. Student carrels. Photo by the author

The program stated that "carrels should be of wood..., high enough to afford a sense of privacy," that they "should be arranged in alcoves around the book stacks,...near windows for enjoyment of natural light in a pleasant view," and that they should include locking cabinets for storage [Phillips Exeter Academy 1966: 7]. And this is precisely what Kahn provided. Each of the perimeter study carrels features a locking cabinet below, a triangular "privacy" screen, and a tiny rectangular window that offers a view outdoors because, as Kahn recognized, "occasional distraction is as important in reading as concentration" (quoted in [Jordy 1974: 334]). Sally Murray James describes how the carrel's geometry and materiality shaped her experience:

My nook was exactly the magical, private world Kahn had intended. The comforting brick wall. The warm, light wood. The sliding shutter on the window to vary the width of possible distraction. The cabinet under the window, which locked. The generous triangle of wood running interference between studies at hand and the nearby stacks [James 1993].[4]

Muller also acknowledges how the "specific configuration of built-in furnishings from shelves to desks carefully choreographed with the natural light and registered closely with the human body become a primary source of architectural expression/celebration" [2008: 189]. The geometric forms of the carrels, chairs, shelves, wall panels, and the materials of which they are made, inform the private study experience. We can contrast the warm, textured materials – the wood, carpet, travertine, and brick – of what Kahn called the "served" spaces – the central hall, the reading arcades – with the utilitarian materials – slate floors, metal bookstacks and doors, fluorescent light bulbs – of "servant" spaces like the stacks and stairwells [Wickersham 1989: 147]. This is Kahn's material rhetoric, using materials to denote and connote different spaces in the Library.

The Library's program called for "a number of choices as to chairs, tables, light and temperature," and suggested that in some areas the surroundings be "as inviting and pleasant as those of a literary club" – although, throughout, the interior design was to "assure and protect...dignity, distinction, and individuality" [Phillips Exeter Academy 1966: 6, 8-9, 11]. The scale in the arcades is more intimate than elsewhere, and the mood a bit more domestic, too. White oak panels, Oriental carpets, paintings and sculptures, and model ships enhance the anti-institutional ambiance. In addition to the carrels, the region beyond the stacks offers enclosed rooms, large tables, and "homes-away-from-home" reading areas with sofas and armchairs grouped around fireplaces and windows [LeCuyer 1985: 77]. The variety of study areas that Kahn ultimately provided reflects his sensitivity to the diverse "modes" of study: a comfy couch and a fire for an engrossing novel; a rigid chair and large table to spread out materials for a research project; a private room for group recitations of a play.

Kohane explains how the arcades' brickwork reflects Kahn's appreciation for the psychology of reading – and, consequently, creates an atmosphere conducive to study. The masonry, he says "delineates individual bays, which interact with the natural light to provide the intimacy needed for the isolated and passive act of reading" [Kohane 1990:114]. Kahn refers to these bays as "discovered place[s] in the folds of construction" (quoted in [Architectural Forum 1972: 77]). Even the books in the stacks reinforce the arcades' peaceful ambiance by providing a "visual and acoustic barrier" to the public central hall [Kohane 1990: 114]. Furthermore, the stacks "thwart the potential panopticon of the central plan"; because they stand between the librarians in the central hall and the students in the outer regions, the librarians have only limited means of surveillance [Kohane 1990: 114]. This sense of "reading autonomy" bespeaks a much different relationship between reader and book than that represented in the early twentieth-century libraries, with their great halls under careful surveillance, and the medieval libraries, with their books chained to desks. Exeter offers a much freer, less controlled, more personally directed learning experience.

The library's geometry and materiality permit and prohibit various visual perspectives, thereby serving to define the politics of reading and learning, and, by extension, of the institution that provides these opportunities. The 1966 library program addressed the hierarchical relationship between librarian and patron by recommending

that the circulation desk be situated at the library's "working center" in order to foster "meaningful encounters between student and specialist in the creative use of books"; the committee realized that their recommendation "differ[ed] from current practice," in which the desk is placed near major entrances so the librarian can oversee patrons' activity throughout the building [Phillips Exeter Academy 1966: 13]. But their proposal "ensured that service took priority over supervision" [Phillips Exeter Academy, Design of the Library]. Shapiro declares to the library Friends that the building's form and function "rest on a fundamental trust": "There are no gates or barriers. The circulation is on the second level. No one is stationed at the doors. The building respects it patrons" [2002]. Annette LeCuyer reports that Jacqueline Thomas, Academy Librarian, "attributes the overall lack of disciplinary problems to both the caliber of students and Kahn's design" [1985: 77]. A panelist at the AIA convention celebrating the library's 25 Year Award also suggested that Kahn's design, with its geometric volumes, functions rhetorically to promote fitting behavior: "The space educates and makes you thoughtful, it is quiet not because of isolation and intimidation but because the open central space calms you down and connects you with everyone and everyplace in the building..." (quoted in [Shapiro 1997]).

Yet librarian Jacqueline Thomas told me a slightly different story. When the building first opened, she said, the students – mostly boys, since the library had become co-ed only in 1970, and there were still relatively few girls there in 1971 – "didn't know how to use the building. They weren't used to all those floors and all that freedom" [Thomas 2009]. The openness, the massive volumes, the placement of students in visually prominent places, where they could look down on staff from the balconies – these factors confused students' normal codes of behavior and thus, Thomas surmises, led to some misbehavior [Thomas 2009]. Sally Murray James recalls: "The architect had a son about my age.... I don't know whether Kahn ever imagined the boy as a student at the school, making light of the building, as students do — launching paper airplanes from the mezzanines or leaning into the central space to hail a friend four floors down" [James 1993]. Archivist Ed Desrochers also recollected the problem of "interfloor communication" [2009] between students on the mezzanine and main floor carrels, which is why the librarians now seem to discourage use of the mezzanine carrels. I saw few occupied during my visit.

The architectural geometry itself thus seems not to be sufficient in suggesting appropriate behavior and disciplining students. The Library provides a *habitus*, which Bourdieu defines as a system of "durable, transposable dispositions, structured structures predisposed to function as structuring structures" [Bourdieu 1972: 72]. These "structuring structures," rather than prescribing or dictating behavior in particular settings or situations, merely shape predispositions that are more embodied, internalized, than conscious (see [Dovey 2005 and Mattern 2007]). The habitus creates a field of "possibles" of potential behavior – and, as Shapiro [2002] notes, "[s]tudents have major responsibility there" to shape those potentials. "Each year, a group of senior day students is selected [as proctors] to help maintain smooth functioning and effective management" of the library [Shapiro 2002]. The proctors work from their own carrels and supervise students working around them, calming and shushing when necessary. I attended a pre-Spring 2009 term planning meeting during which several proctors discussed strategies for handling a group of "uppers" who regularly held loud conversations about subjects that "aren't appropriate for the library." "Students take care of students," librarian Thomas told me, and as a result, "they really feel the building is their own" [2009]. Thus, when

the building's formal rhetoric alone fails to elicit fitting behavior from its inhabitants, librarians' and proctors' modeled behavior and instruction provide verbal and performative support for appropriate codes of behavior. The normal functioning of these reading spaces, these zones of literacy, thus relies in part on *orality*.

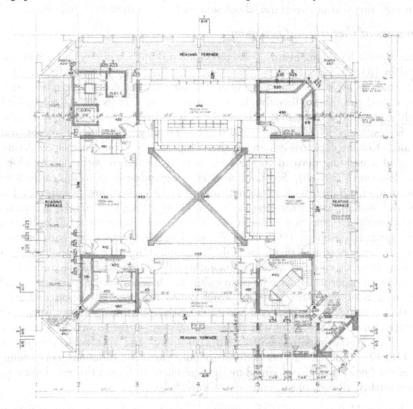

Fig. 5. Detail of plan of fourth floor. Louis I. Kahn Collection, University of Pennsylvania and the Pennsylvania Historical and Museum Commission

Before moving on to look more closely at how orality informed the library design, I will briefly address how other non-book print forms are accommodated in the building. In Kahn's original design for the library he positioned the "special areas" – periodicals, fiction, and rare books, among others – on the first floor; we might say that placing these collections in the central hall implies their centrality to the collection and to the mission of the Library. The committee, though, urged Kahn to move the periodicals to the ground floor, accessible *beneath* the grand circular stair leading up to Rockefeller Hall. The Library program had recommended that the periodicals room "be immediately accessible by location on the ground floor, since a librarian would customarily be in charge of this room at all times" [Phillips Exeter Academy 166: 22]. Even if the placement of periodicals on the ground floor is dictated by demand and the need for supervision, its position beneath the central hall and the stacks is indeed symbolically significant; it implies a subordinate, or at least "other," status. Fiction also moved up to the third floor, and the seminar rooms and rare book collection to the fourth, suggesting perhaps that these spaces will be in low demand, or perhaps in the case of the special

collections, that they represent the highest level of ascension toward enlightenment (fig. 5).[5] The two seminar rooms are typically used for the administration's events and occasional classes, but Thomas says that "a few upperclassmen discover these rooms" [2009] and the nearby rare book rooms, after having never ventured up to the fourth floor in their first year or two at the school, and make them their new study bases.

Geometries of rhetoric and pedagogy

Oral rhetoric has a long history at Exeter. Golden Branch, a library and debate society founded in 1818, is believed to be the oldest secondary school society in the country. Today's students must take three years of any language, ancient or modern, to earn their diplomas. And the Library literally places rhetoric, orality, at its core. Rockefeller Hall not only expresses the "invitation of books," but it also represents the library as a "space for social exchange" [Andreotti 1984: 162]. "Literacy, a relatively recent human invention," Kohane explains, echoing Walter Ong [1982], "could not alone define the meaning of a building devoted to learning, since it developed within an existing oral culture" [Kohane 1990: 130]. So "Kahn devoted the grandest space to this earlier form of communication. Orality, with its accompanying facial expressions, gestures, and vocal inflections," Kohane says, mirroring (a bit *too* closely) Ong's language, "complements literacy, creating a connection between two activities necessary for a full realization of human capacities" [Kohane 1990: 130]. We see formal expressions of both orality and literacy, as Ong describes them, in Kahn's design: Ong characterizes thought and expression in oral cultures as additive, rather than subordinate; redundant; and conservative, in order to enhance its memorability. There are formal parallels in Kahn's repetition of basic geometric patterns, which build concentrically upon one another, rather than relating in complex syntaxes. Conversely, print, Ong argues, suggests that "words are things," and its fixity – of words on the page, of the sequence of pages in the codex – conveys the importance of "control of space" and rhetorical "closure" [Ong 1982: 118, 121]. Rockefeller Hall performs parallel rhetorical functions, controlling our vision of the books, which are framed by rigid geometrical forms; this enveloping frame connotes totality, closure, of the landscape of knowledge.

Rockefeller Hall is a mix of the oral and literate – a blending appropriate for a contemporary culture defined by what Ong calls "secondary orality," a "more deliberate and self-conscious orality" [Ong 1982: 136]. Kahn did not intend for Rockefeller Hall to function like the grand central reading rooms one finds in late nineteenth- and early twentieth-century libraries because, as he puts it, "everybody knows that a big reading room is only a place where boy meets girl" (quoted in [Andreotti 1984: 162]).[6] This is not the place for coy chatter. This space is reserved instead for a particular kind of orality and performance: that which is formal, sanctioned, controlled – such as that between a librarian and student, or during one of the planned readings, concerts, film festivals, or receptions that take place in Rockefeller Hall (fig. 6). Furthermore, the volumes and materials of the central hall lead one to presume that any utterance louder than a whisper will reverberate throughout the building; the space thus incorporates its own material form of acoustic discipline. Yet the *habitus* is quite different in the stacks. During my visit a small group of boys congregated in the third-floor stacks to discuss everything *but* books, and their conversation was distinctly audible throughout the central hall. Kahn recognized that "in a small room one does not say what one would in a large room" – but those "structuring [acoustic] structures" are muddled when the small room spills out into the large (quoted in [Kohane 1990: 101]).

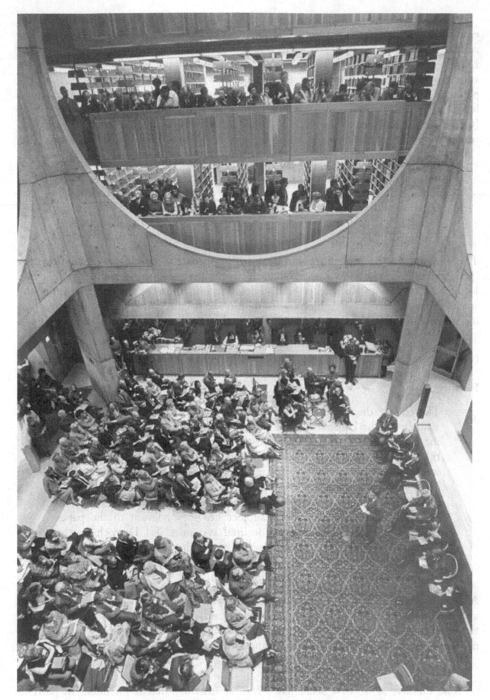

Fig. 6. Event in Rockefeller Hall. Photo courtesy of Bradford E. Herzog

As we discussed earlier, Harkness pedagogy, a method rooted in disciplined orality, is embodied in the Library's form. The rhetorical resonance of Kahn's geometry was reaffirmed in 1985, when Exeter again implemented curricular changes that emphasized Library use. A new Junior Studies course, taught by librarians and instructors from a variety of subjects, and required of all ninth-graders – called juniors, or "preps," in PEA parlance – would "acquaint [students] with the entire library as a place of rich and varied learning" [Shapiro 1986] and introduce them to the "foundations of good scholarship" [Greer 1999]. In letter to the Library Friends, Shapiro describes the scene of thirteen teachers modeling a Harkness discussion for new students in the Periodicals Room:

> For these [faculty playing students] from seven different departments housed in four buildings, no space could have been more suitable. The Library is, after all, Phillips Exeter's only building that is undeniably interdisciplinary. What better place for a demonstration of the pedagogical method that does more than anything else to connect the disciplines... [Shapiro 1992].

The Library, as the program committee had hoped, has become a "laboratory for (pedagogical) research and experimentation" [Phillips Exeter Academy 1966: 1]. The Library's form – with Rockefeller Hall's circle cut-outs framing and tying together the stacks of books across all subjects – both physically and symbolically integrates the disciplines, and indeed makes this space a curricular "architecture of connection."

The curricular changes of the mid-1980s made the Library central to the *Uppers'* (eleventh graders') curriculum, too. The eleventh-grade American history term paper has "become a rite of passage at Exeter" [Shapiro 1986]. Shapiro describes the project to the Friends:

> The end of the winter term, in late February and early March, brings virtually all the Uppers to the Library, as every one of the 22 sections in the U.S. History course comes in for at least one class. As the first stage in the legendary American history term paper, the librarians introduce the students to strategies for starting research. Jackie Thomas starts by describing the many encyclopedias in the reference collection, bibliographies and special reference works. She reminds each class how to use the card catalog to identify subject headings relevant to the paper topics, and explains the Dewey decimal system.... Ed Desrochers, the Assistant Librarian and Academy Archivist, then introduces the students to the periodicals collection and the *Readers' Guide*, and talks about the resources available on microforms [Shapiro 1991].

Although we can assume that students are now learning more about electronic databases, and are using the online catalog rather than a card catalog, there is still a spatial and temporal structure to the eleventh grade year, with each term associated with particular media forms and particular spaces within the Library.

The Library, as we have seen, has a formal structure that is intended, in part, to instruct visitors about its construction and use, and to argue for a particular definition of *Library*. Kahn employs various material and formal rhetorical tropes to serve these didactic and persuasive functions. Andreotti argues that Kahn's translation of Form into

Design relied on a language of "'orders' of space, light, structure, materials, and construction. Each 'order' poses its own demands". For example:

> The order of light demands that the choice of lighting be consistent with the building's formal characteristics.... The order of construction demands that the building reveal "how it is made.".... Through the process of design, all these orders must be synchronically realized in ways that reinforce and make concrete the building's Form [Andreotti 1984: 161].

In regard to the order of "construction," Kahn was known as a practitioner of structural rationalism, who held that the building was to expose the "marks of its making" and serve as a "record of its creation" [McCarter 2005: 303]. "The materials of construction were to be honored, always to be left exposed" [McCarter 2005: 452]. The brick piers on the façade displayed how they bore weight, while the beams in Rockefeller Hall displayed the logic of the space's construction. However, Goldhagen argues that the 'X' beam is "grossly exaggerated for dramatic effect" [2001: 3]. Structure is thus occasionally exaggerated or otherwise manipulated for rhetorical purposes.

Integrating the orders of materials and construction, Kahn believed that "the only ornament appropriate to modern building" [McCarter 2005: 452] began with the joint – the meeting of construction materials. Where in the library does brick meet concrete, or glass, or teak – and what "constructional truth" or larger institutional truth about the nature of the library, is revealed trough this meeting? [Wickersham 1989: 147]. At the macro scale, we might also look at the rhetorical function of the joints between the library's three "doughnuts," or zones of activity. These zones, as we have seen, were differentiated by building material, scale, ambiance, etc. While Kahn employed reinforced concrete in the central hall, he chose brick for the periphery. While he chose a monumental scale in the central hall, he built on a more human scale in the periphery. These architectonic and material differentiations denote a differentiation between these three functions of the library institution. Kahn drew a clear distinction between the central hall and the bookstacks; their floors are not contiguous, and in order to access one from the other, one must retreat to the building's perimeter, to the elevator or one of the corner stairwells. By separating these spaces physically Kahn distinguished them, yet a continuous concrete floor slab connects the book stacks and the reading arcades, providing functional and experiential continuity.

Jordy prefers to address Kahn's architectural rhetoric through the "degree to which his method of work was ideally calculated to maximize meaning at various levels of reference": the level of functional use; the level of structural syntax (e.g., the crossbeams, the circle-in-a-square design); and the ceremonial extrapolation of the syntax (e.g., the meaning embodied in the central hall) [1974: 335]. According to Jordy, these levels often fail to reinforce each other; the three levels represent disparate understandings of the library form and of the meaning of the institution itself. We see the separation of the central hall from the book stacks, and the circular cutouts presenting the books as the library's "ornament," when the emphasis was to be "not ... on housing books but on housing readers using books." We also find rhetorical inconsistency in the exterior and the approach to the building. Some critics are perturbed by the circuitous entrance. Cesar Pelli complains that "There are certain things that are consistently unresolved in Kahn's work: I can never find the main entrance in his buildings. I find his buildings to be more about themselves than about the people who have to live with them ..." (quoted in [Kawasaki 1983: 216]). According to Michael Graves, Kahn was a self-professed Classical

architect, and "[f]or a classical architect there is a sense that the face of the building is not only a reflection of the plan that it holds but also a reflection of the foreground plan that we are entering against. And Lou Kahn seems to be quite comfortable obviating that very substantial aspect of classicism…" (quoted in [Kawasaki 1983: 219]). Kohane, like Graves, faults Kahn's rhetorical façade; he regards as a mistake Kahn's "concealing such an important space (the central hall) behind the building's brick peripheral doughnut; the design "denies an external representation of the public sphere" within [1990: 129]. If the interior is to provide an "invitation [to] the books," why should the exterior be so uninviting? "[T]he exterior wall," Jordy argues, "remains substantially that – exterior to (parenthetical to) the idea of 'library'" [1974: 335]. Kahn originally intended to mark the entrance with a brick and granite plaza surrounded by stone benches and a hedge, yet these features were eliminated for budgetary reasons. The plaza was to have been a "first invitation" to the building and an external echo of one of the library's key internal functions: providing a place to meet [Kohane 1990: 110]. Thus, while we might try to rationalize, or find cohesion among, these recalcitrant aspects of the design – its breaking the geometry of the quad, its indeterminate scale, its perplexing entrance – we must also remember that Kahn had intended to clarify the logic and "spirit" of the transition between external and internal spaces. The budget foiled his plans.

Media forms and architectural geometries

When Academy Librarian and program committee member Rodney Armstrong left Exeter shortly after Kahn's building opened to become the librarian of the Boston Atheneum, architecture critic Ada Louise Huxtable described the Library – Armstrong's "parting gift" to the Academy – as "one of permanent grace, in the pre-McLuhan tradition, although electronic resources are duly included" [Huxtable 1972: 40].[7] The Library housed not only "readers using books," but also patrons using microform, film, and cassettes. This building, according to the library committee's program, was to "affirm the regard at the Academy for the work of the mind and the hands of man" – and this work came in forms other than the codex [Phillips Exeter Academy 1966: 2]. In 1966, Armstrong's committee acknowledged that,

> Today the function of the library has so changed that a new building should provide areas for creative independent study and for easy social exchange of ideas, contain seminar rooms for instruction in techniques of study and research, and house a wide variety of written and audio-visual accounts of man's achievements and aspirations. It must be equipped with microfilm viewers, tape recorders, slide and motion-picture projectors, record players and television receivers. Incorporating every facility that would today encourage cultural use, the new library must, nevertheless, be spacious enough to meet future demand and innovations [Phillips Exeter Academy 1966: 1-2].

Kahn of course provided space for independent study and social exchange, as directed. Yet these new media formats, with their own formal geometries, would present different spatial demands, and the library would have to accommodate them. However, Kahn's design, based on the metaphor of "tak[ing] the books and go[ing] to the light," is rooted in the "module" of the codex. His declarations about library Form typically address a very limited scope of contemporary library activities – perhaps purposefully. According to Andreotti, Kahn was highly critical of the "mechanized, anonymous character of contemporary libraries" and the notion of the library as "information center"

[Andreotti 1984: 161], which is why he looked for inspiration in the historical accounts of monastic libraries. But was his understanding of the "existence will" of *Library* expansive enough, and sufficiently unbound to any particular historical context, to accommodate the rapidly changing ways in which academic and public libraries were, and are, translating that "will" into new services and media?

Modularity had become the norm in mid-century American library building. After World War II, many public and academic libraries began to integrate once-separate areas of book storage and reading; tables, carrels, and lounge seating were mixed in with freestanding bookshelves to give readers open and easy access to library materials [Kaser 1997; Oehlerts 1991]. These modular libraries were either square or rectangular in order to allow for easy rearrangement or upgradging. This "rectangularity," according to library historian David Kaser, was dictated by the "real library 'module' – the book itself" [1997: 130]. Exeter's rectangularity is likewise rooted in the book form, although Kahn's library is less modular than many of its predecessors or contemporaries.

But as most architects have come to realize in the past few decades, the book is not the sole library module (nor was it in the early 1970s) – and modularity is not the ideal library design. Architectural historian Abigail Van Slyck addresses the mistakes of much mid-century library design: "In theory, mid-century modular planning enlivened libraries by uniting books and readers. In practice, however, large rectangular footprints, uniform eight-foot-high ceilings, and harsh fluorescent lighting rarely made these building exciting or even pleasant places to be" [2000: 152]. According to Van Slyck, architects have eschewed the monotonous regularity of the modular building in favor of comfortable, inviting places with plenty of windows, skylights, and atria to invite natural light. There is a "renewed appreciation for the simple act of reading a book, as well as a sharp realization that modular libraries of the postwar ear failed to enhance that act" [Van Slyck 2000: 152].

Kahn sought, through his investigation of the monastic libraries, to "reawaken…[the] fundamental human desires and aspirations" – to read and to learn – and thereby create "a modern library that embodied a more complex and substantial understanding of individual and social experiences" [Kohane 1990: 130]. Kahn deserves credit for breaking away from the rational, positivist design strategies of the modernists; for rejecting the modularity of International Style library design; and for realizing that form follows not only *use*-function, but also an institution's symbolic or aesthetic functions. His Exeter library adequately captures, in brick and wood and concrete, the "experiences" of reading and learning – in both their intimacy and communality, their informality and formality. Yet his design remains rooted in a "codex" mentality, for which reading remains the primary function.

How does this library accommodate individual and social experiences that involve reading newer textual forms, or that require practices of media "consumption" that exceed the term "reading"? "Post-print" (by which I mean not an era *after* print, but an era defined by the coexistence of print and its successors – much as Ong's secondary orality is defined by the coexistence of orality and literacy) libraries, however, require a form quite different than that dictated by the book "module." Furthermore, these contemporary libraries "mean" more than reading and meeting; they also serve as community cultural centers, as digital media warehouses and "navigators" through this "sea" of information, as media production and transmission centers, and in a variety of other capacities. The library Form must therefore incorporate spaces that articulate these

additional functions. How has Kahn's library incorporated new media forms and new service functions in the nearly forty years since its opening?

The 1966 library committee was prescient: they called for their architect to create spaces for all kinds of new technologies – including microfilm and microcard readers in the periodicals room; soundproof typing and listening rooms; seminar rooms that could be "transform[ed]...into a miniature auditorium for showing films, filmstrips, transparencies, and slides"; and even, for the card catalog area, an "electronic appliance observed at the Rockefeller Library" [Phillips Exeter Academy 1966: 8, 10],[8] which was "comparable to a telephone jack, speeds communication of information to inquiring readers and contributes to the efficiency of routing at the circulation desk" [Phillips Exeter Academy 1966: 9]. They requested "small metal plates permitting connection of electrical utilities" in each carrel and recommended that the "whole library should be so wired as to permit at some later date reception of audio-visual transmissions from outside or within the building" [Phillips Exeter Academy 1966: 10, 20].

In January 1976, Jacqueline Thomas reported to the Friends that, "because all the carrels were wired when The Library was built, students are not restricted to the sound proof carrels in the basement but, with headsets, they can listen to cassettes throughout the building." Two years later, the Friends helped the library start a film collection, although librarian Henry Bragdon admitted that he thought "in the few years during which boys and girls are at school, the time is better spent reading and writing than in looking and listening" [1978]. That same year, alum Jim Ottaway donated the Bown Adams' collection of classic and silent films. The Friends celebrated the donation by gathering to watch *The Phantom of the Opera* in Rockefeller Hall. The next year, however, Bragdon wrote the group to ask if any of them happened "to possess projectors for 8mm and/or 'super-8' silent film...and would be willing to part with them"; the Library didn't have the necessary exhibition equipment to make good use of its growing film collection [Bragdon 1979a, 1979b]. Shortly afterward Shapiro [1980b] reported that the library has a great collection of stereographs, too, "but no proper means of viewing them." Thomas admitted to me during my visit in January of 2009 that she's still searching for the equipment necessary to take advantage of the silent film collection.

The library was considering how to exploit its video resources, too. Shapiro reported to the Friends in September 1980 that the library's new "video resources could...be made immensely more useful if we had the necessary equipment to help establish a course in video production." A review of a 2009 course guide reveals that there still are no courses in video production at PEA. Yet the library was the first place on campus to have video technology, Edouard Desrochers recalled [2009], and teachers who wanted to use video in their classes had to report to the library's fourth-floor seminar room. "Like microforms," Shapiro said, "videotapes have emerged from the world of technology to take an important place in libraries" [1984b]. In 1983, 388 classes and 309 student group gatherings made use of the library's video resources [Shapiro 1984a].

These examples demonstrate that, rather than selecting their films and videos and "go[ing] to the light," the filmgoers met in Rockefeller Hall, while the video watchers gathered in an adaptable fourth-floor seminar room. The same qualities that make the arcades ideal for reading a book make it unsuitable for watching a film. These different media have different relationships to light – and although Huxtable regards Kahn's design as having a "pre-McLuhan quality," McLuhan's distinction between "light-through" and "light-on" media might help to explain the functionality of the building's

geometries and materiality for reading and watching [McLuhan 1994: 129]. A book requires that light be cast *on* it, and ideally, this light would filter *through* a window. Video is presented via light *through* a monitor screen, but monitors don't mix well with light streaming *through* windows. Film requires that light be projected *on* a screen, ideally a screen in a dark room, positioned a sufficient distance from the projector; the projection space thus requires a particular geometrical form. Kahn's design, with its focus on books and light, did not prioritize these other forms of media reception; the building simply had to adapt to "accommodate" them.

But the Library was not concerned only with providing materials and spaces for *watching*; it was also a space for *listening*. By the mid 1970s, the Library had become the "reserve desk for required listening in courses in music appreciation. ... [The Library] purchased new equipment and relocated the listening area to accommodate growing demand. New equipment, complete cataloguing, and easier access than before have combined to encourage more leisure listening" [Bedford 1976]. Plus, more teachers were assigning poetry and dramatic recordings for their classes. Yet despite this new and improved listening area, in September 1979 Henry Bragdon reported to the Friends that "eventually we would like to have a music room" to make use of the library's growing collection of jazz records, sheet music, and musical scores.

New developments were combining these modes of listening and looking. In 1976 librarian Henry Bedford reported that the library had become home to the language laboratory, "with cassettes and portable equipment," but it wasn't until Fall 1982 that Shapiro wrote the Friends with news that the Modern Language Browsing Area" had appeared "on the mezzanine overlooking the main floor of Rockefeller Hall," above the circulation desk. According to Desrochers, the first floor mezzanine was "a blank screen when we moved into the building," [2009] and it was an obvious choice to accommodate these rapidly evolving collections (fig. 7). This new language area would house language books, for which new shelves would have to be built, and "all language records and cassettes in the Library's collection, as well as a turntable and cassette player. We have bought a new slide projector, and a screen has been installed for both slides and film.... The room will also feature maps, posters, foreign language games, and a bulletin board for information about opportunities abroad" [Desrochers 2009]. This small mezzanine space would become one of the most progressive spaces in the library, combining all material, in all media formats, in a particular subject area. Yet the space couldn't have been conducive to this experiment in "format-blind" collection; lighting and acoustic limitations would have made it difficult for students to "mix formats" – to, say, watch a film while another student attempted to read a book in the dark.

In 1991 Henry Shapiro paused to reflect on the media-inspired changes that the library had undergone in the previous two decades:

> Entire new technologies have come into play since the building was occupied. One room is devoted to word processing, while three rooms include video equipment; a separate alcove is set aside for recorded books, and the music listening area has expanded from one to two rooms; two CD-ROM indexes of magazines and newspapers are available in the Periodicals Room. New ideas have increased the use and circulation of books (we still have lots of those!): special displays of paperbacks and of recent acquisitions appear on the main floor... [Shapiro 1991].

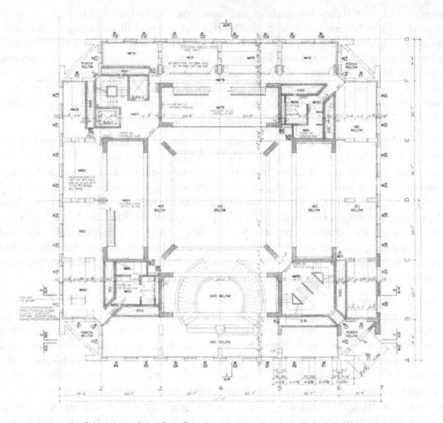

Fig. 7. Detail of the plan of the first floor mezzanine. Louis I. Kahn Collection, University of Pennsylvania and the Pennsylvania Historical and Museum Commission

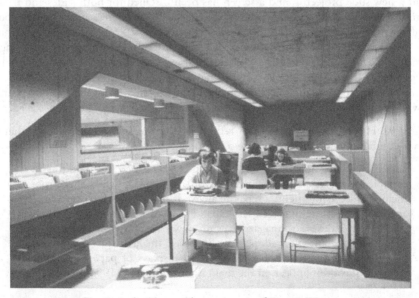

Fig. 8. Audio library. Photo courtesy of Dennis Waters

Some spaces lent themselves more easily than others to technologically-driven changes. In the mezzanine language lab, Desrochers recalls, renovators had to pull wiring down from the lights to power the media equipment. LeCuyer also reported that "unsightly conduits have been face fixed across timber panels and brick walls alike" [LeCuyer 1985: 78]. Librarian Thomas said that the library was the "first place on campus to computerize" – yet she argues that, because the original design included chases for wiring and the carrels included outlets, the installation of cabling in 1994 was relatively painless [2009].

The first floor mezzanine spaces eventually became home to most of the audiovisual collections. When the modern language laboratory moved out of the Library, its former space above the circulation desk became the video library. The videos joined computer labs, staff offices, and the music collection and listening area in the southern part of the first-floor mezzanine (figs. 8 and 9). However, though these audio-visual collections were honored with dedicated space – albeit small, low-ceilinged rectangular rooms –, these spaces were accessible by only one of the main staircases and by separate staircases to the left of the circulation desk and hidden behind the card catalog. There is no direct passage (aside from routing through a staff area) between the CDs and DVDs; one must return to the first floor and go up a separate staircase to pass from one room to the other (fig. 7). These collections are disconnected not only from one another, into separate realms of sight and sound, but they are also segregated from the stacks above. Their marginalization is apparent even from the floor of Rockefeller Hall: the grand circular cutouts that frame the book stretch from floors two through four. Records, CDs, and DVDs are thus not enclosed within this window onto the landscape of knowledge. They, unlike the books, are not "treasures" worth framing.

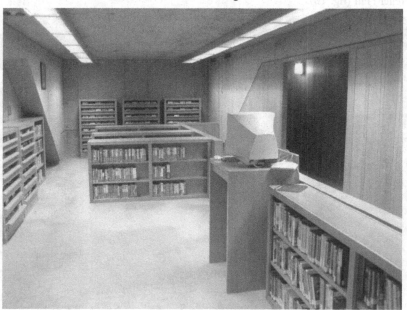

Fig. 9. Video library. Photo by the author

In 2001, at the request of the Student Council, the Library opened CinemExeter, a collection of contemporary movies held in racks in front of the card catalog, near the circulation desk in the central hall. The movies' placement right by the check-out, and the commercial nature of their packaging, again suggest that these media are of an entirely different class than the books above. These are commodities intended to *circulate* – not within the building, in the way that books circulate between the stacks and carrels, but between the library and the outside world. Most students, Thomas said, check out the videos to watch in their dorm rooms. The Library isn't concerned with providing space for the serious contemplation of film; students, faculty, and staff (Thomas reported to me that CinemExeter has drawn in many staff who had never before used the library) provide this space for themselves, outside the building's brick "screen" walls.

The card catalogue

The library itself acknowledges that "[w]hile no structural changes have been made to the interior of the Library, the usage of a number of areas has changed in the last three decades" [Phillips Exeter Academy, Changes and Renovations]. Kahn's triangles still draw the eye upward in Rockefeller Hall, his circles still frame the books, and his doughnuts still define the relationships between the various stages of research and the various components of a library's identity. Yet some of these geometries – the doughnuts, in particular – are used somewhat differently than they were in 1971, in part because the collection distributed throughout these geometric forms has evolved considerably in that time. Consequently, the *map* of that collection has evolved. Yet the quintessential material representation of that map – the card catalog – has maintained its prime location near the circulation desk; it's still the first thing visitors see after climbing the stairs to Rockefeller Hall (fig. 10).

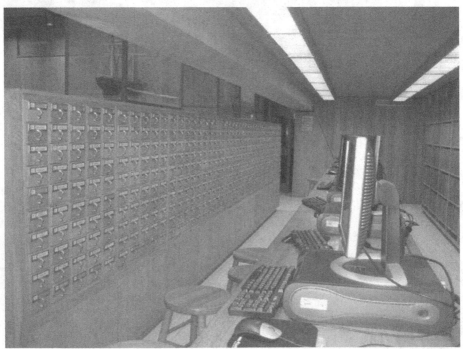

Fig. 10. Card catalog. Photo by the author

This massive architectural furnishing, to whose geometric logic the planners gave some consideration in their library program, purports to embody the structural logic of the building. The codex is both the geometric and intellectual module of the building and the catalog is its heart.

Yet there hasn't been a card added to that catalog since 1994, when the online catalog went live. As the physical catalog lost its use value, the Library explains, it became a "beautiful artifact" [Phillips Exeter Academy, Changes and Renovations]. It, like the books stacked above and indexed within its drawers, is the building's "ornament." Except unlike the books, which are to be used *and* looked at, the catalog is merely a formal representation of the library's cultural heritage. Shapiro explained to the Friends in 1994:

> The card catalog familiar to all of us will be retained in the Library, though new cards will not be added. It is an architectural feature of Rockefeller Hall in the Louis Kahn building, and it will also be a reassuring presence as those who are accustomed to it adapt to the new (digital cataloguing) system. Indicating the link between the old catalog and the new will be, symbolically, the name of the new system: BIBLION is the ancient Greek word or 'book,' and reminds us that the computer provides us with new ways of finding the books we need, not ways of forgetting about books or eliminating them from our research [Shapiro 1994].

Kahn is known to have drawn inspiration from ruins; Scully, we'll recall, described his library as "a diagrammatic realization of the Neoplatonic order indestructible within the ruin" [2003: 317]. This card catalog, a symbol simultaneously of loss and survival, is no less a rhetorical ruin.

Yet in the ground beneath this ruin, we might say, are seeds of the future. At roughly the same time that the card catalog was decommissioned, the Library set aside space in its basement, once used primarily to store periodicals and microforms, for the Academy's telecommunications (now Information Technology) department. "This is an immensely important and symbolic as well as technical step," Shapiro reported to the Friends in 1996. "All libraries are in a state of flux, as computer systems spring to life in the ether-, inter- and other-net-scapes." He continues, "Too often there is a tug between libraries and computer departments of a school or university, but the new location of our telecommunications department aligns the efforts at Exeter" [1996]. However, I gathered from my conversations with the librarians only a begrudging support of IT's presence in the basement; there seemed to be a resentment of IT's growth – not only its symbolic growth, as its "other-net-scapes" blanket the Gutenberg Galaxy, but also its physical growth, as its expanding servers and staff require more real estate on campus.

The only above-ground analogue for IT's subterranean presence is the library's wireless network. Kahn considered how new technologies should impress themselves upon design: "The world cannot be expected to come from the exercise of present technology alone to find the realms of new expression. I believe that technology should be inspired" [Kahn 1971: 33-4]. Christian Norberg-Schulz has taken this to mean that engineering is essentially integrated with Design, and both are equally inspired by Form [1979: 32]. Yet, in a Form like a library, where "technology" is integral to the very essence of the building type, we might also consider how "inspired [learning] technology" might generate a realm of "new [architectural] expression." Aside from the computers sprinkled throughout the building, the plasma television attached to the wall in the

ground-floor Periodicals Room, and the immaterial presence of the wireless network – a "space" whose rhetoric is chiefly non-architectural and non-Euclidean – we find no expressions *integral to the architectural design* that reflect the "inspiration" of new media technologies.

Instead, what is reflected in Kahn's design is the fixity of print, its locked position on the printed page. We might argue that the Class of 1945 Library remains frozen in the light of the Enlightenment, unable to represent in its geometric spaces the non-geometric nature of post-print media and the disorder of nonlinear, hyperlinked modes of learning. Jordy wonders "to what extent (if at all) did the quest for primal meaning founder in somewhat contrived archaism and inflated monumentality?" [1974: 330]. Did Kahn's insistence on "first beginnings" – his use of the basic forms, the structural essence of the library institution – preclude the creation of an institution that is functional today, and in the future? Douglas M. Knight, Chairman of the Friends, wrote to the group in June 1980, to address the relationship between the library's timeless values and contemporary challenges:

> As we reflect on the past centuries all of us are aware that the great changes are not in the ends of education but in the means of attaining those ends. I doubt that we are wiser than we were in 1781, but we certainly have to make our way through a more tangled maze of information in order to reach some small state of wisdom.
> For me the Library embodies this shift and this need more clearly than any other aspect of the Academy. Its variety of resources and services is essential in a world as urgent and complex as our own [Knight 1980].

The library's ordered geometry, however, speaks not of this "tangled maze," but of rationality, stability, tradition. This place is not "urgent and complex," but, rather, timeless and essential. We must wonder about the appropriate relationship between this cultural space and the culture out of which it arose, and to which it contributes. Should the library function rhetorically as a synecdochic representation of, formally and epistemologically similar to, this "urgent and complex" world? Or should it represent an alternative to that complexity, a space of exception?

Acknowledgments

I would like to express my sincere thanks to Jean-Louis Cohen, who encouraged me to begin this research in graduate school; to Robert Kirkbride; to Jacqueline Harris, Ed Desrochers, and other library staff members at Phillips Exeter Academy; and to the staff at the Architectural Archives of the University of Pennsylvania.

Notes

1. Since the brick was produced in Exeter – it was the last batch produced by a company going out of business – it has ties to its local context [Huxtable 1972: 33].
2. Photographs of the building's exterior are readily available online, so I have not reproduced any such images in this essay.
3. For the 2008-9 school year, tuition and fees were roughly $38,000.
4. The assignment of carrels is a recurring debate and a heated political issue: Library staff and students have varied between prioritizing day students, who have no dorm rooms in which to keep their school materials, and prioritizing upperclassmen.
5. In letters to Kahn, librarian Rodney Armstrong [1966a; 1966b], responding to the architect's initial drawings, recommended particular adjacencies and groupings of library functions; Armstrong paid particular attention to the services offered on the first floor.

6. It is significant that boy couldn't meet girl – and girls' voices couldn't be heard in the library – until 1970, when the library went co-ed
7. McLuhan is again evoked in an unpublished document titled "Library Pitch" and attributed to "Bedford," whom we might assume is Exeter history teacher Henry Bedford. Bedford, citing McLuhan's famous phrase, "the medium is the message," acknowledges that PEA's library conveys messages about the institution's values. While McLuhan, Bedford claims, "has been preaching that print is not only square, but well on the way to extinction, "Exeter wants to say that books are important.... A school's educational philosophy, and the values of its alumni, are manifest in its building program. The Exeter faculty affirms, with full confidence that the alumni concur, that everything still rests on a boy and a book, and a place where the two can comfortably get together" [Bedford? 1968: 9-10].
8. In a letter to the Friends of the Academy Library, Henry Bedford acknowledged that "microfilm just is not very sexy. Indeed reading it, somebody once remarked, is like kissing your girlfriend through a window pane... [Yet] few people are sentimentally tied to brittle newsprint, and no library any longer can store and bind volumes of newspapers" [1977].

References

ANDREOTTI, Libero. 1984. Conceptual and Artifactual Research Programmes in Louis I. Kahn's Design of the Phillips Exeter Academy Library (1966-72). *Design Studies* 5, 3 (July 1984): 159-65.

ARCHITECTURAL FORUM. 1972. The Mind of Louis Kahn. *Architectural Forum* 137 (July/August 1972): 76-77.

ARMSTRONG, Rodney. 1966a. Letter to Louis I. Kahn, May 27, 1966. Louis I. Kahn Collection, Box 030.11 #7, Folder 030.11.A.6.1, Architectural Archives of the University of Pennsylvania, Philadelphia, PA.

———. 1966b. Letter to Louis I. Kahn, August 18, 1966, Louis I. Kahn Collection, Box 0.30.11 #7, Folder 030.11.A.6.1, Architectural Archives of the University of Pennsylvania, Philadelphia, PA.

[Bedford, Henry?]. Library Pitch. 1968. January 8, 1968, Louis I. Kahn Collection, Box 030.11 #7, Folder 030.11.A.6.2, Architectural Archives of the University of Pennsylvania, Philadelphia, PA.

BEDFORD, Henry F. 1976. Letter to the Friends of the Academy Library, July 1976; reprinted in Friends of the Academy Library, *Collected Letters*. Phillips Exeter Academy, n.d.

———. 1977. Letter to the Friends of the Academy Library, March 1977; reprinted in Friends of the Academy Library, *Collected Letters*. Phillips Exeter Academy, n.d.

BOURDIEU, Pierre. 1972. *The Logic of Practice*. Rpt. Cambridge: Polity Press, 1990.

BRAGDON, Henry W. 1978. Letter to the Friends of the Academy Library, April 1978; reprinted in Friends of the Academy Library, *Collected Letters*. Phillips Exeter Academy, n.d.

———. 1979a. Letter to the Friends of the Academy Library, May 1979; reprinted in Friends of the Academy Library, *Collected Letters*. Phillips Exeter Academy, n.d.

———. 1979b. Letter to the Friends of the Academy Library, September 1979; reprinted in Friends of the Academy Library, *Collected Letters*. Phillips Exeter Academy, n.d.

BROWNLEE, David and David DE LONG. 1991. *Louis I. Kahn: In the Realm of Architecture*. New York: Rizzoli.

DESROCHERS, Edouard. 2009. Personal Communication, January 12, 2009.

DOVEY, Kim. 2005. The Silent Complicity of Architecture. Pp. 283-296 in *Habitus: A Sense of Place*, 2nd ed., Jean Hillier and Emma Rooksby, eds. Burlington, VT: Ashgate.

ECO, Umberto. 1997. Function and Sign: The Semiotics of Architecture. Pp. 181-201 in *Rethinking Architecture: Reader in Cultural Theory*, Neil Leach, ed. New York: Routledge.

FORTY, Adrian. 2000. Language Metaphors. Pp. 62-85 in *Words and Buildings: A Vocabulary of Modern Architecture*. New York: Thames & Hudson.

GAST, Klaus-Peter. 1999. *Louis I. Kahn*. Boston: Birkhäuser.

GOLDHAGEN, Sarah Williams. 2001. *Louis Kahn's Situated Modernism*. New Haven: Yale University Press.

GREER, Peter C. 1991. Letter to the Friends of the Academy Library, January 1991; reprinted in Friends of the Academy Library, *Collected Letters*. Phillips Exeter Academy.

———. 1999. Letter to the Friends of the Academy Library, February 22, 1999; reprinted in Friends of the Academy Library, *Collected Letters*. Phillips Exeter Academy.

HALE, Jonathan. 2000. Systems of Communication. Pp. 131-170 in *Building Ideas: An Introduction to Architectural Theory*. New York: John Wiley & Sons.

HALL, Edward T. 1959. Space Speaks. Pp. 162-185 in *The Silent Language*. New York: Anchor.

HUXTABLE, Ada Louise. 1972. New Exeter Library: Stunning Paean to Books. *New York Times* (October 23, 1972): 33, 40.

JAMES, Sally Murray. 1993. Seeking Light. Unpublished essay, November 1993; reprinted in Friends of the Academy Library, *Collected Letters*. Phillips Exeter Academy, n.d.

JORDY, William H. 1974. Criticism: Kimbell Art Museum, Fort Worth, Texas; Library, Phillips Exeter Academy, Exeter, New Hampshire. *Architectural Review* 155, 928 (June 1974): 330-335.

KAHN, Louis I. 1961. A Statement by Louis I. Kahn" *Arts and Architecture* (February 1961): 465. Rpt. 2005: Form and Design, pp. 464-471 in Robert McCarter, *Louis I. Kahn*, New York: Phaidon.

———. 1965. Space Form Use: A Library" *Pennsylvania Triangle* 43 (December 1965): 43-47.

———. 1970. Architecture, Silence and Light. Pp. 20-35 in *On the Future of Art*, Arnold Toynbee, et al. New York: Viking Press. Rpt. 2005: Architecture: Silence and Light, pp. 472-479 in Robert McCarter, *Louis I. Kahn*, New York, Phaidon.

———. 1971. The Room, the Street, and Human Agreement. *AIA Journal* 58, 3 (September 1971): 33-34. Rpt. 2005: Pp. 480-485 in Robert McCarter, *Louis I. Kahn*, New York, Phaidon.

KASER, David. 1997. *The Evolution of the American Academic Library Building*. Lanham, MD: Scarecrow Press.

KAWASAKI, Kazumi. 1983. Thoughts About Louis I. Kahn. *Architecture and Urbanism*, November 1983: 216-236.

KNIGHT, Douglas M. 1980. Letter to the Friends of the Academy Library, June 1980; reprinted in Friends of the Academy Library, *Collected Letters*. Phillips Exeter Academy, n.d.

KOHANE, Peter 1990. Louis I. Kahn and the Library: Genesis and Expression of 'Form'. Pp. 98-131 in *VIA: Ethics and Architecture* 10, John Capelli, Paul Naprstek and Bruce Prescott, eds. New York: Rizzoli.

KOYAMA, Hisao 1983. Louis I. Kahn and His Times. *Architecture and Urbanism*, November 1983): 19-23.

LECUYER, Annette. 1985. Evaluation: Kahn's Powerful Presence at Exeter. *Architecture* (February 1985): 74-79.

MARLIN, William. 1973. Within the Folds of Construction. *Architectural Forum* 140, 3 (October 1973): 26-35.

MATTERN, Shannon- 2007. Resonant Texts: Sounds of the American Public Library. *The Senses & Society* 2, 3 (Fall 2007): 277-302.

MCCARTER, Robert. 2005. *Louis I. Kahn*. New York: Phaidon.

MCLUHAN, Marshall. 1994. *Understanding Media: The Extensions of Man*. Cambridge: MIT Press.

MULLER, Brook. 2008. Metaphor, Environmental Receptivity, and Architectural Design. Pp. 185-203 in *Symbolic Landscapes*, Gary Backhaus and John Murungi, eds. New York: Springer.

NORBERG-SCHULZ, Christian. 1979. Kahn, Heidegger and the Language of Architecture. *Oppositions* 18 (1979): 29-47.

OEHLERTS, Donald E. 1991. *Books and Blueprints: Building America's Public Libraries*. New York: Greenwood.

ONG, Walter. 1982. *Orality & Literacy: The Technologizing of the Word*. New York: Routledge.

PHILLIPS EXETER ACADEMY. Academy Archives. http://www.exeter.edu/libraries/4513_4623.aspx?tab=2. Accessed January 12, 2009.

———. Changes and Renovations. http://www.exeter.edu/libraries/4513_4535.aspx. Accessed January 12, 2009.

———. Design of the Library. http://www.exeter.edu/libraries/4513_4522.aspx. Accessed January 12, 2009.

———. The Harkness Table. http://www.exeter.edu/306/pages/aca_harknesstable.html. Accessed January 12, 2009.

———. The History of Harkness Teaching. http://www.exeter.edu/admissions/147_5238.aspx. Accessed January 12, 2009.

———. 1966. *Program of Requirements for the New Library Recommended by the Library Committee of the Faculty.* Exeter, NH, June 1966.

RUSSELL, James S. 1997. The Richness of Louis Kahn's Exeter Library Stands the Test of Time. *Architectural Record* (May 1997): 94.

SCULLY, Vincent. 1989. Introduction. Pp. 14-44 in *Kahn: Libraries–Bibliotecas.* Xavier Costa, et al. Barcelona: Publicaciones del Col.Legi d'Arquitectes de Catalunya.

———. *Modern Architecture and Other Essays* (Princeton: Princeton University Press, 2003).

SHAPIRO, Robert N. 1980a. Letter to the Friends of the Academy Library, September 1980; reprinted in Friends of the Academy Library, *Collected Letters.* Phillips Exeter Academy, n.d.

———. 1980b. Letter to the Friends of the Academy Library, December 1980; reprinted in Friends of the Academy Library, *Collected Letters.* Phillips Exeter Academy, n.d.

———. 1982. Letter to the Friends of the Academy Library, Fall 1982; reprinted in Friends of the Academy Library, *Collected Letters.* Phillips Exeter Academy, n.d.

———. 1984a. Letter to the Friends of the Academy Library, January 1984; reprinted in Friends of the Academy Library, *Collected Letters.* Phillips Exeter Academy, n.d.

———. 1984b. Letter to the Friends of the Academy Library, June 1984; reprinted in Friends of the Academy Library, *Collected Letters.* Phillips Exeter Academy, n.d.

———. 1984c. Letter to the Friends of the Academy Library, September 1984; reprinted in Friends of the Academy Library, *Collected Letters.* Phillips Exeter Academy, n.d.

———. 1985. Letter to the Friends of the Academy Library, June 1985; reprinted in Friends of the Academy Library, *Collected Letters.* Phillips Exeter Academy, n.d.

———. 1986. Letter to the Friends of the Academy Library, June 1986; reprinted in Friends of the Academy Library, *Collected Letters.* Phillips Exeter Academy, n.d.

———. 1988. Letter to the Friends of the Academy Library, October 1988; reprinted in Friends of the Academy Library, *Collected Letters.* Phillips Exeter Academy, n.d.

———. 1991. Letter to the Friends of the Academy Library, September 1991; reprinted in Friends of the Academy Library, *Collected Letters.* Phillips Exeter Academy, n.d.

———. 1992. Letter to the Friends of the Academy Library, February 1992; reprinted in Friends of the Academy Library, *Collected Letters.* Phillips Exeter Academy, n.d.

———. 1994. Letter to the Friends of the Academy Library, June 30, 1994; reprinted in Friends of the Academy Library, *Collected Letters.* Phillips Exeter Academy, n.d.

———. 1996. Letter to the Friends of the Academy Library, October 1996; reprinted in Friends of the Academy Library, *Collected Letters.* Phillips Exeter Academy, n.d.

———.1997. Letter to the Friends of the Academy Library, July 1997; reprinted in Friends of the Academy Library, *Collected Letters.* Phillips Exeter Academy, n.d.

———. 2002. Letter to the Friends of the Academy Library, October 2002; reprinted in Friends of the Academy Library, *Collected Letters.* Phillips Exeter Academy, n.d.

THOMAS, Jacquelyn H. 1976. Letter to the Friends of the Academy Library, January 1976; reprinted in Friends of the Academy Library, *Collected Letters.* Phillips Exeter Academy, n.d.

———. 2009. Personal communication, January 12, 2009.

VAN SLYCK, Abigail. 2000. A New Chapter. *Architectural Record* (October 2000): 151-153.

WICKERSHAM, Jay. 1989. The Making of Exeter Library. *Harvard Architecture Review* 7: 138-49.

WIGGINS, Glenn E. 1997. *Louis I. Kahn: The Library at Phillips Exeter Academy.* New York: Van Nostrand Reinhold.

WURMAN, Richard Saul, ed. 1986. *What Will Be Has Always Been: The Words of Louis I. Kahn.* New York: Access Press and Rizzoli.

About the author

Shannon Mattern is Assistant Professor and was, through Spring 2009, Director of Graduate Studies, in the Department of Media Studies and Film at The New School in New York. Her book, The New Downtown Library, was published by University of Minnesota Press in 2007, and other essays examining various relationships among media, architecture and urban planning have appeared in the *Journal of Architectural Education*, *The Senses & Society*, *International Journal of Communication*, *Public Culture*, and *Space and Culture*, among others.

Dorian Wiszniewski

7a Haddington Place
Edinburgh
EH7 4AE SCOTLAND
dorian.wiszniewski@ed.ac.uk

Keywords: mathematics, politics, radical passivity, ideality, narratology, experientiality, seriality, meaning-structure, phenomenology, hermeneutics, language, mimesis, phenomenological opening, exactness, inexactness, methodological artefact, design process, Walter Benjamin, Edmund Husserl, Jacques Derrida, Paul Ricoeur

Research

Encountering the Geometry and Rhetoric of Lamb's House, Leith, Edinburgh, Scotland

Abstract. This paper considers geometry and rhetoric through an examination of the empirical and the narratological, comparing the architectural experience of dimensionality (geometry, scale, proportion, material, weight and measure) and the order of telling tales. Of interest here is the experience of stories through material constructions, and there are two aspects to such architectural narratological experience that concern the designer. First, the experience of geometry and narrative in the built artefact; second, the experience of geometry and narrative in the course of the design process, as narrative becomes construction, architecture and building. The second part of the paper discusses an architectural project for a restructuring of Lamb's House in Leith, Edinburgh. The discussion and project draw associations and sparks the communicative potential between the lines of construction, which are by nature geometric, and the lines of narrative, which conventionally are textual but in architecture are represented through its construction.

Introduction

There are inestimable number and type of relations to be formed through architecture. Perhaps due to the legacies of Pythagorean and Cartesian philosophical mathematics and post-Hegelian politics, many pairings are reductively dialectical, casting differences as dissociative and oppositional rather than as associative and communicative. The pairing of geometry and rhetoric presupposes a relation between the mathematical and the political. However, rather than being constrained by specific geometric paradigms and ideals that foreclose the rhetorical and political dimension, this paper and the project it illustrates record an interest in both a fluid sense of geometry – what might be called geometric ideality – and, consequently, a more open rhetoric that promotes the communicative rather than the persuasive.

This paper considers geometry and rhetoric through an examination of the empirical and the narratological, comparing the architectural experience of dimensionality (geometry, scale, proportion, material, weight and measure) and the order of telling tales. Of interest here is the experience of stories through material constructions. There are two aspects to such architectural narratological experience that concern the designer. First, the experience of geometry and narrative in the built artefact; second, the experience of geometry and narrative in the course of the design process, as narrative becomes construction, architecture and building. This paper (and the project it adumbrates) draws associations and sparks the communicative potential between the lines of construction, which are by nature geometric, and the lines of narrative, which are conventionally textual but in architecture are represented through its construction.

Nexus Network Journal 12 (2010) 421–443 NEXUS NETWORK JOURNAL – VOL.12, No. 3, 2010 **421**
DOI 10.1007/s00004-010-0048-y; *published online* 15 September 2010
© 2010 Kim Williams Books, Turin

Considering first the experience of buildings

Walter Benjamin claims that architecture – and he is talking of buildings – is experienced "in a state of distraction" by an "absent minded examiner" [Benjamin 1992: 232]. He has in mind the general everyday experience of architecture, suggesting that under passive, everyday encounter any canonical status of architecture recedes, including utility, symbolic function and persuasive force. Whether architecture today retains its canonical status from Benjamin's day is not so much the point, although it is worth mentioning that if architecture has lost its canonical status, then the already fragmentary nature of architecture's mode of appropriation (we only ever engage with a building a bit at a time and over time) necessitates other reasoning to establish relations. In other words, without canonical assurance, architecture's everyday users rely more than ever on the cumulative process of optical, conceptual and tactile appropriation. Furthermore, without recourse to canons, we also have to make up our own minds about what it all means. For this very reason, as Benjamin notes, the absent-minded passive encounter with architecture gives it a radical aspect, casting what Benjamin terms "cult value" [Benjamin 1992: 233] – which today might also stand for any "enigmatic signifier" of populist iconic value[1] – into the background. Passivity undermines any rhetoric of persuasion.

Benjamin's view on the radically passive mode of appropriating buildings resonates with Husserl's notion of passivity in the appropriation of geometry and with Paul Ricoeur's appropriation of narrative. In *The Origin of Geometry* Husserl states, "Passivity in general is the realm of things that are bound together and melt into one another associatively, where all meaning that arises is put together passively" [1978: 165]. Husserl theorises a passive experience of geometry; Ricoeur does the same for narrative, and Benjamin allows us an insight into how it operates in architecture. Benjamin's theorisation of the radically passive everyday encounter with architecture is premised on the absence of *a priori* understanding of the relation between parts and whole. In everyday encounters with the built environment, users presume that relations exist and instinctively embark on a not entirely conscious quest to establish relations,[2] an eidetic aggregation of parts that takes time. Whether consensus among the multiple users and their varied experiences of a given building can be formed is doubtful; even if it were, this would require even more time and involve the prior release of the views as a form of discourse.

In such a difficult terrain of meaning it is easy to see why the apparatuses of culture and government find it easier to maintain absolute values and universal codes. But what can be said for architecture can also be said for geometry and narrative. In other words, the distracted encounter with architecture, geometry and narrative all describe a passive quest for meaning but with radicalising potential for free, rather than prescriptive, association. The fact that architecture embeds geometry and narrative within its own representational practices points to the possibility of drawing upon the compound effect of the three strands of architectural, geometric and narrative radical passivity to facilitate and encourage the open reading of architecture rather than simply promoting architecture as another instrument in the rhetoric of persuasion. It is this play, between the empirical understanding of geometry and narrative in the "world of things" [Derrida 1978: 122] that any building can hold, for anyone at anytime, that this paper and the project that it describes center upon.

An interest in the radical condition of passivity arises through a phenomenological turn.[3] In simple terms, this equates to a move from the scientific to the more artful. If the scientific journey can be caricatured by the avoidance of falsehoods and the attempt to put a halt to the free play of associations [Derrida 1978: 165], clearly a very desirable modality if one is trying to solve problems, the (Husserlian) phenomenological turn liberates the play of associations, bringing them to rest only temporarily, but recurrently. The phenomenological turn has a very heavy commitment to serial encounters with things and thoughts, but wishes to promote further encounter with the same things over and over again whilst sparking different thoughts and actions. So, whether or not we are informed, by canon or otherwise, (Husserl's and Ricoeur's) phenomenology recognises that for the person who engages with things such as buildings, there is an intellectual contrariness that can be characterised as a play between the scientific and artful mindsets. This is not to say that human beings are naturally cast as somewhere between scientists and artists; these terms are merely theoretically useful to describe different modes of thinking that we are all capable of but which, under phenomenological tolerance, are permitted, in fact encouraged, to contaminate and activate one another.

In his analysis of Husserl's *The Origin of Geometry,* Derrida invokes Ricoeur's analysis of Husserl to note that the root of this contrariness lies in the distinction, and clear but tense relationship, between intention and intuition [Derrida 1978: 140, n. 167]. Intuition operates without intention. However, its own grasping ghosts the very same serial mode of encounter and relaying of significance that is hoped for by the methods of fulfilling intention.[4] That is to say, the instrumentality of intention more often than not requires a series of moves to convey such intent; this is akin to intuition in that it too operates by grasping things in series. Thus the structures of intuition and intention are similarly serial in manner. Although given to us by Husserl within a theory of appropriation of geometry, what we can say also about the absent-minded passive progression through a building is that it involves a process of appropriating meaning through a series of intuitive grasps, a series of experiences that seem to add up to something consequential.

Thus, when a building is organised in accordance with geometric principles, these organising principles may take on the status of canons and offer a further structure for a progressive and perhaps intuitive appreciation of its meaning. However, two aspects of the radically passive condition [of absent-mindedness or distractedness] may still come into effect in the experience of such principles. Following Benjamin's analysis, the geometric canons may recede into the background as any other canon, but also, following Husserl's analysis, geometric principles, even under scrutiny, always abstract reality to an ideal condition; such distractions, as Husserl states, "is especially true of sciences which, like geometry, have their thematic sphere in ideal products, in idealities from which more and more idealities at higher levels are produced" [Derrida 1978: 166]. Therefore, rather than providing explicitness to a construction, a geometric principle may further enhance the shift from sense-intuition and the self-evident to the tacit and abstractly representational dimension.

Without delving into specific geometric principles, it can be understood that geometry in architecture can be employed to either override or co-opt its fragmented and serial mode of appropriation. As the history of architecture shows, the ideal dimension of geometry can be used to overcome the fragmentary, providing canonical guidelines. However, equally evident in the history of architecture is the (radical) potential for geometry in architecture to carry participants beyond the experience of an immediately

sensible and straightforwardly useful thing. The potential in the ideality of geometric principles may be coupled with the disjunction and pause of serial experience to cultivate ways for coming to terms with the phenomenology of the thing.

We never experience architecture as a whole; we experience it a bit at a time. This serial experience can be very distracting, since we fluctuate between using the building for its utilitarian purpose and engaging the building as a historical/cultural artefact. Between the seriality of building experience and the seriality of our distracted experience (and the branching of each into the geometric and narratological), we make patterns of successive intersection and diversification. Optimistically, and from a standpoint interested in creativity, neither aspect of the coming together and moving apart need be seen pejoratively. Such a succession, such interwoven seriality, may be seen as the necessary progression of creativity. However, all that is being outlined here is a move from the anticipation of truth concepts, and therefore specific expectations, to what Derrida calls a "*lived anticipation* as a radical responsibility." Such "lived anticipation" is the necessary mindset for opening [Husserl's] phenomenological enquiry, which has no expectation other than to move beyond a current horizon [Derrida 1978: 141]. To reiterate, the scientific and artistic categories inadequately explain a phenomenological movement and opening. There is something else that drives all thinking, a disquietude in all thought, which, depending on the attitude of the designer, can either be denied or accepted, silenced or amplified, muted or recorded. To accept, amplify and record such disquietude is the premise of phenomenological enquiry.

Before discussing the impact of the serial experience of architecture on a specific recording of what may be called points of consensus and their requisite disquietudes (contrariness) through architecture's design processes, I will deliberate on this other dimension, this other reasoning, that Husserl brings to thinking on geometry and, in fact, any ordering system. He states, "Geometry and the sciences most closely related to it have to do with space-time and the shapes, figures, also shapes of motion, alterations of deformation, etc., that are possible within space-time, particularly as measureable magnitudes" [Husserl 1978: 177]. Here Husserl aptly defines architecture's complicity with geometry, and highlights three things: first, geometry carries a principle of mathematical truths: second, geometry also allows for those things that are not geometrically pure, which, are nonetheless geometric and allow variations and differences to be understood as such; third and foremost, the principle of mathematical truths has validity for all people through all time, "and not merely for all historically factual ones but for all conceivable ones" [Husserl 1978: 179] (for example, the right angle may invoke a history from Thales to Le Corbusier).[5] Therefore, in summary, Husserl's analysis highlights that the principle of truth coincides with that of difference (or non-truth) in perpetuity.

Geometry and its perception in representation therefore has an ideality that is more encompassing than any Ideal. Geometric ideality involves ideal objects, right angles and any apparently aberrant acute or obtuse angle commonly used in architecture as a rectifying in-situ cut-to-fit. What geometry holds within its system is an expansive dialectical tension, for example, between truth and uncertainty, regularity and irregularity, exactness and inexactness, sameness and difference. Husserl suggests that only by recurrently engaging with this tension can the principles of geometry be properly understood. It might be said that "seriality" describes the dynamic of geometry. As Bertrand Russell observes, "Projective Geometry [has] shown how to give points, lines and planes an order independent of metrical considerations and of quantity; while

descriptive Geometry proves that a very large part of Geometry demands only the possibility of serial arrangement" [Russell 1903: 199, quoted in DeLanda 2004: 370]. Architecture is intrinsic to both the projective and descriptive branches of geometry. Architecture and geometry have powers of both ordering and serialising because they are pre-supposed to have an originating intention that presumes any part, even inexact parts, to be a sub-condition of the whole.

Some even argue that inexact geometries are "*morphogenetically* prior to exact ones" [DeLanda 2004: 371]. That is, the irregular stuff that sits between the more regular stuff has genealogical precedence. Husserl doesn't make this claim, but he does suggest there is an important relation of differences between the spatio-temporal world and the ideal of geometry that all geometrical constructs retain. It is less that the irregular finally becomes interwoven into the regular, and more that geometry has a logical priority over that which as yet does not reveal its order. Geometry is a means for making sense of the world. Its invention/discovery comes subsequent to language; geometry is a fine-tuning of language and behaves as a specific language with its own logicality. The logic of geometry represents the very logic of order, even the very order that language employs to make sense and come to terms with anything. Any utterance, then, textual or geometric, is capable of being presumed part of a greater system.

In summary, any geometrical expression holds within it a reference, not just to the spatio-temporal originating moment of the invention/discovery of geometry, but also to the very Ideal of the origin of geometry. This is a metaphysics that resonates with all other metaphysical notions. By focussing on the question of the origin of geometry, Husserl theorises a communicative principle that lies within all human production, and suggests that the experience of geometry, which clearly has a very special resonance when experienced within architecture, gathers its power of meaning from a triple compound resonance: between the existential circumstances of the immediate experience; the absent ideal of a geometric origin; and its echo in the spiritual/intellectual dimension of the question of human and world origin. He does this not to romanticise the spiritual dimension of origin, which might foreclose our production in the world as mere representations of an ideal, but to open a fuller magnitude of the meaning-structure of geometry, which according to a (Husserlian) phenomenological consciousness has its "own proper dehiscence" [Derrida 1978: 153] – burst openness. Husserl's point, underscored by Derrida's analysis, is to illustrate that everyday questions of our existence can be tied to fundamental existential questions through any mediation (meaning-structure) of our language: via architecture, geometry or narrative. The suggestion is that we should not only enjoy gathering together all the fruits of such questioning, but that we are ethically *compelled* to grow and gather such things. Furthermore, we should assemble them by whatever series makes good sense for the spatio-temporal conditions of today, whilst recognising that such relations are always ripe and ready to burst open again for future reconfiguration and transconfiguration.

* * *

Husserl thinks geometry as language. Its ordering principles are as those of language. This is not to say that geometry emulates word language, but that it has rhetorical dimensions: both language and geometry structures rely on gradually coming to terms with the relations between their ideal whole and multiple serial conditions of their parts. Husserl alerts us to an alignment between the hermeneutics of geometry and the hermeneutics of language. He draws our attention to the point that when the serial experience of architectural language and geometric arrangements flow together the

rhetorical condition of each is opened to the other. To interweave the lines of geometry as lines of narrative is simultaneously a coincidence and dehiscence and makes a phenomenological opening. Such an opening provides invitation to read and take a view, rather than ideological foreclosure of a particular view represented persuasively by architecture.

For an understanding of rhetoric and narrative we can turn to Paul Ricoeur. According to Fredric Jameson, Ricoeur is one of the few professional philosophers through which "narrative is affirmed, not merely as a significant field of research, but well beyond that as a central instance of the human mind and a mode of thinking fully as legitimate as that of abstract logic" [Lyotard 1986: xi]. What gives narrative its philosophical weight is the "pre-narrative quality of experience" [Ricoeur 1991: 142]. Of specific philosophical importance is that experience has a narrative structure and that narrative follows and represents the very structure of experience through its own experiential system.[6]

Ricoeur plays with Aristotle's view of the relationship between the terms *poesis*, *mythos* and *mimesis* as they were historically applied to the specific arts of Greek epic, tragedy and comedy. For Aristotle's praxis there is a moral obligation for the arts to promote the ideology of Greek politics, offering a didactic role for representation (*mimesis*), and operating in the same linear trajectory as the emplotment (*mythos*) and the productive activity that arranges the emplotment meaningfully (*poesis*).[7] In simple terms, we are talking here of recorded actions (representation, *mimesis*); the sequence in which the actions have been enacted (emplotment, *mythos*); and the morality of narrative and message to be promoted by the choice of characters and events enacted (virtue, *poesis*). Obviously, the characters (who they are and what they represent), what they do (the sequence of actions) and the sequence in which they do them (what the actions represent as part of a moral tale) constitute the recognizable pattern of Greek mythology. Such a clear linearity lends itself very well to instruction. The place and role of heroes and villains is organised by a clear schema, but, more importantly, what this facilitates is the place of virtue. The myth narrative, according to Aristotelian *poesis*, plays out the contest between frailty and virtue. The main aspect of heroism is to overcome human frailties. Therefore, for Aristotle, praxis secures a predetermined moral code through the lofty pursuits of virtuosos, requiring actions of heroic stature, be they feats of physical strength or ingenuity and cunning.

For Ricoeur, on the other hand, praxis is less lofty; it is gritty, as involved with the vicissitudes of everyday life as the promise of an imagined ideal. Thus, it is necessarily more complex, but flexible. Ricoeur brings Husserl's notion of the phenomenological opening into his operations for praxis. Therefore, Ricoeur's praxis charts the effects as *poeisis*, *mythos* and *mimesis* become playfully, but seriously, transfigured and interlinked. In this sense, Ricoeur's praxis, although stemming from hermeneutics, is not entirely hermeneutical, but is political and attempts a form of creative practicality in light of the everyday, in contrast with one steeped in a stable, unchanging vision of virtue. What constitutes virtue is by nature dynamic, and must be considered with respect to actual, rather than pretend or even bona fide political practices. Virtue must be an authorial task if creative production wishes to be politically active.

Ricoeur's praxis acknowledges that not all politics can be or need be engaged as complex hermeneutics, but rather than reducing philosophy to political inactivity or theories of the mind, Ricoeur's praxis proposes how production-as-hermeneutics

contributes to political engagement, particularly as creative production.[8] For Ricoeur, it is necessary to have flexibility in the bonds between *poesis, mythos* and *mimesis* to counter the possibility (or tendency) for any modality, any knowledge system, geometric, literary, philosophical, political or academically architectural, to merely represent itself. Thus Ricoeur promotes flexibility in the very workings of representation, though not to promote or deny ideological or existential validity. Ricoeur wishes to eradicate neither the didactics of any representational dimension nor the sensuosity of material encounter. Ricoeur, like Husserl before him, wishes only to breach any impasse between idealism and materialism. As he describes it, the political task of hermeneutics is "to reconstruct the set of operations by means of which a work arises from the opaque depths of living, acting, and suffering, to be given by an author to readers who receive it and thereby change their own actions" [Ricoeur 1991: 139-140]. Ricoeur echoes Husserl's hope for such methods to contribute positively and practically to the world. Ricoeur rebukes the interiority of certain theories, including even those of language games, which, either by non-committal politics or doctrinal authoritarianism, foreclose and limit didactic possibilities and totally prescribe the nature and purpose of experience.

Ricoeur strikes an optimistic chord for architecture. Bringing play into the representation is not simply for fun, it is serious indeed. Elasticity in the geometric, poetic, narrative and representational processes allow for the possibility of a specifically structured, yet open, ethical dimension to any project. What Ricoeur says for hermeneutics can be said for the architectural project: "to reconstruct the whole arc of operations by which practical experience is turned into works, authors, and readers, there is neither an inside nor an outside to the work – the distinction of inside and outside being a methodological artefact" [Ricoeur 1991: 139-140]. A work here is described as a "methodological artefact." This very interesting phrase again points towards the seriality of encounter and logic that Husserl uncovers in his analysis of geometry. The inclusive or exclusive tendencies of the methodology – architectural, geometric or narratological – will be embedded in the artefact; and it is better, then, for these expressions to permit the variant and different as well as the ideologically consistent.

An architectural drawing, model, building or text operates as a "methodological artefact." The history of architecture is a history of methodological artefacts, but also a history of literal reconfigurations and transfigurations of such artefacts. Buildings undergo unceasing revision across time, encountering uses unimagined at the outset. Perhaps, then, it is not such a radical claim that the experience of an architectural project is like performing a hermeneutics of narrative, and vice versa. The passivity of experience in architecture is akin to the passive role of the reader of narrative: the user is a reader influenced by the concrete circumstances of the encounter, but is also privileged as an author who makes-sense-of, generating new associations and narratives. The user/reader participates in "a concrete process in which the textual [architectural] configuration conjoins the practical prefiguration and the practical transfiguration" [Ricoeur 1991: 140] of the work. To reiterate, virtue has to be constituted as an authorial task if creative production wishes to be politically active and meaningful.

* * *

Again, we never experience architecture as a whole; we experience it a bit at a time, and the same can be said of geometry and narrative. In this sense the experience of architecture, geometry and narrative share fragmented but serial modes of appropriation. Looking to the passivity of everyday experience of each permits us to understand the radical potential of each. In coming to terms with the parts of experience, gathering and

reassembling them, we cannot help but presume there is some absent but common origin. Even if not immediately appreciable, the commonality of origin is intelligible as a product of human, hence communicative, action. However, communication can be nurtured only by maintaining variation and difference within ideological consistency. Architecture can very readily communicate this. The absent origin of an architectural project echoes the absent origin of geometry and narrative; all echo the absent origin of human and world. It is no wonder that the passive experience of architecture is very distracting: between the series of building experiences and the serial experience of our distractions, we make patterns of potential significance in successive intersections and diversification. Such succession, such interwoven seriality, may be seen as the central agency of creativity.

Geometry and narrative in the design process of Lamb's House

We now consider the experience of geometry and narrative in the course of the design process, as narrative becomes construction, architecture and building. What follows is a series of "methodological artefacts" that illustrate aspects of the design process of a specific architectural project. These "artefacts" illustrate play in the confluence of specific architectural contexts, architectural geometric principles and architectural and historical narratives. Views of history are gathered and recorded, acting in series to record either points of consensus or the requisite disquietudes (contrariness) upon opening the project to a phenomenological enquiry. At no point during the design process was there an intention for the project to preclude enquiry; rather, the methodology attempts to record as much as is possible within the practical constraints of a project with real historical, economic and political tensions, and to record them in a manner that encourages deeper reading of the artefacts produced. It is hoped that rather than transcribing the histories and events word-to-word, the artefacts open a curiosity for reading more of the architectural and historical narratives embedded in or responsible for the project.

The project was commissioned after a successful competition submission in January 2007. Due to economic pressures on its portfolio, the National Trust for Scotland was looking to safeguard the future existence of Lamb's House by setting up a combined design proposal and purchase bid competition. There was no pre-requisite programme. The building was most recently used as office space, but due to maintenance obligations the economics of this had become untenable. We won the design competition and worked with the commercial arm of the City of Edinburgh council property and development section to prepare an economically viable purchase bid. Our design and purchase bid suggested its domestic use could be re-instated and the building safeguarded through maintenance covenants with the new owners, whilst increasing the public amenity by opening "Mary's Garden" to the public and re-instating the medieval public throughway of Water's Close to Leith Shore. The project provides 6 domestic apartments in the existing building and 3 domestic apartments and an office in the new building. Our project received Planning consent with Historic Scotland approval in July 2008. Building construction and tender documentation is being prepared at the time of writing this paper.

Fig. 1. Contemporary Ordinance Survey Map of Leith

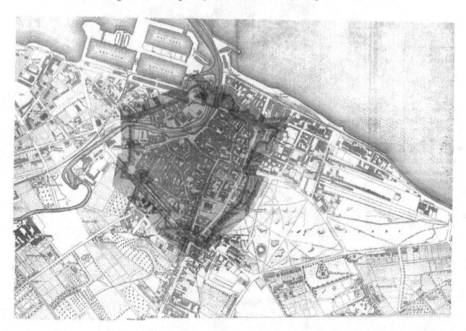

Fig. 2. The 1851 Johnstone Map of Leith with the citadel walls of 1560 superimposed

The maps shown in figs. 1-3 record two significant time frames. The times around 1560 were turbulent in Scottish History.[9] The Scottish Reformation was in full gear, with much bloody fall-out. John Knox was preaching Calvinist doctrine from the pulpits of St. Giles, just across the High Street from the palace of Catholic Mary of Guise,

daughter to one of the most powerful family alliances in France – the Guise and Bourbon. Mary of Guise was mother to Mary Queen of Scots (1542-1587) by James V (who died only six days after the birth of his heir), and remained guardian and queen regent of Scotland until her daughter was old enough to formally assume the throne on which she was crowned Queen, in 1543, at the age of nine months.[10] Mary of Guise also had a palace in Leith, which was a separate city to Edinburgh but operated as its port and main connection between Scotland and continental Europe, especially since the 1305 sacking and appropriation of Berwick by Edward I of England.

The 1851 Johnstone Map of Leith (fig. 2) still shows the medieval street patterns, many of which were widened or removed to make sanitary and rational urban blocks subsequent to Edinburgh's City Improvement Act of 1867. It also shows that the citadel walls had more or less been removed, the docks had undergone expansion, but the town had not been so significantly expanded as Edinburgh. The 1744 Kirkwood map shows that the citadel walls had already been removed or reduced to mounds (see fig. 3).

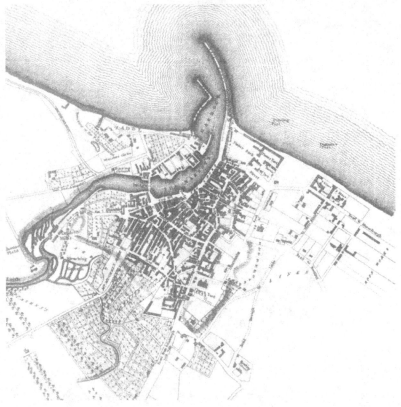

Fig. 3. 1744 Kirkwood Map of Leith

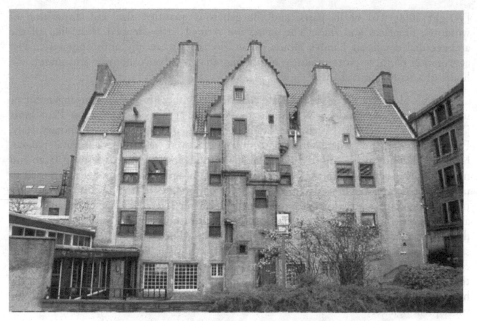

Fig. 4. Lamb's House as it currently stands

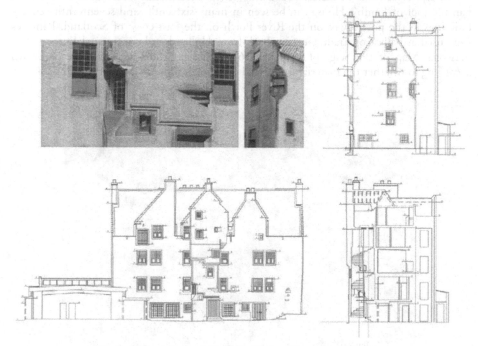

Fig. 5. General Survey of Lamb's House as it currently stands

Domesticity is the character written throughout the body, skin and detail of Lamb's House (figs. 4-5). Even on first encounter, domesticity and domestic comfort is clearly conveyed by the human scale of the seeming ad-hoc arrangement or "wilful anarchy"

[Wright 2000: 16] of its parts, and the generous quantity, size and disposition of windows, fireplaces and flues. The gables are termed 'crow-stepped', but, like all the architectural details of Lamb's House, these too are intrinsically anthropometric. The aggregation of these parts produces a building that is at once homely and grand, the house of a Scottish merchant.

Lamb's House is not a classically formal design, either in domestic arrangement or urban planning. As Andrew Wright in the National Trust's Conservation Plan hints [Wright 2000: 15]), the Scottish inclination reversed practices in contemporary Italy, France and England, where farms or country seats were re-invented as rural palazzi, bringing urbanity to the countryside. In Scotland, the Tower House – less a palazzo and more simply a tall house in the open countryside – offered a rural model transposed to urbanity. Like a tower house, Lamb's House accommodates all the gesturing twists and turns of its occupants that would provide protection yet take advantage of the best views and prospects; however, in the urban context such prospects look into gardens, yards, down closes, along streets and across skylines and, whilst within the walls of a more secure citadel, can take the opportunity to express such experiential privileges and comforts as external architectural features. It is the coupling of urban and domestic scales that is so intriguing about this building, and this juxtaposition of civic decorum with the human-scale rituals of living that guides the architectural proposal depicted in the subsequent figures.

Untypical of roofs in historic Scotland, which were mainly slate, stone or lead, the pan-tile roof of Lamb's House can be seen in many sixteenth- and seventeenth-century buildings in the port towns on the River Forth on the East coast of Scotland. Pan-tiles were used as ballast on trade journeys back from Holland and continental Europe. The Petworth Map of the Seige of Leith (fig. 6) illustrates "roofs are red, blue or brown according to whether the material is tile, lead or slate, or thatch" [Steer 1961-62: 280].

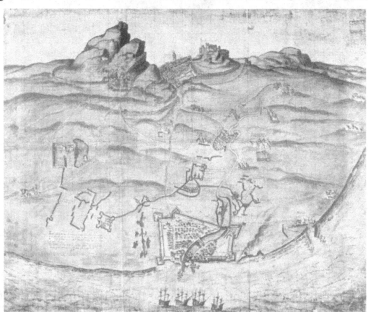

Fig. 6. The Petworth Map of the Seige of Leith (Edinburgh and Leith)

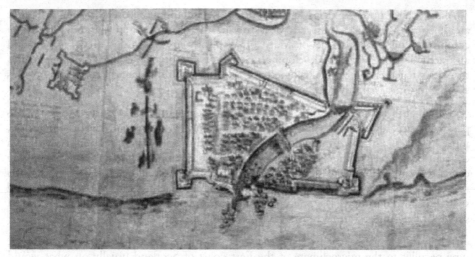

Fig. 7. The Petworth Map of the Seige of Leith (Leith)

In March 1560 an army of English and Scots laid siege to Leith.[11] The French and Scots loyal to Mary of Guise and Mary Queen of Scots defended Leith, and there were heavy casualties on both sides. This map records a pivotal moment in Scottish history, when Mary of Guise, ill since November 1559, died on June 11. John Knox rejoiced. The Treaty of Edinburgh was signed on 6 July 1560, and the Map was prepared a day later [Steer 1961-62: 280]. Part of the agreement was that Mary Queen of Scots and her husband Francis, King of France, should no longer bear the English coat of arms, in recognition of Elizabeth as Queen of England. The English and French armies agreed to leave Scotland forthwith and adopted a policy of non-interference with Scottish politics. The Treaty needed ratification from Francis and Mary, but this never happened.[12]

However, the political constitution of Scotland took a significant turn on 11 August, 1560, when the Scottish Parliament voted to promulgate the Protestant faith, and five days later abolished the Pope's jurisdiction and prohibited the celebration of the Catholic Mass. The Protestant Lords had secured significant power in the Scottish administration.

In December 1560, King Francis of France died. King Charles IX took up the throne of France under the regency of Catherine de Medici, his and Francis's mother, until of appropriate age to rule by himself. Rather than take up the marriage suit of Don Carlos of Spain, or any other offers of suitors from powerful continental European nations or retire to her French country estates as duchess of Touraine, Mary decided to return to Scotland and do her duty as Queen of Scots. On Tuesday 19 August 1561, aged only nineteen, Mary

> once more set foot on her native soil at the port of Leith ... Her arrival was unexpectedly early – at about nine o'clock in the morning – as favourable winds had carried the royal party from France more swiftly than had been anticipated. Nevertheless, by all accounts, her reception was enthusiastic and joyful ... Since Holyrood Palace was not yet made ready for her arrival, the queen was taken first of all to the house of one Andrew Lamb at Leith; here she had a short rest and took to her midday dinner, before being conveyed from Leith to Holyrood [Frasier 1971: 171].

This project proposes that Mary's homecoming should be recorded through the new architecture of Lamb's House. It does this in two ways: figuratively and directly by commissioning a new statue of Mary on a plinth in the garden (see Fig.13); and abstractly and indirectly by developing a series of interpretive architectonic procedures that draw together the gestural geometry of the existing building and a materiality of this specific historical narrative (see figs 8-14).

Much of the architecture of Lamb's House is not as it was when Mary Queen of Scots paid her visit. However, the sense of human scale remains. The geometry is asymmetrical, more like the body posed mid-gesture than the body standing to attention. As well as a conventional survey of the whole layout of the existing building (see fig. 5), we asked the client to commission us to survey specific details of the building. It was important to record the specific nuances of the details that worked together with the volumetric and spatial disposition to give the building its human scale and lived-in quality. A measured survey of building gestures was undertaken.

Even though it was August when Mary arrived, there was a "harr", a thick fog of the type peculiar to the microclimate of the East coast of Scotland usually on what would otherwise be a warm and sunny day, and so the fires were probably lit.[13] Lamb's House, although splendid and clearly qualitative, was more modest than the grandeur of Linthligow Palace, where Mary was born and spent her first years in Scotland, the French court she had just left, or of Holyrood Palace where she would soon reside. However, it is has many Scottish qualities: it is certainly stylish yet very homely. There is no doubt that Mary ate cake in the snugness and comfort of a beautiful oak lined room.

To memorialise Mary's homecoming may open her particular narrative and the unresolved political problems of Scottish History to a new wave of blind prejudice. However, perhaps it is in the celebration of such an everyday event of having dinner (or walking in the garden) that one can properly memorialise Mary's homecoming without it opening the old and, for some, still painful wounds of religious bigotry and scurrilous political intrigue. But how should such a fine, intimate but significant and everyday moment be recorded and made manifest? To provide dinner for a guest is to be a fine host. Perhaps recording the cutting of cake is to index the traces of such hospitality. Perhaps such traces and indexing might stimulate other lines of communication.

Fig. 8. Details and Gesture Survey

Fig. 9. Cake Cutting

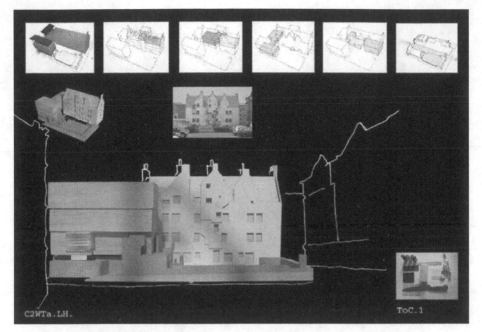

Fig. 10. Tectonics of Homecoming, Gesture, Cake-Cutting and Hospitality

The oak shutters of the existing windows remind us that once they would have been contiguous with wainscoting and other wall paneling. Such cabinetwork not only provides real warmth but is also sign of comfort. What a fine thing for homeliness. Figs. 9 and 10 illustrate processes and drawings that forge relationships between the geometries of cutting cake, architectural drawing, architectural models and cabinetwork. The suggestion is that the new architecture might find an appropriate language at such confluences. Figs. 11 and 12 illustrate drawings and models that promote further alliances between cake cutting, architectural drawing, cabinetwork and the geometry of gesture between the new and the existing buildings.

In the bottom right hand corner of the survey details (some of which are illustrated here in fig. 8), details that hold the geometry of the human scale as it meets the geometry of urban context are indexed to their locations in the existing building floor by floor. The drawings shown in fig. 11 have taken the index code of such details and relocated them with the promise that such gestures can be transfigured in the appropriate places of the new building according to their new programmatic and urban relations.

Specific gestures are deemed appropriate for specific locations; some lines of construction and geometric relationship are transfigured in scale whilst retaining material quality; some retain direct references to their source gesture; others act to reinforce the community of domestic spaces between the old and new buildings, for example the main stair of the new building that positions itself opposite and adjacent to the main stair of the existing building whilst wandering back on itself to overlook the common garden and close.[14]

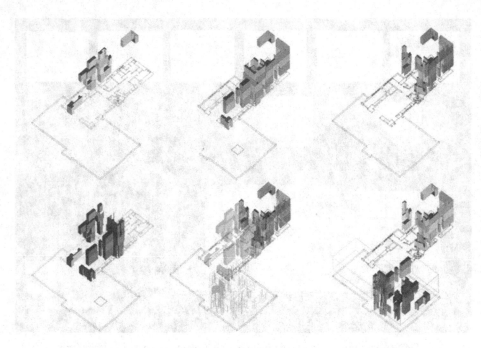

Fig. 11. Details and Gestures transfigured and transposed to new building

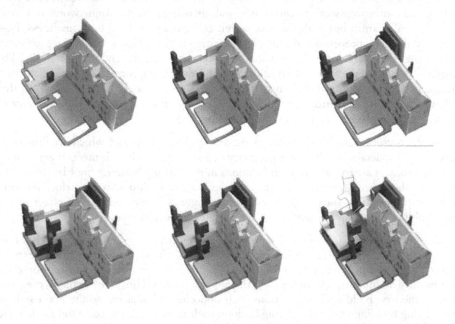

Fig. 12. Anchoring Details and Gestures to specific locations

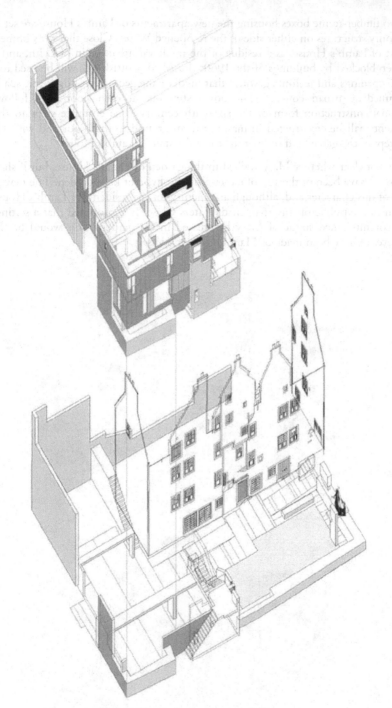

Fig. 13. The Project – Boxes and Gesture

Two timber-frame boxes housing the new apartments of Lamb's House are set on top of masonry structures on either side of the re-opened Waters Close that runs immediately in front of Lamb's House, as a residue of the medieval urban grain of Leith, and which had been blocked by buildings of the 1960s. Finished Scottish oak will be used to frame specific openings and tectonic gestures that mediate the geometry of domestic space with the immediate urban context. The boxes step out at each floor level following a traditional construction form of the sixteenth century. The entrance steps to the new apartments will be constructed in masonry from ground to first floor and will echo the crow steps of the gables and scale of the turnpike stair in Lamb's House.

It is not clear whether Mary walked in the garden of Lamb's House, but if she did it was sure to have been of the size of either a small physic or knot garden. The new garden will be of this character and, although an amenity for the residents of Lamb's House, will be open to the public off the re-opened Waters Close. It is proposed that a setting for a newly commissioned statue of Mary be created in the garden. This would be the first statue ever to have been made of Mary Queen of Scots.

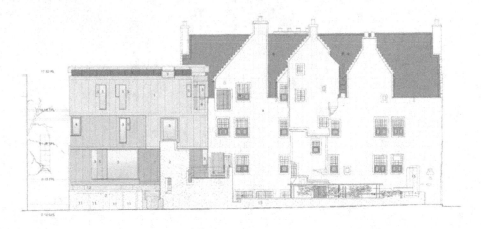

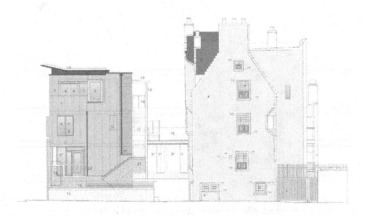

Fig. 14. The Project – South and East Elevations

Notes

1. In mind here is the tendency, promoted by politicians, commercial clients, architects and cultural commentators, to valorise certain overt expression as iconic, therefore, as enigmatic and substantial. See, for example, [Jencks 2005].
2. In his introduction to Husserl's *The Origin of Geometry*, Derrida's summary of Husserl's theorisation of the relation between a geometrical and pre-geometrical world echoes this formulation of Benjamin's premise of an architectural and pre-architectural world. "However profound our ignorance concerning historical facts, we know with an immediate and apodictic knowledge ... [a] pregeometrical world as a world of *things* disposed of according to an anexact space and time ... [and] that material qualities (colour, weight, hardness, and so forth) must necessarily be 'related' to these pregeometrical, spatiotemporal shapes by a supplementary eidetic determination" [Derrida 1978: 122].
3. Thomas Carl Wall [1999] proposes the phrase "radical passivity" to describe a shared "preoccupation" between Levinas, Blanchot and Agamben. Wall's text and the sources it cites offer an important background understanding to the particular phenomenological turn this paper promotes. Such "radical passivity" focuses on the philosophy of politics and the search for an appropriate political attitude that first operates through a positive concern for co-existence; Levinas's *autrui* is the common agency for such concern. The phrase "radical passivity", however, seems oxymoronic. It seems to suggest the simultaneous promotion of actively reformist politics through being emphatically unreactive. How can this be so?
 The explanation is as follows. On one hand, passivity speaks of the transitive condition of existence, of being-in-relation, of passing time, of passing through time, allowing time for the other side of the relationship and the other in the relationship to flourish. The notion of passivity, then, although speaking of a lack of reaction and opposition also speaks of what is not being opposed, and that is the actions of others. It can be said that passivity invokes the very action of opening a way for being in relation to others. On the other hand, as well as holding the dynamic of agitation, radical politics also speaks of a liberalist concern for establishing political relations from fundamental principles (for example, a radical liberalism fuelled aspects of the American Civil War; in this sense, then, radical pertains both to what is fundamental, equal rights for all people, and the action of agitation to reform political systems that pervert the principles of fundamental human relations). The radical relation, then, is theorised by Wall as the essential relation that we are all bound to by being in the world with others. Therefore, not only does radical passivity suggest an essential relation between one and other and an essential responsibility to wait upon, listen to and come to terms with the action of one party by the other, to radicalise passivity is both to understand the action of being in relationship as a fundamental condition to being in the world whilst pursuing such a relationship through political action.
 Wall's formulation operates transcendental metaphysical dynamics. He states, "passivity in the radical sense, before it is simply opposed to activity, is passive with regard to *itself*, and thus it submits to itself as though it were an exterior power. Hence, radical passivity conceals, or harbors in itself, or communicates with, a *potentia*; it is always outside itself and its own other. Passive with regard to itself, the essential passivity of the subject must undergo itself, suffer itself, feel itself *as other*. In this sense, passivity is purely passionate" [Wall 1999: 1].
4. Husserl refers to this tendency as "horizon-certainty". He asserts that we always know that we are in a world of endless unknowns but which are as real as any of the realities we know. In other words, we have our own limits (horizons) of understanding, but we also know that there is yet more to know beyond these horizons. Husserl asserts that the "horizon-certainty" principle is "presupposed" by the human condition "in order that we can seek to know what we do not know"; see [Husserl 1978: 176].
5. According to Diogenes Laertius, "Thales was the first to inscribe a right-angled triangle, whereupon he sacrificed an ox" [*Lives and Opinions of Eminent Philosophers*, quoted in Nancy 2003: 51]. This may also explain Le Corbusier's inclusion of an ox in his *Poème de l'Angle Droit*. The ox and right angle are both symbols of metaphysical significance. Thales makes a gift to the gods who provided him with the revelatory truth of a geometric principle;

Le Corbusier makes a gift of his belief in the truth of a right angle (and primordial significance of an ox to both mortals and gods) to the muse of poetry. See [Curtis 1986: 166, 167] and [Benton 1987: 242, 243].

6. Alistair McIntyre extrapolates from this basis to suggest that our social structures operate to this same sense of narratology, even considering social structures themselves as enacted epics; see [McIntyre 1994: 128-129].

7. Aristotle claims that Poetry bifurcated in accordance with the corresponding kinds of character. He obviously sides with the "serious-minded" people who imitated "fine-actions" rather than the more trivial people who imitated more trivial actions [Aristotle 1996: 7].

8. Ricoeur's hermeneutics operates from a political conscience and tries to address criticisms of post-modern language practitioners. For example, Manfredo Tafuri, as critical theorist of a historical materialist persuasion, suggests that some architectural intertextualists act as mere "manipulators of the imaginary" who cannot avoid the temptations for "pirouetting on only one foot," and who turn political practice into "tightrope walking," playing games "with a history whose meaning and limits they skillfully keep hidden from themselves", promoting the "multiplication of winks and high signs" to finally make only "text of impotence." These are damning criticisms, to be kept in mind whether it is the architectural project or any other creative production. See [Tafuri 1987: 301].

9. The political turbulence between England and France had a major part to play in the politics of Scotland at this time.

10. In 1558, on the suggestion and under protection of King Henry II of France, Mary Queen of Scots was taken to France and married to the Dauphin Francis to become Dauphiness of France.

11. This was known in England as the "War of the Insignia". The battle arose over the over the presence of French Troops in Scotland that kept the power of the Protestant Lords under control. The protestant Lords made an agreement with the English, the Treaty of Berwick, in February 1560. The English promised to support the Scottish Protestant Lords in their claims on the premise of religious freedoms. However, the English were more concerned by the threat Mary Queen of Scots posed to the English Crown through the claim made by her French father-in-law Henry II of France on the death of Mary Tudor, daughter of Henry VIII of England, in November 1558. Mary, who at this time was Queen of France after the death of King Henry II on 10 July 1559, had not rescinded this claim; see [Fraser 1971: 129].

12. Mary's claim to the English throne is pivotal to her imprisonment and eventual execution; see [Fraser 1971: 115].

13. "On the day the galleys were due to land at Leith, thick fog descended. A thick fog on the coast of Scotland was not an unexpected hazard, even in the middle of August" [Fraser 1971: 171].

14. "Close" is an old Scots word used in the East coast of Scotland for a lane or narrow street between buildings designed principally for pedestrian use, and literally describes the closeness of one building to another. Closes are a major feature of Edinburgh's and what is left of Leith's medieval urban infrastructure. On the West coast of Scotland, a close refers to the stairwell of tenement buildings, referring in this instance to the closeness of neighbours off a common stair.

References

ARISTOTLE. 1996. *Poetics*. Malcolm Heath, trans. London: Penguin Books.

BENJAMIN, Walter. 1992. *Illuminations*. Hannah Arendt, ed., Harry Zohn, trans. London: Fontana Press.

BENTON, Tim. 1987. The Sacred and Search for Myths. In *Le Corbusier Architect of the Century*. London: Arts Council of Great Britain.

CURTIS, William. 1986. *Le Corbusier: Ideas And Forms*. London: Phaidon Press.

DELANDA, Manuel. 2004. Materiality: Anexact and Intense. Pp. 370-377 in Lars Spuybroek, *Nox: Machining Architecture*. London: Thames and Hudson.

DERRIDA, Jacques. 1978. *Edmund Husserl's Origin of Geometry: An Introduction*, trans. John P. Leavey, Jr., ed. David B. Allison, New York: Nicholas Hays.

FRASER, Antonia. 1971. *Mary Queen of Scots*. London: Granada, Panther Books.

HUSSERL, Edmund. 1978. *Origin of Geometry*. David Carr, trans. Pp. 155-180 in Jacques Derrida, *Edmund Husserl's Origin of Geometry: An Introduction*, New York: Nicholas Hays.

JENCKS, Charles. 2005. *The Iconic Building – The Power of Enigma*. London: Frances Lincoln.

LYOTARD, Francois. 1986. *The Postmodern Condition: A Report on Knowledge*, Manchester: Manchester University Press.

MCINTYRE, Alistair. 1994. *After Virtue, a study in moral theory*. London: Duckworth.

NANCY, Jean-Luc. 2003. *A Finite Thinking*. Simon Sparks, ed. Los Angeles: Stanford University Press.

RICOEUR, Paul. 1991. *A Ricoeur Reader, Reflection and Imagination*. Mario J. Valdés, ed. Toronto: University of Toronto Press.

RUSSELL, Bertrand. 1903. *Principles of Mathematics*. New York: W. W. Norton.

SPUYBROEK, Lars. 2004. *Nox: Machining Architecture*, London: Thames and Hudson.

STEER, Francis W. 1961-1962. A Map Illustrating the Seige of Leith, 1560. *Proceedings of The Scottish History Society* 1961-62: 280-285.

TAFURI, Manfredo. 1987. *The Sphere and the Labyrinth, Avant Gardes and Architecture from Piranesi to the 1970s*. Cambridge, MA: MIT Press.

WALL, Thomas Carl. 1999. *Radical Passivity, Levinas, Blanchot and Agamben*. New York: State University of New York Press.

WRIGHT, Andrew. 2000. *Lamb's House Conservation Plan*. National Trust For Scotland.

About the author

A registered architect in the UK since 1986, Wiszniewski took up an academic post with The University of Edinburgh in 1995 and co-founded the partnership Wiszniewski Thomson Architects in 1996. In 2006 Wiszniewski Thomson Architects won the Royal Scottish Academy Gold Medal for Architecture for the Water House, Crieff. Upon winning a design competition for the extension and renovation of Lamb's House, a sixteenth-century merchant's house, Leith, Edinburgh, Wiszniewski Thomson Architects formed a partnership with Cadell[2] in 2005. In 2009 Wiszniewski completed a doctorate thesis entitled "Architecture and Unavowable Community: Architecture and Community as Affirmation of Insufficiency and Incompleteness." Academic papers have been published in China, Denmark, France, Germany, Greece, Holland, Spain, Turkey, UK, and USA; core interests are the architectural-political-philosophical overlap on issues of representation and production.

Angela Grauerholz

École de design
University of Québec at
Montréal
C.P. 8888, Succ. Centre-
Ville
Montréal, Québec
H3C 3P8 Canada
grauerholz.angela@uqam.ca

Keywords: Urban planning,
circular, photography,
theorizing, limits of
language, ellipse

Research

From Circle to Ellipse: Footnotes to a Photographic Essay

Abstract. In linguistics, ellipsis (from the Greek: *élleipsis*, "omission") or elliptical construction refers to the omission from a clause of one or more words that would otherwise be required by the remaining elements. Photography encapsulates a wide range of experiential possibilities with the rhetoric of visualization and discursivity. The medium constantly reminds us of the basic geometric principles of perspective: perceived rather than measured, brought into consciousness through basic knowledge without need to name the phenomenon. It is the image that fills the gap, pronouncing elliptically what we feel, see and conclude, while the subject recounts the story.

Viewers enjoying August Fuhrmann's stereoscopic Kaiserpanorama in 1880s Berlin. See [Crary 1999]

Geographicae enarrationis

[1] Circular models of urban planning—Paris being oft-quoted, down to the simple traffic island—introduce centers where there are none, developed entirely from a geometrical plan with streets converging to a central point. Punctuating the urban landscape, monuments and fountains designate places to be approached from all sides. As objects and in plan they are typically round, but they are never circular to the eye.

[2] Similarly, most circular architectural structures are unusual, even curious—simultaneously typical and atypical. For the most part, they can be categorized as containers (water, fuel and spectacles), towers (cylindrical), cages (mostly bird cages, at times with domelike structures) and (of course) churches, reverberating with the phrase "God is a circle whose centre is everywhere, whose circumference is nowhere" (pseudo-Hermes Trismegistus, *The Book of the 24 Philosophers*, twelfth century). The spaces are measurable, but the experience is not. This is where architecture and photography meet.

[3] Photography tells us about our experience, enabling verification of discrepancies between the real and the perceived. Our desire to expand perception of the real—starting with early experiments in immersive environments (see panoramas)—to more recent technological developments in virtual space, also alludes to the speculative aspects of photography:

For Bergson, the 'virtual' served as an ontological distinction between the possible and the actual; aligned with the possible, the virtual was posed over and against the actual and the real. … Bergson's use of 'virtual' seems to be taken directly from its optical definition, as if he were familiar with the Keplerian distinction between imago and pictura. Bergson turns the optics of light rays into a metaphor for perception: 'To obtain this conversion from the virtual to the actual,' he writes, 'it would be necessary, not to throw more light on the object, … Then we have total reflection. The luminous point gives rise to a virtual image which symbolizes, so to speak, the fact that the luminous rays cannot pursue their way … The objects merely abandon something of their real action in order to manifest their virtual influence [...] this is as much to say that there is for images merely a difference of degree, and not of kind, between being and being consciously perceived.'

The difference emphasized by Bergson here—'between being and being consciously perceived'—becomes the difference between the real and the virtual [Friedberg 2006: 141].

[4] Theorizing photography extends into its subject matter, and touches as much on philosophical matters of time and space as on the everyday and its paradoxes:

Several of Duchamp's cryptic statements on the transition from the space of everyday life to the four ¬dimensional continuum suggest that the series of overlapping circles super-imposed upon these segments indicate entry into a fourth dimension. For Duchamp, the circle was a figure of dimensional collapse. In a text from The Green Box he demonstrated this conviction by describing the rotation of a hori-zontal dividing line, G that intersects a vertical axis. This vertical line suggests a division into a left plane and a right, which are occupied by points A and B. Duchamp attempted to demonstrate the collapse of such a 'left' and 'right' by asserting that the dividing line G may rotate in three dimensions either to the left toward A or the right toward B, but in either case the continuous path of circular rotation—in which one end meets the other destroys left and right, displacing them by two isomorphic but directionally opposite continuums [Joselit 1998: 66].

[5] Considering the limits that language places on expressing the breadth of human experience, we are indebted to Jorge Luis Borges, whose analogy for the rhetorical geometry of knowledge remains unrivaled:

I declare that the Library is endless. Idealists argue that the hexagonal rooms are the necessary shape of absolute space, or at least of our perception of space. They argue that a triangular or pentagonal chamber is inconceivable. (Mystics claim that their ecstasies reveal to them a circular chamber containing an enormous circular book with a continuous spine that goes completely around the walls. But their testimony is suspect, their words obscure. That cyclical book is God.) Let it suffice for the moment that I repeat the classic dictum: The Library is a sphere whose exact center is any hexagon and whose circumference is unattainable [Borges 1998: 112-113].

[6] By deliberate omission, by creating a gap, we open up a space—like a parentheses, or the ellipsis in a sentence—and our imagination steps in to fully inhabit the space to be comprehended. Fragments become representative of the whole, while reiteration helps us to dwell on the various aspects:

For the self, exposed to the meaninglessness of existence, the circle is an orientational pattern that can impose coherence on the infinity of being: it transforms the infinite into unity, either through the beacon of a center, with reference to a potentially inclusive whole, or through the comprehensive totality of a circumference, with reference to a center thus potentially defined. … The self is experienced only through its thoughts and actions, which appear to it as a continual process of expansion toward a circumference that is the fullness it lacks [Von Molnar 1987: 163].

References

BERGSON, Henri. 1990. *Matter and Memory (Matière et Mémoire 1896)*. N.M. Paul and W.S. Palmer, trans. New York: Zone Books.

BORGES, Jorge Luis. 1998. *Collected Fictions*. A. Hurley, trans. New York: Penguin Books.

CRARY, Jonathan. 1999. *Suspensions of Perception: Attention, Spectacle, and Modern Culture*. Cambridge, MA: MIT Press.

FRIEDBERG, Anne. 2006. *The Virtual Window: From Alberti to Microsoft*. Cambridge, MA: MIT Press.

JOSELIT, David. 1998. *Infinite Regress: Marcel Duchamp 1910-1941*. Cambridge, MA: The MIT Press.

VON MOLNÁR, Géza. 1987. George Poulet's Metamorphoses of the Circle: A Critical Reading. Pp. 163-168 in *Romantic Vision, Ethical Context: Novalis and Artistic Autonomy*. Theory and History of Literature, vol. 39. Minneapolis: University of Minnesota Press.

OUTSIDE THE ASTRODOME—While it's almost indescribable inside The Astrodome, it is also superb OUTSIDE as this photo shows. Taken during a near capacity baseball game it clearly shows the planning that has gone into customer parking services at Houston's air-conditioned all-purpose stadium.

ASTROCARD

PLACE
STAMP
HERE

13

Found postcard of the Astrodome in Houston (1965)

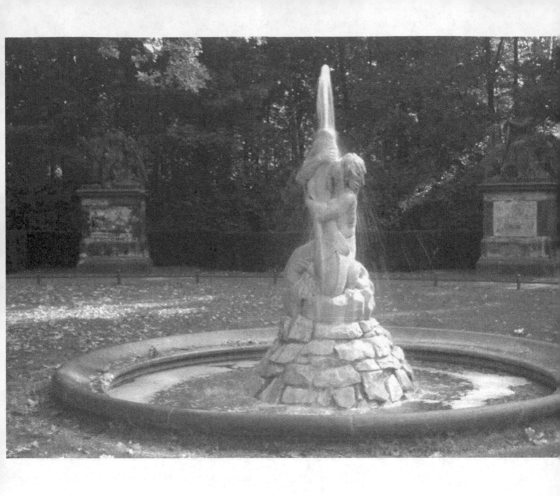

Acknowledgments

All photographs in this essay are by Angela Grauerholz unless otherwise credited.

About the author

Artist/photographer, graphic designer, Angela Grauerholz teaches book design and photography at the École de design, Université du Québec in Montréal where she is presently directing the Centre de design at UQAM. Her extensive exhibition record includes participation in major national and international events, such as the Biennale of Sydney, Documenta IX in Kassel, and the Carnegie International in Pittsburgh, Fotofest in Stockholm, and the Biennale de Montréal, as well as exhibitions at the Musée d'art contemporain de Montréal, the Power Plant in Toronto, and the Albright-Knox Museum in Buffalo, The Museum of Contemporary Photography, Columbia College, Chicago, the Blaffer Gallery, The Art Museum of the University of Houston, the Vancouver Public Library. She recently completed a work for the web: www.atworkandplay.ca.

Sherine Mohy El Dine Wahba

Faculty of Engineering
Cairo University
35, Ibrahim El-Refai st.
Nasr City, Cairo EGYPT
sherine_wahba@yahoo.com

Keywords: Environmental
control systems, architectural
design elements, architectural
form, geometry and aesthetics

Research

Friendly and Beautiful: Environmental Aesthetics in Twenty-First-Century Architecture

Abstract. Until recently, environmental control systems have been more often suppressed than expressed, hidden from casual observers and building users, rarely featured as architectural design elements, or considered aesthetically. While the impact of the overall form of a building on its thermal environmental performance may not always be apparent, the mutual influences of shape, form and orientation should be evident to – if not a basic activity of – a well-informed professional. A primary aim of this paper is to encourage a new aesthetic sensibility for the 21st century; one that conceives architectural form with respect to environmental context and ecological efficiency. Toward this end, I propose a method of comparative analysis, using several recently completed and speculative architectural projects.

1 Introduction

Over time, humans have cultivated a wealth of knowledge about living in harmony with a variety of environmental conditions. This accrued wisdom has produced many ingenious and commonsense building methods, optimizing local resources and site conditions, while evolving spaces to support and promote human activities. Whether by vernacular tradition or professional training, this has been accomplished with a very high degree of artistic expression [Fathy 1994]. The multiple influences of architectural form – pragmatic, social, aesthetic – are essential to assessing the validity of an architectural solution. Originating from the Greek term *aisthetikos*, aesthetics represents the study of beauty, an open-ended field of inquiry that continues to evolve as social, political, technological and ecological developments contribute to new views on art, architecture, design and their manifestations in the built environment [Baird 2001:3-4].

2 Research problem, aim and methodology

The main aim of this study is to address formal geometry as qualitative criteria for a more integrated approach to conceiving environmental control systems in buildings. Specifically, how might aesthetics enhance their quantitative, functional and scientific dimensions? Architectural design is dependent on a satisfactory reconciliation of the intuitive with the rational; "A building has to be both poem and machine" [Jones 1998]; [Baird 2001: 4]. All applied technologies – complex or simple, active or passive – should be part of an architectural language where building envelopes generously and advantageously embrace site geometries and orientation. We will briefly address the aesthetic potential of environmental control systems and offer an initial sketch of a larger program to focus on the following issues:

- being environmentally friendly and creatively expressing environmental control systems, opening up a wide range of potential design solutions;
- integration of building services and passive environmental control systems as inherent to the design solution;

DOI 10.1007/s00004-010-0045-1; *published online* 30 September 2010

– identifying examples of fruitful collaborations among disciplines and design professionals for further study.

3 Expression in architecture: the issue of environmental systems

3.1 Historical contribution

Thermal environmental control systems in buildings range from fully active, through hybrid, to fully passive. Most buildings represent hybrid solutions. For pre-industrial man, including the ancient Greeks and Romans, passive environmental control systems were openly expressed in the building forms and materials selection, in response to ambient climate conditions. Despite the visual exaggeration of early features of environmental control, the tendency for the mid-nineteenth century was to incorporate newly developed systems unobtrusively into the building fabric [Baird 2001: 13]. Until recently, then, environmental control systems were typically implicit rather than explicit.

3.2 Environmental control systems: potential for expression

Vertical and horizontal transportation, exploited as major service systems with expressive potential, includes the full range of the thermal environmental control systems; active, passive and in between. Passive systems are expressible externally through form, the solar and polar orientation of the building, the geometries of site and exposure to the elements, as well as in the detailing of the exterior envelope. The building façade or external envelope is a primary thermal environmental control system; composition of the façade influences the rate and degree of heat gain and loss to the building through thermal radiation, convection and conduction. To make use of the ambient energies of sun, wind and outside air temperature, the building skin is concerned with the admission/rejection of solar radiation, fresh air and heat gains/losses due to temperature differences. The main design features here include proportion and disposition of glass to solid, and techniques of solar shading, including extensions and fins, which augment pressure differentials on the various windows, and the horizontal and vertical orientation of the envelope surfaces. The main concern in the building interior, on the other hand, is provision of thermal comfort and air movement by natural forces. Table 1 (below) sums up the different approaches and types of the thermal control systems in relation to their potential expression [Baird 2001: 10-17].

4 Creation of theory: aesthetics in architecture

4.1 Aesthetics and perception in architecture

Etymologically, *aesthetics* relates to perception. Modern use of the term was coined by Alexander Blaumgarten in 1750 to denote the study of taste in fine arts. During the last century, there has been a search for a positive science of aesthetics, while the field of empirical aesthetics has grown substantially. These studies have sought to identify and understand factors that contribute to the perception of an object or a process as "beautiful" or as a "pleasurable" experience, and to better appreciate the human desire and ability to create and enjoy creating displays that are aesthetically pleasing. Here, George Santayana's distinctions among sensory, formal and symbolic aesthetics (see Table 2 below) are still useful [Lang 1987: 179-204].

Active systems	Passive systems
−Usually designed by engineers. −Consist of heating, ventilating and air conditioning systems.	−Traditionally the role of the architect. −Are dependent on the building form, construction methods and material selection.

Banham's three modes of Environmental Management [Banham 1969: 23]:		
Conservative	Selective	Regenerative
Involves relatively massive construction to isolate internal and external temperatures.	Uses external fabric of the building to admit desirable environmental effects and reduce the undesirable.	Implies the use of energy to control the internal environment.

Hawkes reworked Banham's terms to make a clear difference between [Baird 2001: 10-11]:	
Exclusive	Selective
Use ambient energy sources in creating natural environments.	Rely predominantly upon mechanical plants to create controlled artificial environments.

Levels of Rush's visible integration scale [Baird 2001: 15-17]:		
Level 1	Levels 2 and 3	Levels 4 and 5
Not visible, no change.	−Handle them simply and forthrightly. −Visible, but little or no surface change.	−Treating systems as design opportunity. −Visible with size or shape change or with location or orientation change.

Table 1. Types of thermal environmental control systems involved in relation to their expressive potential

Whether or not one pursues profound studies of aesthetics, what makes one building or place beautiful or not remains open to a considerable amount of personal interpretation. Furthermore, the aesthetics of a given architectonic language selected and/or developed by the architect, design professional, and/or client is influenced by many factors, including context, program, and construction materials and methods, as well as personal or cultural predispositions. Bearing in mind that there is by no means a single solution for any given architectural design problem, it is incumbent on responsible designers to explore widely for sources of inspiration at various scales, to contribute to the whole concept as well as its parts.

4.2 Normative environmental design theory

A friendly built environment depends on a variety of factors, including the need for design professionals to advance ecological and humanitarian ideals and not only their own skills and knowledge. New and available building and system technologies should be tuned to site conditions, allowing local climate and geometries of site topography to exert predominant influence on the shapes and forms of buildings and cities. Many architects have designed multiple buildings in the same cities, for similar purposes, yet their designs may be startlingly different from one project to next. Analyses of these differences have long been central to architectural theory, providing case studies for professionals and academics. Many practitioners urge that a responsive and healthy environment stimulates an individual's physical, mental and spiritual development, providing a sense of security, pride, privacy, community, and vitality, at a scale in keeping with human needs rather than dictated by machines or computer-compiled statistics. They hold that harmony among site and climate, the built environment, and occupants will further encourage conservation of energy and natural resources [Lang 1987: 217-32].

	Sensory Aesthetics	Formal Aesthetics	Symbolic Aesthetics
Background and Field of Concern	-We know very little about sensory aesthetics. Speculations on the topic [for instance, Rasmussen 1959 and Heschong 1979] are based largely on highly subjective and fascinating introspective analyses.	-Concerned with the appreciation of shapes and structures of the environment in response to certain patterns, proportions or shapes that are not biologically based, but are based rather on self conscious and intellectual reasoning. -Based on the Gestalt Theory of Perception.	-Concerned with associational meanings of the patterns of the environment that give people pleasure through significance, meaning and feelings.
Aesthetic Values	-Sensory values are those generated by pleasurable sensations. -They are obtained from the textures, smells, tastes, sounds and sights of the world. Here, we are more concerned with sight and hearing.	-Formal values arise from the order of sensory material, perception of the system and relationships that exist in the patterns, proportions and ordering principles.	-Expression or associated values as: *Unity and Rhythm*.
Aesthetic Variables	**Formal Aesthetics**		**Symbolic Aesthetics**
	-The shapes, proportions, rhythms, scale, degree of complexity, colour harmony, illumination and shadowing effects of the built and natural worlds. -Elements of design: dots, lines, planes and volumes -Principles of Composition: simple or complex. -Order and disorder: Perceptual Order and Proportional Schemata.		-Image, sign and symbol. -Variables in the built environment that carry meanings are: ▪ Building configuration ▪ Spatial configuration ▪ Materials ▪ Nature of illumination ▪ Colour

Table 2. Santayana: Study of Sensory, Formal and Symbolic Aesthetics

5 The green manifesto: the new link and paradigm

In *The New Paradigm in Architecture*, Charles Jencks considers the new aesthetics of environmentally conscious buildings in the late twentieth and twenty-first centuries [Jencks 2002: 228-34], describing the landform, blob and topological surface as new metaphors of nature and methods of dealing with complexity: "A computer is not a brain, an ecology is not a body, but these are all analogies of each other" [2002: 228]. For Jencks, metaphor offers a vital agency of expression in the new paradigm of twenty-first-century multiplicity, grafting ecological principles with cybernetic technologies. For example, such high-tech architects as Norman Foster, Richard Rogers, Renzo Piano, Dominique Perrault, and Jean Nouvel now routinely incorporate growing plants in their structures, creating self-sustaining systems supported by, but not limited to, computer-centered technologies [Wines 2000: 8-15].

The five case studies shown below provide an overview of analyzed examples of late-twentieth-century environmentally conscious buildings.

Case Study/ Building	Architectural/ Environmental Treatments	
	Geometries of Site	**Geometries of Form**
1. SCIENCE AND TECHNOLOGY PARK: Gelsenkirchen, Germany, 1989-1995, by Kiessler + Partner, Munich. [Baird 2001, 68-75] & [Herzog 1996, 98-99]		
	A 300m elongated glazed comb-like gallery is placed on a north-south axis overlooking an artificial lake; part of an urban park.	-Nine pavilions lead from the three-storey triangular cross- section glazed arcade forming a linear comb-like form. -The linear façade slopes skywards facing west forming a funnel towards the sun.
	Geometries of Design Elements	**Environmental Control Details**
	 a. Winter day b. Summer day c. Summer Night	*-Passive systems*: in summer the boundary between inside and outside is blurred, extending the building's arcade to the park, allowing for natural ventilation and night cooling, avoiding need for mechanical systems. Large openings in the west façade and appropriate construction materials are influenced by sound conditions. *-Active systems*: a photovoltaic solar panel system is installed on the roof. Control of the environmental system is via a bus system that facilitates energy management.
	The rectangular lower third of the long glass façade may be opened electronically to create a walkway to the public to make use of the cooling potential of the lake water.	

Case Study 1. Analyzed examples of late twentieth-century new architecture: environmentally conscious buildings: Science and Technology Park

Case Study/ Building	Architectural/ Environmental Treatments	
2. COMMERZBANK HEADQUARTERS: Frankfurt, Germany, 1991-97, by Foster and Partners. [Herzog 1996, 108-9]	**Geometries of Site**	**Geometries of Form**
	The world's first ecological high-rise tower whose plan is triangular in form, each side being curved to maximize space efficiency. The triangular form is integrated in the trapezium shaped site to fit in its corner.	Lifts, staircases and services are placed in the three corners of the triangular floor plate. The lifting pattern is designed through vertical masts enclosing the corner cores and supporting eight-storey vierendeel beams which in turn support clear span office floors and gardens enabling all to be totally free of structure.
	Geometries of Design Elements	**Environmental Control Details**
		a. Atrium b. Garden c. Terrace
	The sixty-storey skyscraper is cut open and turned inside out forming a hollow shaft around which spiral a series of sky gardens; through which natural light and fresh air enter the hollow core and spaces that face-in on it.	Natural Ventilation with opening windows is applied. Winter gardens spiral up the tower to become the visual and social focus for four-storey clusters of offices. These gardens are linked to a central atrium, throughout the full height of the building, acting as a natural ventilation chimney for the inward looking offices.

Case Study 2. Analyzed examples of late twentieth-century new architecture: environmentally conscious buildings: Commerzbank Headquarters

Case Study/ Building	Architectural/ Environmental Treatments	
	Geometries of Site	**Geometries of Form**
3. MENARA MESINIAGA: IBM Malaysia, 1992, by Ken Yeang. [Herzog 1996: 160-1], [Daniels 1997: 28] & [Mostafa 2008: 192-7]	 a. Built form- b. Planting & terraces- c. Orientation- d. Glazing & shading	
	An example of a sound environmental filter with vertical landscaping that transforms the impact of high-rise buildings in the ecosystem of a city. Its tri-partite structure consists of a raised green base responding in plan and form to the tropical climate, orientation and location, and creatively integrating with the site.	The circular spiraling fabric of the tall building with landscaped sky courts allows vertical relief for office users, in addition to providing continuity of spaces through connecting the land with the building. The sloping landscape base shifts in each floor to connect the land with the vertical of the building.
	Geometries of Design Elements	**Environmental Control Details**
	-Sky gardens that serve as villages. -Spiral vertical landscape. -Recessed and shaded windows in the east and west. -Curtain wall glazing in the north and south. -Single core service on the hot eastern side. -Naturally ventilated and sunlit services. -Spiral balconies on the exterior with full height sliding doors opening up on interior offices.	-At lower three levels artificial landscape was created to shelter and insulate the building from the morning sun. -A sun screen structure, made of steel and equipped with terraced garden balconies, holds aluminum panels and external louvers to reduce solar gain and provide shade. -A sun-roof arching across the top-floor pool and installed solar panels reduce energy consumption of the building cooled by natural ventilation, sun screens and air conditioning.

Case Study 3. Analyzed examples of late twentieth-century new architecture: environmentally conscious buildings: Menara Mesiniaga: IBM

Case Study/ Building	Architectural/ Environmental Treatments	
	Geometries of Site	Geometries of Form
4. JEAN-MARIE TJIBAOU CULTURAL CENTER: New Caledonia, 1998, by Renzo Piano. [Wines 2000:130-1] [Herzog 1996: 160] [Mostafa 2008: 213-23] 	 A contemporary architecture in harmony with the natural context and human values of the *Kanak*'s community integrates and sinks into the topography of the natural site. Inspired from the traditional Kanak house, with an additional unfinished look, the center consists of 10 buildings with three different sizes creating a symbiosis of: nature, Kanakan tradition and modern architecture. The location is characterized by bold natural contrasts: rich vegetation, tranquility of the lagoon and strong prevailing winds.	 The shell-shaped structures set facing the prevailing strong winds is self-reflective to its function and creates a suction effect on the leeward side, drawing out the warm air that collects in the interior ensuring an adequate air exchange. The design is characterized by its great sensitivity to site and increased use of terrestrial materials and vegetation. Piano refined his design with the help of the local people in a site of remarkable significance, using advanced technology with careful aesthetic consideration.
	Geometries of Design Elements	Environmental Control Details
	-Use of prevailing trade winds to obtain natural cross ventilation. -Ribs and slats with modifying effects to high winds. -Louvers open and close according to wind direction allowing breezes through spaces while air is expelled from the highest roof points; passive ventilation. -Double skinned façade provides large air spaces between woodwork and glass forming the stack-effect where cool air replaces hot air during the day. -The African rot-resistant *Iroko* wood turns silvery grey overtime due to weather effects, harmonizing and blending its color with the coconut palm trunks in site.	 -Computer-operated climate control system in the whole complex. -Manipulation of the region's bio-climatic typology achieving high level of human comfort using passive cooling where the entire buildings are dictated by wind and sun orientation

Case Study 4. Analyzed examples of late twentieth-century new architecture: environmentally conscious buildings: Jean-Marie Tjibaou Cultural Center

Case Study/ Building	Architectural/ Environmental Treatments	
	Geometries of Site	**Geometries of Form**
5. CITY HALL: London, UK, 2002, by Norman Foster and Ken Shuttleworth. [Mostafa 2008: 188-92]		
	A deliberately iconic distorted glass sphere projects out of the flat geometry of the natural site and landscape. Yet through its original transparency, it integrates to all its surrounding. This transparent offset inclined form is designed around a magnificent interior ramp down which the people can symbolically walk above the debating chamber, embodying the democratic process and promoting an image of the modern city.	The naturally ventilated glass egg-like form reduces both the solar gain and heat loss through the building skin. The minimization of building's surface area also results in increasing its energy conservation efficiency. The leaning shape also provides natural shading from intense direct sunlight.
	Geometries of Design Elements	**Environmental Control Details**
	On floor and roof levels and vertical landscape creates a microclimate at the façade on each floor level. It acts as a windbreaker that absorbs CO_2, generates O_2 and counterbalances the huge use of artificial materials with natural plants and soil.	-Solar panels are installed on roof to provide solar power. -Heat generated by computers and lights is recycled, so no chillers are needed. -Cold ground water is used to air condition the building then reused in services and for irrigation in attempt to minimize water use. -The whole building works on quarter of the energy consumed by a comparably sized office building.

Case Study 5. Analyzed examples of late twentieth-century new architecture: environmentally conscious buildings: London City Hall

6 Synopsis: Twenty-first-century environmental aesthetics: an initial sketch

Examining the efficacy of environmental control systems and their aesthetic potential for architectural expression reveals new opportunities to join scientific and artistic facets of architectural practice, two modes often considered to be at odds. Whether active, passive or hybrid, architectural environmental controls can effectively and beautifully express a commonsense attitude toward environmental and cultural resources. This paper, it is hoped, offers an *initial sketch* for assessing formal and symbolic values through aesthetic analysis (table 2) in relation to the environmental friendliness of a building (tables 1 and 3). This sketch is intended to stimulate the development of new research tools to obtain finer-grained feedback regarding quantifiable and qualifiable building assessments, using questionnaires, opinion polls or similar methods. By mindfully integrating the multiple forces that give rise to a building – cultural, topographical, technological – aspects that are often considered separately may be harnessed to enhance a building's experiential measure of pleasure, as well as its longer term sustainability and performance.

Case Study/ Building	Architectural/ Environmental Treatments	Aesthetical Approach Analysis										
		Formal Values					Symbolic Values					
		Order	Rhythm	Unity	Harmony	Complexity	Dominance	Balance	Welcoming	Pleasurable	Stimulation	Uniqueness
	Geometries of Site											
	Geometries of Form											
	Geometries of Design Elements											
	Enviromental Control Details											
	RELATION	NA / Not Applicable		Average Relation			Strong Relation					
	KEY OF MEASURES	NA / Not Applicable		Low		Average		High				

Table 4. Sketch/relation measuring aesthetical values - in relation to - environmental friendliness

References

BAIRD, George. 2001. *The Architectural Expression of Environmental Control Systems*. London and New York: Spon Press, Taylor and Francis Group.

BANHAM, Reyner. 1969. *Architecture of the Well-Tempered Environment*. London: Architecture Press.

DANIELS, Klaus. 1997. *The Technology of Ecological Building: Basic Principles and Measures, Examples and Ideas*. Trans., Elizabeth Schwaiger. Basel: Birkhäuser.

FATHY, Hassan. 1994. Architecture and Environment. The Arid Lands Newletter 36 (Fall/Winter 1994). http://www.ag.arizona.edu/OALS/ALN/aln36/Fathy.html.

HERZOG, Thomas, Ed. 1996. *Solar Energy in Architecture and Urban Planning*. Munich: Prestel.

JENCKS, Charles. 2002. *The New Paradigm in Architecture*. New Haven and London: Yale University Press.

JONES, David Lloyd. 1998. *Architecture and the Environment, Bioclimatic Building Design*. Coordinating Researcher, Jennifer Hudson. London: Laurence King.

LANG, Jon. 1987. *Creating Architectural Theory:* The role of the Behavioural Sciences in Environmental Design. New York: Van Nostrand Reinhold.
MOSTAFA, R. 2008. Environmental Architecture Aesthetics: An Intermediate Relation between Environmental Architecture and Aesthetics in Architecture. Master diss., Cairo University.
SALAH, N. 2006. Aesthetics and Form in Architecture, between Theory and Application. Master diss., Cairo University.
SCIENCE PARK GELSENKIRCHEN. ArchINFORM. Science Park Gelsenkirchen, 1994-2009. http://eng.archinform.net/projekte/3570.htm
WINES, James. 2000. *Green Architecture.* Ed. Philip Jodidio. Köln: Benedikt Taschen Verlag.

About the author

Sherine Mohy Eldine Wahba, Ph.D., is Associate Professor of Architecture in the Architecture Department, Faculty of Engineering, at Cairo University, where she completed her master's thesis and Ph.D. She is also a part-time professor in the Architecture Department at the American University in Cairo and the Arab Academy for Science, Technology and Maritime Transport. Balancing practice, research and teaching, her research interests focus on urban design theory, form generation, architectural theory and criticism.

Sambit Datta

School of Architecture and
Building
Deakin University
1, Gheringhap Street
Geelong VIC 3219
AUSTRALIA
sdatta@deakin.edu.au

Keywords: architectural
geometry, Hindu temples,
mathematical sequences, digital
reconstruction

Research

Infinite Sequences in the Constructive Geometry Of Tenth-Century Hindu Temple Superstructures

Abstract. From its early origins to the tenth century, the Hindu temple embodied a progressive elaboration of a simple formal schema based on a cuboidal sanctum and a solid form of distinctive curvature. The architectural form of the temple was the subject of wide experimentation, based on canonical sacred texts, within the regional schools of temple building in the Indian subcontinent. This paper investigates the practice of this knowledge in the constructive geometry of temple superstructures, with attention focused on the canonical rules for deriving the planar profile of a temple using a *mandala* (proportional grid) and the curvature of the *sikhara* (superstructure) using a *rekha sutra* (curve measure). This paper develops a mathematical formulation of the superstructure form and a detailed three-dimensional reconstruction of a tenth-century superstructure, based upon computational reconstructions of canonical descriptions. Through these reconstructions, the paper provides a more complete explanation of the architectural thinking underlying superstructure form and temple ornamentation.

Construction and canon in temple architecture

From its early origins to the tenth century, the Brahmanic/Hindu tradition of temple construction created a rich legacy of temples spread across India and Southeast Asia [Chandra 1975; Chihara 1996]. During its slow dispersion, the architectural form of the temple reflected ongoing constructive and philosophical experimentation based on canonical sacred texts. In particular, the evolution of the Hindu *cella* embodied a progressive elaboration of this prototypical schema, using a sacred constructive geometry that conveyed the syncretic Upanishadic cosmology [Chandra 1975; Kramrisch 1946]. The morphology of the *Nâgara* (*Latina*) temple and its development can be followed from the earliest extant cellae of the fifth century to entire thirteenth-century complexes and temple cities across South and Southeast Asia [Meister 1976; Datta 1993].

While there are thousands of variations, essentially every temple in the Brahmanic/Hindu tradition can be understood through principles outlined in canonic Sanskrit texts (*shastras*) such as *Mayamata* and *Agni Puranas* [Kramrisch 1946]. These texts provide sets of prescriptive rules that touch on all aspects of temple construction, from site selection, formal typology and location of sculptural elements, to ornamental details. The architectural elements described by such shastras are based on a number of geometric figures known as *mandalas*, and it is from these ritual and cosmic diagrams that temple plans and superstructure have been generated [Meister 1979].

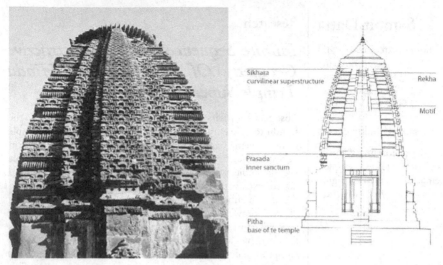

Fig. 1. The basic formal scheme of a Hindu temple. An example of a stone Latina temple (960 CE) from the Maha-Gurjara school of temple building, India. The superstructure exhibits a complex interplay of geometric and mathematical expression based on stereotomic principles of construction and surface articulation

Anga	Part of the body
Caturanga	The subdivision of the ground plan into four offsets (*catur* is Sanskrit for four)
Caturguna	The subdivision of the vertical measure into four parts.
Latina	A term used to decribe the curvilinear profiles of Nâgara superstructures
Maha-Gurjara	A regional school of temple building from Western India.
Mulasutra	Sanskritic term translated as root measure or base module.
Nâgara	Sanskritic term describing a regional variant of Indian temple architecture
Pitha	The first course of the tiered base of the temple
Prasada	The central body of the temple. The term refers to a palace.
Rekha	Refers to a curved line
Shastras	Ancient texts dealing with codified knowledge
Sikhara	The superstructure of a *Nâgara* temple
Silpashastra	Texts dealing with knowledge of the arts
Sulbasutras	Specific texts dealing with the ritual and geometry of Vedic fire altar construction. Also used in the layout of temple plans
Upanishads	Philosophical texts that constitute the core principles of Hindu thought
Vastushastra	The body of knowledge (*shastra*) dealing with habitable sites and the spirit of place

Table 1. Explanation of Sanskritic terminology and technical terms used in the paper

Studies of Indic temple geometry have demonstrated the correspondence of canonical descriptions of constructive geometry with the base plans of surviving monuments. However, as these temples were built in dynamic, ever-changing cultural, physical and sectarian contexts, the actual practice of this knowledge was the subject of wide experimentation over several centuries within regional schools of temple building [Meister 1976; Meister 1979; Hardy 2002]. Thus, while the *shastras* (canonical texts) may have been prescriptive, a multitude of interpretations and variations were possible within the canonical rules. Indeed, this ambiguous relationship between strict canon and subtle experimentation presents many challenges in relating the idealized geometry models to extant temples [Bafna 2000].

To understand the mathematical principles underpinning temple architecture, it is necessary to rigorously examine the geometries at play in the formal foundation of Indian temple architecture, the early Nâgara cella. The formal schema of the cella comprises the base (*pitha*), an inner sanctum (*prasada*) and, later, a superstructure of distinctive form (in particular the curvilinear *sikhara* of the northern Indian Nâgara tradition) (fig. 1 and Table 1). Textual and graphic descriptions of two- and three-dimensional propositions governing the conception, composition and construction of temples are offered in the literature.

The traditional study of Indian architecture is usually cast under the rubric of *vastushastra* or *silpashastra*. *Vastushastra* refers to the body of knowledge (*shastra*) dealing with habitable sites and the spirit of place. It is from this primary literature that ideas governing traditional architecture are drawn. Ancient writings on *Vastushastra* are spread through a diverse body of texts ranging from such philosophical texts as the *Upanishads*, to technical manuals encoding artisanal knowledge like the *Brhat Samhita*, *Mansara*, *Mayamatam* and *Vastusutra Upanishad*. Varahamihira's *Brhatsamhita* [Bhatt 1981], a sixth-century treatise on astrology and astronomy, offers valuable evidence on the use of mandala geometry for the layout of buildings [Meister 1976]. The *Mansara* [Acharya 1980] is commonly held to be the most comprehensive and representative text on ancient Indian architecture. Dagens' [1994] translation of *Mayamatam* and the *Vastusutra Upanishad* [Boner et al, 2000] provides summaries of this body of literature. Scholars have attributed the technical descriptions of constructive geometry to the various *sulbasutras* [Meister 1979]. While these ancient texts serve as a primary reference for temple scholars, secondary modern references [Kramrisch 1946; Dhaky 1961; Chandra 1975] offer access to and interpretations of their ideas. Kramrisch [1946: vol. I, 437-442] provides an accessible listing of traditional texts relevant to *Vastushastra* (for a detailed examination of these and other texts, see the discussion on the sources of evidence for temple architecture in [Bafna 2000]).

The superstructures of *Latina* temples have a distinctive curvilinear form composed of a series of motifs (fig. 1). The surface geometry of these shrines results from intricate mathematical and geometric expression based on stereotomic techniques [Kramrish 1946; Meister 1979]. This paper investigates the practice of this knowledge in the constructive geometry of temple superstructures in the tenth century.

Comparative analysis of geometry : discussion

Computational modeling provides a robust methodology for researching the genesis and evolution of geometry in temple architecture. The fragmented discontinuity of textual accounts, lack of graphical representations, and heavily eroded early remains make the process of establishing the lineage of formal continuity difficult. In this context,

computation presents an attractive methodology for capturing, analyzing and comparing partial geometry models from textual and graphic descriptions and specific temple sites spread over time, geography and culture. For example, form models can be derived from data recovered from existing temples, two and three-dimensional idealized geometries can be reconstructed from textual canons (*shastras*), and these models can be analyzed and compared to yield new knowledge on the role of geometry in the genesis and evolution of temple architecture over time.

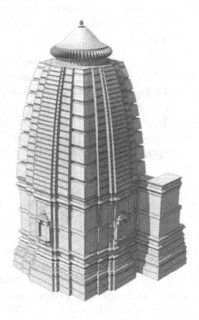

Fig. 2. 3D reconstruction of the Temple of Ranakdevi, Wadhwan. The superstructure geometry is modelled using the geometric progression for scaling and curvature of individual units

This paper describes the computation of three distinct geometries for understanding the construction and conception of temple superstructure, as represented by the three-dimensional reconstruction in fig. 2. First, a generic skeletal model of the superstructure using rule-based computation is generated (fig. 4). Second, detailed models of individual motif geometry from temples are recovered using close range photogrammetry, and a tiling procedure based on the sum of infinite sequences is described (fig. 5). Finally, the superstructure geometry is developed by combining the first and second computations to generate a three-dimensional solid model of the surface geometry (fig. 6).

The reconstructions present new possibilities for interpreting the formal and geometric bases of temple form, demonstrating how the computability of a global geometry can form the basis for comparative analyses of a multitude of temple superstructures that are derived from the same constructive canon. Further, the parametric variation of generated global models allows for a rapid evaluation of the geometric similarities and differences between multitudes of samples. The advantage of this process is that changes made at any stage due to revision of assumptions or testing of alternatives can be easily propagated between the models. Further, since the models of the surface geometry are based on generic constructions, they can be easily transferred to other, similar forms, such as related but different schools of temple building, and can be

easily incorporated at any stage, whether due to revision of assumptions or the testing of alternatives. In placing a specific temple between possible precursors and descendents, the use of constructive geometry as a generator in the evolution of temple architecture form emerges as a series of related instances arising from similar techniques (for the application of this method to comparing the base and superstructure, see [Datta and Beynon 2008]).

Superstructure Geometry

Archetypal forms of superstructures can be computed from generic descriptions of geometric constructions using rule-based generation. Textual and graphic descriptions of mathematical and geometric constructions described in the literature [Dhaky 1961; Meister 1979] are codified in the form of shape rules and constructive methods to generate classes of formal three-dimensional geometry corresponding to the two-dimensional canonical descriptions. The three-dimensional form of the superstructure is based on encoding two control profiles: the horizontal plan profile and a vertical curved profile (fig. 3). The derivations of the curved profile (*rekhasutra*) are based on Kramrisch's [1946] interpretation of the canonical procedures for laying out curves.

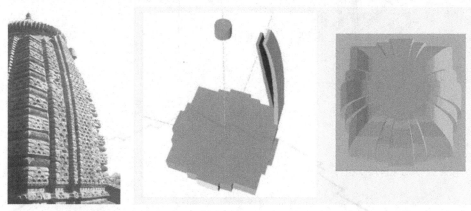

Fig. 3. Left: Surface geometry of the temple of Ranakdevi at Wadhwan with three offsets (four faces) showing the curvature. Middle: A generated example showing a base with three offsets, central axis and geometric envelopes of the central spine (offset). Right: Top view of a generated example showing the global model of the surface geometry

Horizontal and vertical control geometries of the surface are derived from textual (canonical) accounts in the temple literature. The horizontal profiles are computed using a set of shape rules derived from the literature on temple geometry [Meister 1976; 1979; 1986]. The vertical profile is based on descriptions [Kramrisch 1946; Dhaky 1961] provided in scholarly texts (explained in detail in the next section on curvature). The generation of geometric form with this technique allows a large class of profiles – and, by extension, superstructure forms – to be explored.

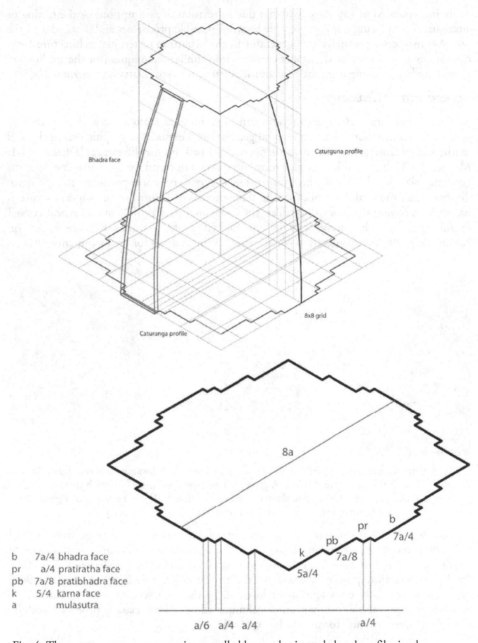

Fig. 4. The superstructure geometry is controlled by two horizontal closed profiles in plan and an open curved profile in section. The horizontal profile (*caturanga*) is offset into four faces based on a proportionate subdivision of the ritual 8x8 grid (bottom). The rules for computing these profiles are described in the literature [Meister 1979; Datta, 2001]. The curve measure (*caturguna*) is derived by joining points of intersection in the vertical grid in the XZ-plane (top). The *rekha* (curve measure) is shown on the *bhadra* face of the superstructure. The top profile (*skandha*) is divided into six parts and the bottom profile (*caturguna*) is ten parts of the *mulasutra* (root measure)

The global model is then subdivided into four component motifs, corresponding to the four faces (fig. 4). Each component motif is developed in detail using close-range architectural photogrammetry [Streilein et al. 1998; Debevec et al 1996]. Finally, the global surface is tiled with the detailed component motif models. The reconstruction approach developed by the author [Datta 2001] comprises the following steps:

- a global model of the superstructure using rule-based generation;
- local models of motif geometry;
- parametric tiling model combining the above.

The computation of each of the above is described in the following sections using the surface geometry of the temple of Ranakdevi in Wadhwan (fig. 1) as an exemplar.

The Ground Plan

Embedded in the plan of most temples is a ritual grid diagram of 8 x 8 = 64 squares (*mandala*), prescribed for temple building in the *Brhat Samhita* [Bhatt 1981] and later texts [Meister 1976]. This grid is used to generate the ground plan and control measure in the configuration of stone temples. For example, Meister [1979] shows how the horizontal profile depends on the number of offsets (*angas*) and the proportional relationships between each offset are derived from the recursive subdivision of the sixty-four square grid. Based upon field measurements, the basic module (*mulasutra*) of the ritual grid is a = 660mm. The horizontal profile has three offsets (four faces, *caturanga*) and these are sub-measures of the basic module: a, $a/4$, $a/4$ and $a/6$, respectively. Widths of the offsets in terms of the basic module (*mulasutra*) are $5a/4$, $7a/8$, $a/4$ and $7a/4$ respectively. Using these measurements, the plan profile of the temple may be computed (fig. 4).

Description of Curvature

The vertical profile is based on the extrusion of the profile of the ground plan in the vertical direction [Datta 1993]. The extrusion in the vertical direction is based on a curved profile (*rekha*), which establishes the degree of curvature of the superstructure and controls the overall geometry of the superstructure (fig. 3). Following Kramrisch [1946] and Dhaky [1961], Datta [1993] developed a mathematical procedure to generate the curvature based on textual descriptions. This procedure is dependent on the height of the superstructure, the number of vertical units chosen for each offset and the choice of an integer (one of 3,4,5,7) for controlling the degree of curvature. In the example reconstruction used in this paper, the integer chosen is 4 (*caturguna*, or four-fold division). A detailed description of the derivation of curvature is provided in [Datta 1993].

In actuality, each offset has a different number of units, and hence a different rhythm. For simplicity, we treat the entire superstructure as a single unit (fig. 4). Following Kramrisch [1946], the rules for deriving the *rekha* are summarised as follows:

If the base profile (ritual grid) is divided into ten parts, then the width of the top of the superstructure, or *skandha*, is six parts, the height being given (multiple of *mulasutra*). This establishes the extent of the bottom and top profiles (fig. 4). If the integer chosen for the curve is 4 (*caturguna*), the height is H, and then the successive vertical divisions are: $H/4$, $1/4(H - H/4)$, $1/4(H-3H/4)$, up to n terms, where n is the

number of units [Kamrisch 1946: 11-13]. As described above and shown in fig. 3, the global geometry of the superstructure can thus be characterized by the following:

- generating a horizontal base profile in the XY-plane based on rules for dimensioning the 8x8 grid and its proportionate subdivision into offsets;
- generating a vertical curved profile based on rules for dimensioning a vertical grid in the XZ-plane and its proportionate subdivision into stone units.

This method of reconstruction is significant because of the state of decay of existing artifacts. As the profile creation process is computed from parametric rules based on canonical description, a large class of profiles, and by extension, superstructure geometry, can be explored. The advantage of this rule-based generation of profiles based on parameterized rules is that the same set of rules can be used to generate "best-fit" constructive models that correspond to field measurements and observations of surviving monuments. The rule-based model generation process allows temple scholars to conjecture about the range of possible measures that may have been used to derive the ground plan and superstructure geometry of related monuments.

Infinite sequences: A mathematical formulation

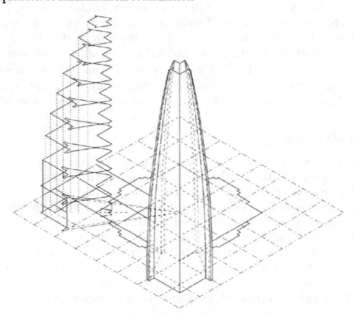

Fig. 5. Analysis: The corner geometry of the superstructure is subdivided into constituent units based on a series progression. A tiling function is used to scale each constituent unit in the series with self-similar motif geometry

Having established a computational method for the ground plan geometry and basic superstructure form, the detailed modeling of each of the facets and their geometry is described in this section. As discussed, the *caturguna* profile defines the generation of the *lata* portion of the *sikhara* while the critical profile in establishing the degree of curvature of the *latas* of a *sikhara* is the *rekhasutra* or curve measure (fig. 4). However, each *lata* (see the temple surface in fig. 1) is made up of a sequence of scaled motifs.

The surface of the superstructure is composed of a series of carved motifs that exhibit a progressively diminishing sequence of self-similar forms. While no guide exists in the canonical literature on how these sequences are handled, two clues are available in the mathematical and cosmological texts. First, the notion of *shunyata* (nothingness) and the infinitesimally small occupies a central place in the syncretic Upanishadic cosmology. Second, the preoccupation with and knowledge of *shredhishektras* (mathematical series) are evident in Vedic mathematical texts.

A method for generating the latas based on the description of the derivation of the *rekha* is developed in this section [Kramrisch 1946; Datta 1994]. The bounding (skeletal) geometry of the corner offset (*karna*) is tiled with scaled copies of the unit of carving. The parametric surface is developed using the global model as a skeletal surface tiled with a sequence of scaled units using the local geometry of the motif (fig. 5). This forms the basis for the repetitive tiling of the surface using a scaling function based on the curve profile shown in fig. 4. The tiling procedure is dependent on the height of the *sikhara* and the number of vertical units chosen for each lata. In practice, each *lata* would have a different number of units, and hence a different rhythm. For simplicity, in this paper, we treat the entire superstructure as a monolithic unit.

We can formalise this subdivision process as follows:

$$\left(a^0 = H\right)a^{(n+1)th} = \frac{1}{R}\cdot\left\{a^{nth} - a^{(n-1)th}\right\}, R \in \{3,4,5,7\}$$

<div align="right">Eq. 1</div>

Where R is the curve measure, H is the height of the superstructure.

Although the problem of deriving the curvature may be solved by geometric construction, and certainly was solved in this way by the ancients, a more intriguing formulation is possible. To find out how the cella superstructure may represent a finite encoding of the infinite, we cast the height of the *sikhara* and the properties of the *rekhasutra* as a geometric sequence using the remainder subdivision algorithm (Eq. 1). Further, we can define the problem as one of determining the height of the *m*th unit in a given progression of *n* terms using the height of the superstructure as the finite sum of an infinite geometric sequence. In the following sections, we convert the constructive steps into a summation series of an infinite sequence of terms.

The first term of the progression is $H/4$, and the common ratio, $r = 3/4$. From the common ratio of the series represented in Eq. 2, we can generalize the derivation of a common ratio r, for a given R.

$$\frac{H}{4}, \frac{3}{4}, \frac{H}{4}, \left(\frac{3}{4}\right)^2 \cdot \frac{H}{4}, \left(\frac{3}{4}\right)^3 \cdot \frac{H}{4}, \ldots, \left(\frac{3}{4}\right)^{n-1} \cdot \frac{H}{4}$$

<div align="right">Eq. 2</div>

To rationalise the subdivision of the *sikhara* height H, we use the common ratio r, which is independent of the height (Eq. 3), and express the height H of the *sikhara* as the sum of *n* terms of a geometric progression.

$$R = \frac{R-1}{R}, R \in \{3,4,5,7\}$$

<div align="right">Eq. 3</div>

The sum of n units of a geometric progression, H being the height of the *sikhara*, a being the first term and r the common ratio, can be rewritten as:

$$a + a \cdot r + a \cdot r^2 + \ldots a \cdot r^{n-1} = H \qquad \text{Eq. 4}$$

Rewriting (Eq. 5), we can derive the first unit, if the number of terms, n and the common ratio r are known.

$$a \cdot \frac{(1 - r^n)}{1 - r} = H \qquad \text{Eq. 5}$$

Finally, the height of the *lata* unit m can now be derived as the mth term of a geometric progression whose first term is a (Eq. 6) and common ratio is r (Eq. 3),

$$a = H \cdot \frac{(1 - r)}{1 - r^n} \qquad \text{Eq. 6}$$

Using (Eq. 7), we can determine the height of any unit given the *rekha*, number of units in a *lata* sequence and the height of the *sikhara*, all of which are specified in the canon:

$$l^{mth})a \times r^{m-1} = H \cdot \frac{(1 - r)}{1 - r^n} \cdot r^{m-1} \qquad \text{Eq. 7}$$

As described previously, the *rekha*, R is chosen from the set $\{3,4,5,7\}$ and the common ratio of the progression r fixed from (Eq. 3). The next step is to determine the number of units, n. Finally, (Eq. 7) is used to assign the heights of each unit of the sequence. While the vertical height of each unit is fixed, the top of each unit is scaled by a uniform scale factor that is derived from the *rekha* construction. The mathematical generation of a *caturguna sikhara*, on a *caturanga* base is shown (fig. 6).

Fig. 6. A *caturguna-caturanga* superstructure generated to an arbitrarily large set of terms shows how the infinite sequence converges toward a limit

The tiling function is based on the sequential subdivision of the curved surface. The tiling geometry of the corner offset of the superstructure in this temple comprises 8 units. The first (lowest) unit, the last unit and the remaining 6 units follow in a series progression. The tiling corner spine is computed by recursive subdivision of the global geometry using this series formulation of the scaled motifs. The bounding box of each unit is computed from a set of parameters that control the global model, such as the initial starting unit, number of units, scale factor and type of progression. These are then tiled within the enclosing geometry of the corner spine (fig. 4). This process rationalizes the degree of curvature derived from the rule-based curve generation into planar facets that approximate the curvature. Thus the explicit derivation of the curvature of the form as shown in fig. 4 is now replaced by a family of polygonal tiles related by a function of the underlying series mathematics. Using this mathematical formulation, it is now possible to derive the motif geometry directly from this model by a simple substitution rule that maps the bounding box of each unit to the specific geometric size of the tile shown in fig. 5. The resultant model gives the final superstructure geometry where each tile in the series is a self-similar scaled version of the motif model geometry (fig. 2).

Conclusion

This research attempts to "read" geometries embedded in temple remains through computational geometry, an approach that may be contrasted with Robin Evans' theories on geometry in architectural making [Evans 1995]. In his work, Evans uses a series of translations to track the development of architectural form through projective geometry. The building-as-object is cast, through a series of drawings, to the finished product – a projection informed by how architecture develops through the translation of drawing into building, representation into actuality. The particular challenge of my research is the opposite, the translation of building through the geometric and proportional clues present in its surviving form back to its description.

As Affleck and Kvan [2005] observe, the majority of virtual heritage projects attempt to create in the computer a realistic representation of their subject. This is an attempt not so much to recreate a temple form, but to uncover how its architecture was developed. By comparing its formal properties with models from which it may have been derived, advances in computation provide new ways to explore, analyze and explain the genesis and evolution of these historical artifacts. For example, in the temple superstructure example described here, the use of the ritual grid – well known in the layout of temple plans – was projected onto the vertical plane to decipher the compositional structure of the superstructure, including the derivation of the curve measure. The use of series mathematics, well known from temple literature [Datta 2001; Datta 2005] was used to develop the tiling models. The complexities of the surface geometry could be explored and repetitive models obtained through generation and parameterization. The example demonstrates the above principles in the context of one type of tenth-century superstructure, one that follows the profile of the offset in plan, and a curve in section. Thus, computation of spatial information plays a fundamental role in plotting any links between extant architectural remains and the principles of geometrical and architectural composition as presented in the texts. Representation of the building through the series of computed points is not only a device for aiding visualization but a deep description of its underlying geometry, a reverse analogue to the traits that Evans describes as the "instructional device" for the complex cutting of French Renaissance stonework. Through a comparison of the relationships between cosmology, geometry and physical form using computational methods, in these early sites with both Indian and Southeast

Asian models, it is intended that the generative role of geometry within the architectural historiography of Brahminic temples can be clarified and more fully developed.

In brief, the computational approach described in this paper results in the creation of multiple partial three-dimensional models of superstructure geometry. It is envisaged that these models will be useful for supporting the comparative analysis of superstructure geometry of temples from related temple building traditions (e.g., within South and Southeast Asia); piecing together the genesis and evolution (over time) of the geometric experimentation within specific schools of temple building (e.g., Maha-Gurjara, Chandela, etc.); and explaining the complex and problematic linkages between canonical prescriptions of ideal form with the analysis of data recovered from surviving monuments.

This inquiry raises a broader question that merits further exploration and dialogue. Considering the philosophical and mathematical concepts revealed by this method of reconstruction, were ancient Hindu temple builders grappling with a method for encoding a notion of infinity through their use of geometric sequences?

References

ACHARYA, P. 1980. *The architecture of the Mansara*, 2 vols. New Delhi: Manohar Publishers.

AFFLECK, J. and T. KVAN. 2005. Reinterpreting Virtual Heritage. Pp. 69-178 in vol. 1 of *Proceedings of the Tenth Conference on Computer-Aided Architectural Design Research in Asia*, A. Bhatt, ed. New Delhi: TVB School of Habitat Studies.

BAFNA, S. 2000. On the idea of the Mandala as a governing device. *Journal of the Society of Architectural Historians* **59**, 1: 26-49.

BHATT, R. 1981. *Brhat Samhita of Varahamihira*, 2 vols. New Delhi: Motilal Banarsidass.

BONER, A., Sadasiva Ram Sarma, and B. Baumer. 2000. *Vastusutra Upanisad:the Essence Of Form In Sacred Art* (text in Sanskrit with English translation and notes). New Delhi: Motilal Barnasidass.

CHANDRA, P., ed. 1975. *Studies in Indian Temple Architecture.* Varanasi: American Institute of Indian Studies.

DAGENS, B. 1995. *Mayamata: An Indian treatise on Housing Architecture and Iconography.* New Delhi: Sitaram Bhartia Institute of Science and Research.

DAIGORO, Chihara. 1996. *Hindu Buddhist Architecture in Southeast Asia.* Leiden: E. J. Brill.

DATTA, Sambit. 1993. *Geometric Delineation in the Nâgara Cella: Study of the temple of Ranakdevi at Wadhwan*, Ph.D. thesis, School of Architecture, CEPT. Ahmedabad: Vastu Shilpa Foundation.

———. 1994. *Modelling Sikhara form in the Maha-gurjara idiom.* Michael Ventris Research Report, Institute of Classical Studies. London: Cambridge and Architectural Association (AA).

———. 2001. Infinite Sequences and the Form of Cella Superstructures. Pp. 106-112 in *The Proceedings of the Third International Conference on Mathematics and Design*, Geelong, Deakin University.

———. 2005. On Recovering the Surface Geometry of Temple Superstructures. Pp. 253-258 in vol. 2 of *Proceedings of the 10th International Conference on Computer Aided Architectural Design Research in Asia*, Bhatt, A., ed. New Delhi: TVB School of Habitat Studies.

DATTA, S. and D. BEYNON. 2008. Compositional Connections: Temple Form in Early Southeast Asia. In *History in Practice, Society of Architectural Historians Australia New Zealand* [DVD Publication]. Geelong.

DEBEVEC, P., C. TAYLOR, and J. MALIK. 1996. Modeling and rendering architecture from photographs: A hybrid geometry and image-based approach. Pp. 11-20 in *Proceedings of SIGGRAPH 1996.*

DHAKY, M. 1961. The chronology of the Solanki temples of Gujarat. *Journal of Madhya Pradesh Itihasa Parishad* **3**: 1-83.

EVANS, R. 1995. *The Projective Cast: Architecture and Its Three Geometries*. Cambridge, MA: MIT Press.

HARDY, A. 2002. Sekhari Temples. *Artibus Asiae* **62**, 1: 81-138.

KRAMRISCH, S. 1946. *The Hindu Temple*, 2 vols. Calcutta: University of Calcutta.

MEISTER, M. W. 1976. Construction and conception of mandapika shrines of central India. *East and West, New Series* **26**: 409-418.

———. 1979. Mandala and practice in Nâgara architecture in northern India. *Journal of American Oriental Society* **99**, 2: 204–219.

———. 1986. On the development of a morphology for a symbolic architecture: India. *Anthropology and Aesthetics* **12**: 33-50.

MICHELL, G. 1977. *The Hindu Temple: An Introduction to its Meaning and Forms.* London: Harper & Row.

STREILEIN, A. and M. NIEDERÖST. 1998. Reconstruction of the Disentis monastery from high resolution still video imagery with object oriented measurement routines. *International Archives of Photogrammetry and Remote Sensing* **22**, pt. 5: 271–277.

About the author

Sambit Datta is a senior lecturer in the School of Architecture and Building at Deakin University, Australia. His work centres on the mediatory role of geometry in the relationship between formal and abstract ideas and their material realisation in architecture. Using computer-aided design tools, he investigates the geometric ideas that shaped the genesis and evolution of Indian temple architecture. His current research on Asian heritage sites, supported by the Australian Research Council, unravels the formal architectonic links between temple building traditions along the trade routes between South and Southeast Asia. He teaches courses in architectural geometry, parametric modelling and design, has been a visiting scholar at the Centre for New Media, UC Berkeley, and is a director of the architecture practice Shunya. Dr. Datta studied architecture at CEPT University (India), completed postgraduate studies at NUS, Singapore, and received his doctorate at the University of Adelaide, Australia.

Brian Holland

49 Willow St
Brooklyn, NY 11201 USA
hebrian@alumni.upenn.edu

Research

Computational Organicism: Examining Evolutionary Design Strategies in Architecture

Keywords: design theory, historical era: modern and contemporary, algorithm, computer technology, morphology, Richard Dawkins, Manuel Delanda, William Latham, John Frazier

Abstract. The diverse forms of nature, in particular and biological forms, have long been a preoccupation of the architect. As a special category of natural form, biological organisms exhibit extraordinary levels of design adaptability across multiple generations based upon the inherent 'intelligence' of the evolutionary mechanism. Evolutionary design theory in architecture seeks to harness this generative intelligence as the foundation for a new architectural design process. This paper investigates the lineage of evolutionary thought in architectural design, paying particular attention to the current trend towards experimentation with generative algorithmic procedures and the theorization of an evolutionary architecture.

Only nature is inspiring and true; only Nature can be support for human works. But do not render Nature, as the landscapists do, showing only the outward aspect. Penetrate the cause of it, its form and vital development...
Charles L'Eplattenier, 1906, quoted in [Le Corbusier 1925: 198]

Underlying the many visible elements of animal form are remarkable processes, beautiful in their own right in the way that they transform a tiny, single cell into a large, complex, highly organized, and patterned creature, and over time, have forged a kingdom of millions of individual designs.

Sean B. Carroll [2005: 4]

The idea of evolution as we understand it today – a process of natural selection operating within a population of variable replicators – was first introduced to the scientific community by Charles Darwin and Alfred Russel Wallace at the Linnean Society of London in 1858, and was given its first public exposure the following year with the publication of Darwin's book *On the Origin of Species*. In this seminal work, Darwin lays bare for the first time the mechanism of design in the biological world. Then, just four years later, the *Revue Générale de l'Architecture* coined the term "Organic Architecture" as a means of relating architecture to the "organized life of animals and vegetables" as opposed to the "unorganized existence of the rocks which form the substratum of the world" [Collins 1965: 156]. Regardless of whether the editors of the *Revue* were aware of Darwin's controversial theory at the time, and despite the fact that the rhetoric of organicism in architecture has subsequently been as variable as the forms that Darwin's theory describes, the distinction set forth by the *Revue* still remains fundamentally relevant.

Today the debasement of geological forms as "unorganized" is clearly disputed by current scientific theories of self-organization and emergence, which ascribe to matter the inherent generative capacity for spontaneous development of complex order. And even

though organic life is now generally viewed by science as being subject to the same dynamic processes of self-organization as inorganic matter, there still remains one fundamental distinction between the two, and that is DNA: that uniquely productive two-dimensional expression of organic matter that propels the development and evolution of complex adaptive forms among populations of organisms over time. Although we no longer view geological structures as purely informal – as did the editors of the *Revue* in 1863 – the fundamental distinction between rocks and living organisms remains; rocks do not evolve, but plants and animals do. Thus, I believe that the various theories surrounding the pursuit of "organicism" in architecture must be viewed largely in the context of evolutionary thought. After all, in the intervening 150 years since the near simultaneous debut of both Darwin's famous theory and the early rhetoric of organicism in architecture, evolutionary science has come to dominate the field of biology. To biologist Sean B. Carroll, the role of evolution in biology is primary: "...evolution is much more than a topic in biology – it is the foundation of the entire discipline. Biology without evolution is like physics without gravity" [Carroll 2004: 294]. Furthermore, the subsequent breakthroughs in heredity, morphogenesis, and evolutionary development have profoundly transformed our understanding of organic forms and the processes by which they are created, and figure prominently in the contemporary pursuit of a "living" architecture [Hensel 2006].

Many architects today appeal to some notion of evolutionary thinking as a strategy for architectural design. Recent scientific discoveries concerning the distinctly computational mechanisms underlying evolutionary biology, paired with ever-increasing sophistication of digital design software, have inspired and enabled architects to experiment with such tools as genetic algorithms and environmental morphogenetic simulation. The resulting proliferation of formal variety represents a temporal *becoming* that is neither metaphorical nor symbolic, but operative and literally creative. Such a conception of form rejects the recognition of final or ultimate forms in favor of a continuum of evolutionary forms that are continually renewed, either by the influence of external dynamical forces, or through the unfolding of endogenous processes of growth and mutation. This paper investigates the lineage of evolutionary thought in architectural design, paying particular attention to the current trend towards experimentation with generative algorithmic procedures and the theorization of an evolutionary architecture. The motivations for these projects are interrogated through the writings of their proponents. To what extent are they practical – striving for an iterative design optimization through the power of computational variability – and to what extent might they belie an underlying philosophical project, seeking to model a theory of architectural design after the generative processes of nature?

Nature's fecundity, its capacity to produce extraordinary diversity, and our intuitive appreciation of the beauty, economy, and sublimity of biological systems have long inspired admiration and mimicry in the fields of architecture, design and engineering. The use of biomimetics, or the strategic application of adaptive biological design principles to manmade systems, is just one example. Subsequent to the publication of Darwin's theory, evolution has captured architects' imaginations as a way of thinking about design. But before it was theorized as a procedural method for architectural design, the notion of evolution was considered primarily as a conceptual analogy. In *The Evolution of Designs: Biological Analogy in Architecture and the Applied Arts*, Philip Steadman offers an explanation for why theories such as organicism, speciation, and

evolution have been used so often as metaphors in the history of architecture. According to Steadman:

> ... there are characteristics of designed objects such as buildings, and characteristics of the ways designs are produced ... which lend themselves peculiarly well to description and communication via biological metaphor. The ideas of 'wholeness', 'coherence', 'correlation' and 'integration', used to express the organized relationship between the parts of the biological organism, can be applied to describe similar qualities in the well designed artifact. The adaptation of the organism to its environment, its fitness, can be compared to the harmonious relation of a building to its surroundings [Steadman 1979: 4].

Steadman proceeds to classify historical uses of the biological analogy in architecture, identifying several variations on the theme, including preoccupations with growth, anatomy, and classificatory systems. However, as it relates to architecture, his discussion of Darwinism hinges on an understanding of an "evolutionary" development of styles or design trends across time. In other words, his view that the "phenotypic materials" of older styles were adopted and subsequently "mutated" by later architects considers evolution in architecture as a lineage of stylistic tendencies and gradual mutations, punctuated by occasional instances of sudden innovation.

For Steadman, then, architectural evolution is a metaphorical tool for historical analysis, a lens through which the historian can understand a genealogy of styles, which are seen as distinctly historical entities whose forms have progressed over time toward states of higher optimization (for a discussion of the problematic social implications of this view see [Cogdell 2004]). In their search for an architectural theory of evolutionary design, today's organic architects require a very different theoretical framework – one that has the capacity to be generative rather than simply analytical. Nonetheless, Steadman's attempt at a comprehensive analysis of biological metaphor in architecture marks a critical turning point in the development of evolutionary architectural thinking. The timing of this publication (1979) is significant, appearing at a time when operational applications of biological thinking in the form of genetic algorithms had been tested in other fields such as sociology and economics, but had only just begun to be applied to the realm of architecture.

Contemporary architecture's interests in evolutionary systems and biological adaptation have been directly inspired by Darwin's theory of evolution, as well as by the subsequent lineage of scientific achievements in genetics and morphogenesis. Many architects have become interested in adapting this method of form generation and selection as a way to tap into the productivity of the natural world. In 1995, John Frazer published the pioneering *An Evolutionary Architecture*, in which he describes over two decades of research at the Architectural Association, which investigated "...fundamental form-generating processes in architecture, paralleling a wider scientific search for a theory of morphogenesis in the natural word" [1995: 9]. He identifies several important motivations behind this endeavor:

> Architecture is considered a form of artificial life, subject, like the natural world, to principles of morphogenesis, genetic coding, replication and selection. The aim of an evolutionary architecture is to achieve in the built environment the symbiotic behavior and metabolic balance that are characteristic of the natural environment [1995: page].

To this end, Frazer – who worked under Cedric Price on the Generator project – has examined several technical aspects of the evolutionary design model and their architectural application. His research with students at the AA and the Cambridge University mathematics laboratory represented the first comprehensive attempt to develop both the conceptual and the computational framework required for the generative design of architectural forms, as well as their evolutionary response to environmental factors. He identifies the requirements of the evolutionary model as follows: "a genetic code-script, rules for the development of the code, mapping of the code to a virtual model, the nature of the environment for the development of the model and, most importantly, the criteria for selection" [1995: 65].

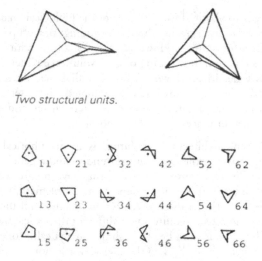

Two structural units.

Coded spatial orientations of units.

Fig. 1. Frazer's Reptile units [1995: 70]. Reprinted, by permission of John Frazer

By the late 1960s, Frazer had already experimented with the first of these elements. His "Reptile" structural system (rep-tile for repetitive tile) was an early attempt at creating a generative formal system capable of being manipulated in the computer as a "genetic code" (fig. 1). Reptile was a component-based approach that utilized a pair of simple structural units. These units could be combined in a number of ways to create a variety of complex forms, and these combinatorial instructions could be manipulated as code within the computer. Although Frazer was already aware of the limitations of a component-based system, and was looking for a more universal process-oriented approach, the required computational power for more complex systems was not yet available. Much later, in 1991, he developed the "Universal Interactor" as a means of influencing the development of his genetic experiments with external environmental factors. The Universal Interactor project consisted of a series of antennae that recorded various environmental data, which were then used to influence the development of the computer model. Later, software packages capable of modeling dynamical environmental forces, such as Maya, would become popular tools for the architectural exploration of environmental influences. These were not readily available to architects at the time of Frazer's research.

Frazer observed that many of the breakthroughs necessary for the development of an evolutionary model of design occurred outside the field of architecture. In addition to the dramatic achievements of genetics and evolutionary biology, innovations in mathematics and computational modeling provided the impetus for many of the early experimentations with evolutionary design techniques. For example, a significant milestone in the development of evolutionary design tools came with the publication of John Holland's *Adaptation in Natural and Artificial Systems*. Affiliated with the University of Michigan and the Santa Fe Institute, Holland is credited with the development of the earliest genetic algorithms in computer science. His work on this subject began in the 1960s, when he identified evolutionary adaptation as the common feature of biological, social, and economic systems. In each field he identified analogous inputs – structures, operators, and performance measures – all of which allowed for the systematic modeling of adaptation through the use of computational genetic algorithms.

Fig. 2. Example of Dawkins' biomorphs, developed over 29 generations in his EVOLUTION software [Dawkins 1996: fig. 4]. © Richard Dawkins 1996, 1987, 1986. Reproduced by permission of the publisher, W.W. Norton & Company, and by permission of SLL/Sterling Lord Literistic, Inc.

Following Holland's pioneering use of genetic algorithms in the analysis of complex systems, one of the earliest and most widely known applications of evolutionary design experimentation was Richard Dawkins' "biomorphs." In *The Blind Watchmaker*, Dawkins developed a simple genetic algorithm to "evolve" populations of simple two-dimensional graphic elements (this application is available online as a java applet: http://physics.syr.edu/courses/mirror/biomorph/). His early experiments breeding these "biomorphs" (fig. 2) in a digital environment represented a milestone in the development of artificial evolutionary strategies: he was among the first to illustrate clearly that in the

absence of a preconceived design, complex forms could be produced from very simple origins through the iterative process of replication, mutation, and selection. A few years later, Frazer himself was able to further his own architectural experiments by following Dawkins' example and by modifying John Holland's genetic algorithms to account for the influence of environmental data.

While it is clear that the development of the genetic algorithm, as well as other programming systems, have made available the necessary computational tools to explore variable populations of designs in the computer, it should be noted that this type of design strategy has also been implemented by hand. William Latham's experimental use of evolutionary techniques as a method of form generation in art is notable, as his work attempts to address the application of aesthetic judgment as the sole determinant of a design's "fitness." His work is directly inspired by natural systems and their tendency toward the development of complex designs from simple recursive operations. Beginning a few years after the publication of Dawkins' biomorphs, Latham conceived an evolutionary design methodology as a manual exercise that performed a series of recursive plastic deformations on a collection of simple forms. This process results in a complex drawing of a phylogenetic tree diagram, which Latham calls the "FormSynth tree" (fig. 3). This diagram chronicles the "evolution" of the original shapes into a variety of complex forms, of which only a few would be selected for fabrication as physical sculptures.

Fig. 3. Hand-drawn FormSynth tree [Todd and Latham 1992: 107]. Reprinted by permission of William Latham

Together with Stephen Todd, Latham developed a custom software tool to automate the processes of three-dimensional form generation and mutation. However, Latham did not automate the process for determining the fitness criteria for replication. Similar to

Dawkins, Latham asserts his role as an artist by subjectively selecting one or more iterations of mutation at each generation according to his own aesthetic judgment. Accordingly, his process could be thought of as a form of genetic breeding, where the artist "steers" the development of form by reacting to generation after generation of random mutation. While not yet architecture, Latham's work as an artist is informative in the way that it uses an evolutionary strategy in an opportunistic way as an effective proliferation of formal variation. The unique choices that Latham faced while steering this selection process are similar to those faced by an architect who might choose to employ this type of evolutionary design strategy. As Dawkins' analogy of the blind watchmaker suggests, evolution is a mechanism that proceeds without intentionality, in the absence of a designer. Accordingly, an evolutionary approach to design seems to require a fundamental reconsideration of the architect's role in the design process.

With this question in mind, Manuel Delanda establishes a theoretical groundwork for the application of genetic algorithms to the architectural design process. In a 2001 essay entitled "Deleuze and the Use of the Genetic Algorithm in Architecture", Delanda adopts a Deleuzian philosophy of form generation, advocating use of population thinking, intensive thinking, and topological thinking as ways to theorize a new role for the architect as the designer of evolutionary architectonic form. His proposal for a virtual process of evolution attempts a comprehensive analog to biological evolution by addressing issues of morphological heredity among variable populations of architectural structures, all of which would be selected for reproduction according to environmental fitness (structural viability in his example), among other subjective criteria. Assuming that the architect is able to overcome the technical challenges of visual representation and environmental responsiveness – most likely by bringing together a three-dimensional CAD package with an engineering platform for structural analysis – he then moves on to address the conceptual challenges posed by such an endeavor.

For Delanda, the main task of the architect becomes the design of a sufficiently productive search space. The primary advantage of genetic algorithms, which he identifies as a special case of search algorithms, is their propensity to "discover" unexpected problem solutions that had not been previously considered. Consequently, only a wide search space is likely to offer a truly innovative result. In his words:

> ... the space of possible designs that the algorithm searches needs to be sufficiently rich for the evolutionary results to be truly surprising. As an aid in design these techniques would be quite useless if the designer could easily foresee what forms will be bred. Only if virtual evolution can be used to explore a space rich enough so that all possibilities cannot be considered in advance by the designer, only if what results shocks or at least surprises, can genetic algorithms be considered useful visualization tools [Delanda 2002: 9].

The process of "breeding" buildings in virtual environments presents a radical reconfiguration of the architectural design process. Again, Delanda does not see this as the relegation of the architect to the level of "prize-dog" or "race-horse breeder"; rather, he imagines the architect as a designer of abstract architectural "body plans" from which tremendous diversity can evolve. Delanda draws on Deleuze's identification of topological invariants as the abstract morphological commonality among related forms that are distinct in metric space, encouraging architects to become the designers of

"abstract diagrams" – topological forms that would serve as the undifferentiated inputs to the automated search procedures of an evolutionary algorithm:

> ... if evolved architectural structures are to enjoy the same degree of combinatorial productivity as biological ones they must also begin with an adequate diagram, an 'abstract building' corresponding to the 'abstract vertebrate'. And it is at this point that design goes beyond mere breeding, with different artists designing different topological diagrams bearing their signature [Delanda 2002: 12].

Here Delanda's assertion of "artistic" autonomy differs from William Latham or Richard Dawkins, who guided the selection of forms at every generation of their evolutionary processes. For the true power of an evolutionary process to be harnessed, Delanda believes, seemingly useless formal developments must be allowed the chance to propagate through many generations, recognizing that these mutations may eventually develop into unexpectedly useful features. This is the most radical aspect of an evolutionary logic: truly advanced structures do not emerge within the span of only a few generations but develop gradually, over long durations. In a sense, then, the designer must resist the temptation to exert excessive control of the selection process, to allow for the possibility of the useful anomaly. Accordingly, Delanda de-emphasizes the designer's role in the evaluation of selection criteria. Rather, by proposing an exploration of diverse architectural "body plans," he emphasizes the importance of the initial "seed germ" and the subsequent rules for automated formal differentiation as the factors most influential to the outcome of the design process.

In 2001 a team of architects and computer scientists at MIT developed an experimental design tool called *Genr8*, which incorporates evolutionary computation, generative computation and environmental modeling into one unified software package. Though primitive, *Genr8* was seen as offering architects a valuable opportunity to work within the framework of an evolutionary design environment. Developed for the 3D modeling platform Maya by Martin Hemberg of the Architectural Association and Dr. Una-May O'Reilly of MIT's Emergent Design Group, the plug-in was intended to "instrumentalise the natural processes of evolution and growth, to model essential features of emergence and then to combine these within a computational framework" [Menges 2004: 49]. With *Genr8*, designers are limited to the use of surface geometries, but these surfaces can be "grown" in a virtual environment using a three-dimensional L-system as the formal "genetic" coding. Growth of these surfaces is influenced by any number of virtual forces that the user situates in three-dimensional space, providing for the simulation of gravity, wind, and other environmental influences. Inclusion of an evolutionary module allows for populations of these surfaces to be selected for replication across many generations according to the designer's intent. The opportunity for multiple, parallel selection criteria is the most interesting feature of *Genr8*. Unlike traditional genetic algorithms, which typically evaluate a single selection criterion, *Genr8* allows the designer to both automate the selection process, and to manually intervene according to an entirely subjective set of criteria. This suggests an interesting parallel between functional optimization and aesthetic preference.

As an experimental application of these opportunities, the architect Achim Menges co-opted this tool for the design of a strawberry bar at the Architectural Association's annual project review (figs. 4 and 5). For this project, Menges attempted to optimize both the design and fabrication of the bar using an evolutionary design strategy. In his

words: "The potentials and limits from initial form generation to the actual manufacturing process were explored by shifting the investigation towards performative patterns that evolve as species across populations and successive generations whilst maintaining structural capacity and geometric characteristics" [Menges 2004: 52]. Interestingly, Menges identified multiple populations of forms for selection rather than individuals, as seen in Latham's work. According to Menges,

> the criterion for evaluation was the relative fitness amongst the emergent species rather than the absolute fitness ranking of any particular individuals … The individual of the chosen species that grew in the last and most developed generation was then selected [Menges, O'Reilly and Hemberg 2004: 53].

In this way, Menges enabled the development of multiple species of designs to develop adequate complexity, and a subsequent richness of design variation was achieved.

Fig. 4 (left). Population of surface species produced in Genr8
Fig. 5 (right). Final design model, from [Menges, O'Reilly, and Hemberg 2004: 52-53].
Reproduced by permission of the publisher

Underlying Manuel Delanda's proposal for an evolutionary architecture is a pragmatic motivation, and his advocacy of genetic algorithms and generative systems is opportunistic. Similar motivations are also evident in the writings of John Frazer, William Latham, and Achim Menges. In their work, natural biological processes of design are emulated not from a mystical desire for communion with a divine force of creativity, but rather in recognition that human design methodologies have yet to produce either the sophistication or the diversity of the natural world. In this sense many architects today have turned to nature in the hope of producing increased efficiency, economy, variety, and innovation. Despite the pragmatism of this approach, there are indeed profound implications for the practice of architecture. If we accept Dawkins' assertion that nature "builds its watch blindly," so too must architecture open itself to the emergence of the unexpected [Dawkins 1986]. Similarly, Inge Rocker asserts that such a

transition away from "a priori ideas towards one of evolution ... requires us to ... examine the current emphasis that is placed on originality, authorship and identity in architectural culture" [Rocker 2002 10].

Although evolutionary systems represent just one set among a diverse array of tools made available with the widespread use of the computer in the design process, the potential of these systems is profoundly far reaching. The development of an evolutionary methodology demands an entirely new design intuition. Recently, as architects and designers have become more accustomed to the use of dynamic simulation tools and hierarchical parametric software, they are developing a sensibility for a formal design process which privileges plasticity and mutability over fixity and stasis. According to Rocker, architects have departed from "... the traditional, predominantly ontological comprehension of architecture" [2002: page] She suggests that architecture is now "... an evolving and dissolving differential data-design that no longer simply 'exists' but rather 'becomes' ..." [2002: 11]. Clearly, an understanding of formal variability is one important step toward an evolutionary design model, but a truly robust genetic system must also incorporate all of the elements previously mentioned by John Frazer, including generative formal strategies, evolutionary computation, and environmental modeling. Armed with these tools, architects will have the power to construct multiple, dynamic processes of formal generation across variable populations of species through time, guiding these forms through a perpetual state of becoming. Only then will the mechanisms of design in the natural world be activated as truly generative agents for a computational organicism in architecture.

References

CARROLL, Sean B. 2005. *Endless Forms Most Beautiful: The New Science of Evo Devo and the Making of the Animal Kingdom*. New York: W. W. Norton.

CHU, Karl. 2004. Metaphysics of Genetic Architecture and Computation. In *Perspecta 35: Building Codes*, Elijah Huje, ed. Cambridge: MIT Press.

COGDELL, Christina. 2004. *Eugenic Design: Streamlining America in the 1930's*. Philadelphia: University of Pennsylvania.

COLLINS, Peter. 1965. *Changing Ideals in Modern Architecture, 1750 – 1950*. London: McGill-Queen's.

LE CORBUSIER. 1925. *L'Art décoratif d'aujourdhui*. Paris.

DAWKINS, Richard. 1996. *The Blind Watchmaker* (1st ed. 1986). New York: W. W. Norton.

DELANDA, Manuel. 2002. Deleuze and the Use of the Genetic Algorithm in Architecture. In *Contemporary Techniques in Architecture*, Ali Rahim, ed. London: Academy-Wiley.

FRAZER, John. 1995. *An Evolutionary Architecture*. London: Architectural Association.

———. 2001. Creative Design and the Generative Evolutionary Paradigm. In *Creative Evolutionary Systems*, Peter J. Bentley, ed. London: Morgan Kaufmann.

HENSEL, Michael. 2006. (Synthetic) Life Architectures. In *Techniques and Technologies in Morphogenetic Design*, Michael Hensel, Achim Menges, and Michael Weinstock, eds. London: Academy-Wiley.

HOLLAND, John H. 1975. *Adaptation in Natural and Artificial Systems*. University of Michigan.

JACKSON, Helen. 2001. Toward a Symbiotic Coevolutionary Approach to Architecture. In *Creative Evolutionary Systems*, Peter J. Bentley, ed. London: Morgan Kaufmann.

LATHAM, William, and Stephen TODD. 1992. *Evolutionary Art and Computers*. London: Academy.

MENGES, Achim, Una-May O'REILLY, and Martin HEMBERG. 2004. Evolutionary Computation and Artificial Life in Architecture: Exploring the Potential of Generative and Genetic Algorithms as Operative Design Tools. In *Emergence: Morphogenetic Design Strategies*, Michael Hensel, ed. London: Academy-Wiley.

ROCKER, Ingeborg. 2002. Versioning: Evolving Architectures – Dissolving Identities: 'Nothing is as Persistent as Change'. In *Versioning: Evolutionary Techniques in Architecture*, SHoP, ed. London: Academy.

STEADMAN, Philip. 1979. *The Evolution of Designs: Biological Analogy in Architecture and the Applied Arts.* Cambridge University.

VAN ECK, Caroline. 1993. *Organicism in Nineteenth-century Architecture: An Enquiry into its Theoretical and Philosophical Background.* Amsterdam: Architectura & Natura.

VON BUELOW, Peter. 2001. Using Evolutionary Algorithms to Aid Designers of Architectural Structures. In *Creative Evolutionary Systems*, Peter J. Bentley, ed. London: Morgan Kaufmann.

About the author

Brian Holland is the 2009–2010 Howard LeFevre '29 Fellow at The Ohio State University's Knowlton School of Architecture. He has worked as an architectural designer for offices in Los Angeles, Denver, and New York, where he completed a variety of award-winning projects. He has been a visiting assistant professor of architecture at the American University of Beirut as well as a nominee for the Chernikhov Prize. He holds a Master of Architecture from the University of Pennsylvania and a Bachelor of Architecture from Cal Poly, Pomona.

Matt Demers

3937 NW 23rd Dr.
Gainesville, FL 32605 USA
javaman@ufl.edu

Keywords: equilibrium,
equilibria, mappings,
transformations, morphology,
topology, Rene Thom, spatial
operators, catastrophe theory,
urban design, Chandigarh

Research

Topology Catastrophe: Catastrophe Narrativization of Urban Morphologies

Abstract. This paper applies Rene Thom's catastrophe theory morphologies to the historical narrativization of urban environments. The confluence of narrative and topology could yield a qualitative yet stable spatial representation of the dynamic development of the human environment. Catastrophe Theory seeks such a qualitative and stable representation of discontinuous or chaotic behavior. Here the descriptions of catastrophe theory are applied to urban forms as a series of "narrative spatial operators" that affectively change the narrative space of urban histories or narratives of urban formation. Each operator is understood to be a combinatorial set of several of Rene Thom's elemental catastrophe morphologies, elemental relations found in communicative materials and used as building blocks of meaning. What is sought is the application of these elemental blocks to the city as an evolving environment. Such an application could possibly be developed into a method for explaining archetypal moments in the development of human settlements, an ontology and epistemology of development that is dynamic like the city itself, yet simple and easily accessed. This topological narrativization is briefly deployed to examine certain aspects in the development of the city of Chandigarh, India.

1 Introduction

At its simplest, catastrophe theory is used to model the behavioral potentials of systems with multiple variables within multidimensional spaces. This description casts a vast net over perceived or postulated systems; all that is needed to apply catastrophe theory to phenomena are the presence of multiple, interacting variables and the possibility of understanding their interactions as tending toward conditions of stasis. These postulated tendencies describe the existence of attractors within the systems analyzed. Following the mathematical shortcut created by Laplace in his early eighteenth-century study of celestial mechanics, if the forces at work upon an object within a system could be summed into a single quantity, the forces and object will tend to move toward a position where the summation of forces is minimized. This minimum position is known as the minimal potential. Because the object in the system exhibits a *tendency to move toward* this local minimum, it is said to be an *attractor.* Once within the domain or general area of the attractor, the behavior of the system will move toward a stable local point of minimal value [Woodcock and Davis 1978]. In addition to the local minima, the potential position of the attractor could also be a local maximum point within the system, but these positions tend to be rather infrequent and unstable.

Rene Thom (1923-2002), the creator of catastrophe theory, initially applied its systems to linguistics [Thom 1974]. Within the stable unfolding of catastrophe surfaces,

Nexus Network Journal 12 (2010) 497–505 NEXUS NETWORK JOURNAL – VOL.12, No. 3, 2010 **497**
DOI 10.1007/s00004-010-0039-z; *published online* 15 September 2010
© 2010 Kim Williams Books, Turin

he found fixed analogs of language's morphological structures. Morphemes and phonemes represent an analogical negotiation of space, forming a system of sound that indicates things out in the world, in physical space. The referential spatiality between the expressive material of language and the things it indicates becomes apparent when morphemes are built into expressions of the relationships between things in the world as simple verbs and conjugates. Catastrophe theory finds its efficacy in explaining complex phenomena with two and three dimensional space graphs. Thus, the relations between variables, the topologies of the systems and the catastrophes themselves can be graphically represented and understood visually, as lines and surfaces (fig. 1). With this graphic interface as his tool, Thom searched for stable occurrences in mathematical spaces that evoke the simple spatial relations so abundant in linguistic communication, relations that are at times quantitatively elusive. For workability, Thom limited the number of dimensions of the topological spaces utilized to five: adding dimensions beyond five would yield a plethora of stable catastrophes – far too many to be easily identified on sight, a condition necessary for usefulness. The original catastrophes are named to describe their figural, visual qualities: fold, cusp, swallowtail, butterfly, elliptic umbilic, hyperbolic umbilic, parabolic umbilic.

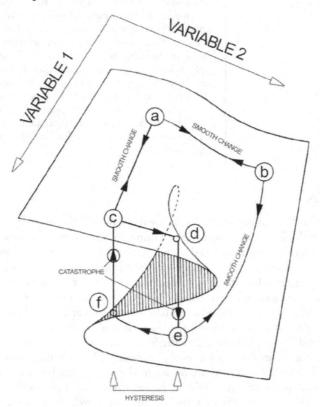

Fig. 1. Modeling continuous and discontinuous changes with a single, continuous "Cusp Catastrophe" surface. Drawing by Matt Demers

1.1 Morphologies and operators: language, narrative and space

While Thom sought to apply catastrophe theory to linguistics, the geneticist C. H. Waddington (1905–1975) became interested in using catastrophe topologies as a tool to understand *homeorhesis* in biological processes, where stable canalized pathways of change resist disturbing influences in embryonic development (see [Woodcock and Davis 1978]). Waddington identified that initially homogenous clusters of embryonic cells differentiate, forming increasingly complex systems of limbs, nerves, and variously programmed tissues. This led to the belief in a qualitative and consistent way of tracking the flow of this developmental process. The sudden, discontinuous emergence of heterogeneity from homogenous sets of elements in time can be regressively linked to the consistencies perceived through time and across multiple examples of developmental processes – a continuous metastructure that references the possible emergence of the discontinuous phenomena.

Combining this initial ambition with Thom's linguistic application of catastrophe theory, we arrive at our current project – producing a stable, qualitative description of the language of evolution, or cast in another manner, the *narrativization of history*. The historical development of cities provides us with an application that is directly spatial – the evolution of the human built environment, how it is understood and communicated. We are seeking a language for the narrativization of urban development, which must contain a rigorous analog for spatial relations as well as a means for describing temporality.

1.2 Thom's sixteen elemental morphologies

Rene Thom identified sixteen stable morphologies derivable from the elementary catastrophe systems [Wildgen 1982; Thom 1975] (fig. 2). Their elementary designation is due to their limited quantity; defining the morphologies in a manner that limits their number to sixteen aids in making the forms qualitatively identifiable because they are being easily remembered. The catastrophes and morphologies referenced by Thom's two-dimensional diagrams are also easily distinguishable and unchanging without limiting their applications. Thus, the seven different catastrophes and their sixteen morphologies can be utilized to describe a seemingly infinite variety of conditions, making complex yet qualitatively similar phenomena in different fields of study graspable.

These two-dimensional morphology diagrams were produced for their didactic quality – their forms and titles are easily understood even if the implications and derivations of each form are beyond the grasp of the viewer/user. Complex topological unfoldings in spaces with up to five dimensions here become simple relational diagrams describing common spatial operations. The spatiality of Thom's French names is referenced by the new names given to the morphologies by Wolfgang Wildgen in his rigorous reworking of catastrophe theory's applications to linguistics, *Catastrophe Theoretic Semantics: An Elaboration and Application of Rene Thom's Theory* [1982]. In this reworking, the morphologies are refined and become known as archetypes, their corresponding names are: *The Archetype of* (1) Stable Existence; (2,3) Birth/Death; (5) Capture; (6) Emission; (7) The Archetype of Metastable Change; (12) Transfer. Wildgen also develops several of his own elemental archetypal morphologies which, while sometimes rather elaborate, highlight the profoundly spatial nature of Thom's original set: The Archetype of: Frontiers; Local Change; Change in Possession; Beating (heartbeat); Transient Existence; Gradual Birth/Death (capture); Passage; Polarization; Neutralization; Reduction of a Trimodal Field; Generating/Abolishing Transferred

Objects; Indirect/Instrumental Action; Object/Instrument Prominence; Compromise; and the Messenger [Wildgen 1982]. These morphologies index the profound link between language and space, allowing for dynamic relations to be maintained in the linguistic, descriptive process. Thom's morphologies offer a progression from continuous, uninterrupted existence (to be), to physical-spatial operations (to tie, to cut off) – a sense of this progression is recovered in Wildgen's archetypes. The progression from a simple ontological condition of existence to increasingly complex relationships between phenomena proceeds via folds in the behavior surfaces mapped in the catastrophe graphs. As spatial dimensions increase beyond three (up to seven dimensions in [Wildgen 1982]) we identify folds of folds as well as folding surfaces contained within folded spaces, etc.

Fig. 2. Table of archetypal morphologies

The richness found in the catastrophe systems allows for analogy with the multifarious conditions of linguistic forms. A specification should be observed to maintain the utility of this analogy: spoken language, while being a sensory analog of spatial relations (the expression of spatial relations in the medium of sound), is itself an extremely dynamic system. Definitions, accents, habits and lexicons are only consistent in their flux, exhibiting conditions of change played out maximally in oral communication. Thom's catastrophe morphologies provide a ground within or against which the flux of

language occurs. Certain relationships of elements – to one another, to space and to time – can be combined and recombined to create any spatio-temporal situation described by language.

One way to understand the manner in which the morphologies work is through "scene-and-frames" semantics, where events in their prototypical shape are composed as diagrammatic analogical "scenes," as in the presentation forms of theater or film [Wildgen 1982]. Using a semantics of scenes and frames to describe a commercial event, the scene is seen to have a set of prototypical characters: buyer, seller, objects exchanged, money, etc. To communicate information about this event, we select parts of a scene to first construct minimal sentences by placing the characters and other scenic elements in simple relationships. Wildgen chose to utilize scenes-and-frames semantics for his application of catastrophe theory, to provide within this specific linguistic paradigm a classificatory schema of the typical spatial and temporal relationships among characters in the scenes [Wildgen 1982: 22-23].

The analysis of language is more easily conducted upon its written forms, which provide an index of oral communication found in a slightly more stable, fixed mode of expression (see [Havelock 1986]). If working with texts instead of oral communication, we need to specify the application of catastrophe morphologies to literate communication; this leaves implications for further study of orality (to be explored elsewhere). Our text will be the historical narrative of city formation and development.

For this analysis we will include at least one more text. The philosopher Michel Serres applied Thom's catastrophe morphologies to narrative processes in his text "Language and Space: From Oedipus to Zola" [Serres 1992]. In his text Serres identified a "set of operators" at work in every narrative:

> The Bridge: a path that connects two banks, making a discontinuity continuous.
> The Well: a hole in space, which can disconnect a trajectory that passes through and simultaneously connects piled spatial varieties and produces a new trajectory – the fall.
> The Hotel: organizes spatial extension into local domains of minimal differentiation.
> The Labyrinth: organizes global space into complex and intertwining relations.
> The Prison: defines a finite space within a global condition.
> Death: the cessation of existence.

Serres describes the operators as perfectly recognizable reproductions of constellated relations commonly found in myths, relations that comprise the series of important events described in the mythic narrative. These operators perform their work specifically on the spaces described in narratives, and one could make the case that the operations implied by each operator form an inclusive subset of modes of relation between Thom's more simple elementary morphologies. For example, the Well Operator could be seen as a bundling of archetypes 4 (changer), 10 (traverser), 15 (lier) and 16 (couper). The beginning and ending of the catastrophic event also adds to the archetypal set of each operator: 2 (finir), 3 (commencer), etc.

Much of Serres's insights in communications theory and narrativization depend on moving beyond the binary logic of membership in classical set theory, where an element

either belongs to a set or does not [Zadeh 1993]; Serres's analyses frequently include fuzzy sets and sack logic. In his influential exploration of communications theory, *The Parasite* [2007], the logic of fuzzy sets is utilized to describe a full spectrum of infinite values and conditions between exclusion and inclusion, thesis and antithesis, etc. In this way, a milieu is constructed out of what was previously a simple selection, a field of equally possible relations among elements, finite groupings formed along with the maintenance of infinite possibilities. Similarly, sack logic is presented as an alternative to what Serres describes as "case logic", a logic of rigid boxes that describe spaces of definite and unchanging size/volume. In case logic, a box or case that holds a large volume can fit a smaller case inside it, but the possibility of including the larger case within the smaller is impossible; if the cases are rigid, the larger will not fit within the smaller. However, utilizing sack logic, the volumes that can be contained by sacks are finite and as clearly describable as the volumes of the rigid cases, yet there is a greater range of inclusive possibilities and relationships between the spaces that can be held. A large sack may well contain a greater volume of material than a small sack, yet under certain conditions, the sacks being empty or nearly so, the largest of sacks could be tightly crumpled and fit within a sack that describes a much smaller volume of space. Both systems of logic, cases and sacks, are perfectly logical and consistent, yet the range of possible conditions and relations they describe are drastically different. The milieu of the fuzzy set and the scalar manipulations of sack-spaces are both useful for describing the spatial logic of language and narrative; a large variety of spatial conditions and phenomena can be described while maintaining the logical consistency of the system employed.

The logic employed by the set-structure of the operators includes the gradual assessment of element membership, exhibited by fuzzy sets and the inclusive scalar flexibilities of sack logic; the binary yes/no condition of classical sets is expanded to provide a multitude of possibilities for member relations. It is important to realize here that we are dealing with a set of operators that describe ways of working (on) spaces. The changes induced are not necessarily transformations, not merely the changing of conditions from *a* to *b*, but are more frequently temporary alterations of a milieu, representing the dynamic component of dynamic systems. This will become clearer when the operators are deployed to describe dynamic narrative spaces.

2 Deployment

2.1 Chandigarh, narrative scales and "sack-logic"

For this investigation, Chandigarh, India, offers an appropriate setting to deploy the catastrophe operators and explore how a city's historical narratives influence features of the physical environment, and how relationships formed by individual citizens and planners evolve over time with that environment as objects of knowledge. Several layers of historical narrativization are at work in the formation of Chandigarh as an object of knowledge in writing. Based on an iconic design by the European modernist master, Le Corbusier, Chandigarh was planned as the modern capital city of the State of Punjab following the Partition of India in 1947, when British India split into the separate nations of India and Pakistan. At the most general, then, Chandigarh represented a modern capital planned as a single, massive project and indicative of the new directions of a sovereign Indian nation. On another level, Chandigarh was planned after the Partition had caused Punjab's loss of its traditional cultural center, Lahore. Thus the newly invented urban fabric was imbued with the tenor of loss and displacement. Finer-

grained details – including administrative, design and construction documents – reveal deeper complexities that appear to subvert the more general narratives (see [Kalia 1987]).

Chandigarh is a poignant example because of the stature still granted to the *Edict of Chandigarh*, an iconic planning document from the city's inception that specified the urban environment in considerable detail. Commemorated by its inscription in a plaque, the Edict is an abbreviated version of the Establishment Statute of the Land of 1959, and today presents the defining spatial features of the city to the world on the official municipal website, http://chandigarh.nic.in/knowchd_edict.htm. But the narrative of development indicated by the static presence of the *Edict* as a development guide for the city's form is of course far too simple to capture the evolution of an entire urban environment over the past fifty years: there is a profusion of discrepancies between the planning document *as written* and the dynamic urban environment to which it gave rise. These deviations should not necessarily be cast in a negative light, however. In fact, they are telling characteristics of the spatial image-metaphors chosen to model the urban environment as an object of knowledge.

A topological analysis of Chandigarh's historical narratives offers a spatial structure for sifting rhetorical details about the design and formation of the city. If we apply sack logic to the narratives, complexities at the documented but quotidian scale of daily interactions – among individual members of the governmental or administrative bodies, alongside the multiplicity of designers engaged in any city-scale project – are not considered contradictory or be found to invalidate logically members of a more general set of elements. As a narrativization structure that encompasses local narrative details within increasingly larger and more general "meta" narratives, the design and development of Chandigarh becomes, at the global-historical level, an instance of propagation of the "International Style" of the Modern Movement, performed to a large extent by the agency granted to Le Corbusier, his ego and his talents. If the metaphorical space of the narrative is perceived as a rigid system of containers (using case logic), generalizations effected in the construction of increasingly larger scales to contain local details seem to negate the value or applicability of many local elements. The observation of element profusion at multiple scales contradicts the containment effected by generalization unless each scale and the *topos* it describes can be seen to be flexible, bendable and collapsible.

Imagine that the complexities of quotidian elements (such as the large cast of designers at work in the project of designing Chandigarh and the individual agency each would command) and the separate variables they may beg for in system-state representation become dimensions that can easily be collapsed, folded and thus contained within a deceptively simple (and seemingly larger) sack system. Initially, this image of a crumpled ball of forgotten and problematic material hidden within an all-but-empty and apparently clear/clean container might seem akin to the metaphorical image of the Grand Narratives of Modernism as a monolithic solid, pocked by tiny fissures and cracks that ultimately undermine its logic. Yet while the sack image allows for the co-existence of multiple scales and disparate and/or contradictory details, there is an important qualitative difference: metaphorically, the sack image eliminates the mental picture of smaller "fissures" undermining a larger narrative. The largest sack, the Grand Narrative of the Whole City, nurtured by an umbilical connection to a singular City Plan and the genealogical material of the founding father, is not altered in any radical or structural manner by the presence of a possibly infinite series of crumpled sacks contained within. The Grand Narrative becomes a *topos* that will hold a variety of contents. Utilizing a

spatial metaphor of sack logic thus modifies the understanding of relevance and value of the narrative materials represented in the rhetoric of history.

2.2 The *Edict* and the *Well*: deployment of "narrative operators"

The *Edict of Chandigarh* discursively represents the inauguration of an urban environment, and in the vocabulary of spatial operators enumerated above it has a dual spatial function in the topology of the city's narrative. To "inaugurate" is "to take the auguries" or omens of a place or event, to presage its dynamic development. Topologically, the *Well* works as a hole in space, cutting trajectories that cross it and simultaneously connecting diverse layers of space by forming new trajectories made locally possible by the working of the hole. Like the *Edict of Chandigarh*, any planning document that offers a general guide for the possible forms of the urban environment can be seen to operate on a discursive topology by forming a *Well*, augmenting existing local trajectories of development and supporting new trajectories through a process of gathering and funneling into determined local conditions.

The richness of relations possible with the vocabulary of spatial operators allows us to see that a local operation that affects the space of the urban system in representation forms a *new space* or *topos*. The workings of the *Well* Operator can be seen to form a *Bridge*, connecting separate domains by a continuous path that was not previously possible. The operators, like the layers of narrative representation in the previous section, can be usefully envisioned utilizing sack logic. Such discursive modeling augments our conception of the dynamic and often unpredictable relations between the seminal vision for a city, and the everyday details of the complex urban environment it precipitates. Perhaps it is obvious that the *Edict of Chandigarh* promoted certain directions for the city's development while precluding others. However, by means of a topological metaphor like sack logic, these generative parameters may be appreciated in a more nuanced light, stimulating rather than prohibiting a profusion of *new* idiosyncrasies and an infinite conception of scales within the confines of the domain of operation. In short, such operations stimulate the perpetual variegation of a city and its narrative. In turn, each spatial operator contains multiple archetypal morphologies which, when postulated and examined individually, add a finer grain of specificity and rigor to the topological representations. Recalling the "bundling of archetypes" mentioned previously, the *Well* formed by the *Edict* can be seen to combine 4 (*changer*), 10 (*traverser*), 15 (*lier*) and 16 (*couper*) and perhaps 5 (*capturer*), and each of these morphologies can be tied to specific aspects of the administrative object being examined.

Conclusion

The logic of founding events allows for a seemingly infinite variety of spaces of relation to emerge, a variety that does not undermine the descriptive power of the means of expression or its logical consistency. From a single narration of place can emerge a rigorous language of space that can then be used as a template for reading and understanding other places. If this language proves useful in describing spatial relations of seemingly disparate conditions (for example, comparing Chandigarh with New York City, the archaeological site of Teotihuacan in Mexico and fictional utopias like Samuel Butler's *Erewhon*), then it might reveal imminent similarities between urban objects, indicating qualifications of urbanity. It is in this flash of recognition, the emergent event so effectively spatialized by catastrophe theory's topologies, that we might find the morphology of the city.

References

HAVELOCK, Eric A. 1986. *The Muse Learns to Write: Reflections on Orality and Literacy from Antiquity to the Present.* New Haven: Yale University Press.

KALIA, Ravi. 1987. *Chandigarh: In Search of an Identity.* Carbondale: Southern Illinois University Press.

SERRES, Michel. 1992. Language and Space: From Oedipus to Zola. Pp. 39-53 in *Hermes: Literature, Science, Philosophy,* Josue V. Harari and David F. Bell, eds. and trans. Baltimore: The Johns Hopkins University Press.

———. 2007. *The Parasite.* Lawrence R. Schehr, trans. Minneapolis: University of Minnesota Press.

THOM, René. 1974. De l'icone au symbole: esquisse d'une théorie du symbolisme. Pp. 229-251 in *Modèles mathématiques de la morphogénese: Recueil de textes sur la théorie des catastrophes et ses applications.* Paris: Union Générale d'Editions.

———. 1975. *Structural Stability and Morphogenesis: An Outline of a General Theory of Models.* D. H. Fowler, trans. Reading, Mass.: W. A. Benjamin.

WILDGEN, Wolfgang. 1982. *Catastrophe Theoretic Semantics: An Elaboration and Application of Rene Thom's Theory.* Philadelphia: John Benjamins Publishing Company.

WOODCOCK, Alexander and Monte DAVIS. 1978. *Catastrophe Theory.* New York: E. P. Dutton.

ZADEH, Lotfi A. 1993. Fuzzy Sets. Pp. 27-64 in *Readings in Fuzzy Sets for Intelligent Systems,* Didier Dubois, Henri Prade and Ronald R. Yager, eds. San Mateo, CA: Morgan Kaufman Publishers.

About the author

Matt Demers is a Ph.D. candidate in architecture at the University of Florida. His research addresses the literary and physical legacies of the Modern Movements in architecture and urbanism, and aims to establish a more constructive relationship with our immediate intellectual past, as well as the present and difficult forms of our cities. He believes that re-establishing a connection with Le Corbusier's modern urbanisms in an affective manner has become a task to resuscitate human agency in the urban environment. He has worked on large-scale development projects in the U.S. and India. While working on a small project in Chandigarh, he became fascinated with the city's development alongside its critical and historical literatures. He has also engaged actor-network theory, catastrophe theory and heuretics as lines of research that can guide a creative epistemology of urbanity.

J. M. Rees

Jack Rees Interiors
1618 Summit
Kansas City, MO 64108-1140
USA
abcjmr@swbell.net

Keywords: cognition, spatial
awareness, memory palace,
Giordano Bruno, homunculus
fallacy

Research

Geometry and Rhetoric: Thinking about Thinking in Pictures

Abstract. Thinking about thinking is tricky business. Pitfalls include a tendency to confuse our metaphors with the act itself, difficulties attendant to discredited notions of introspection as a source of evidence and the twin unreasonablenesses of reductive scientists and mystical humanists. Engaging geometry and rhetoric in a common frame presents the opportunity, especially in the context of architecture, to consider discourse and image in ways that are mutually reinforcing.

Does not 'the eye altering alter all'?
William Butler Yeats

Introduction

On good days, thinking about thinking with images, I am stuck between a rock and a hard place. On bad days, I am completely paralyzed. The problem of representation in thought processes is important because of a conflict between what I believe and what I know. What I know is that I think using images and, by extension, that humans engage the world imagistically as a basic cognitive competence. My conviction is that images of everything – from landscapes, to faces, to geometrical diagrams – form the most basic stuff of mental states and processes; that thinking in pictures is different from thinking in words; and that images can condense broad discursive passages into dense points that can be arranged (and rearranged) in ways different than strings of words. On the other hand, I believe that there is no such thing as a mental picture. If, as Maurice Merleau-Ponty (1908-1961) observes, "consciousness cannot cease to be what it is in perception" [1945: 50] and it is accurate there are no representations in perception due to the "homunculus fallacy," then at the very least the role of representation in thinking is suspect, if not thoroughly discredited. Significantly, artists and other visually inflected makers have not taken much notice.

Architects, designers, painters, poets – iconophiles of all stripes – may be surprised to hear that there is a controversy in philosophy and psychology "over the nature of, and even the existence of, mental images" [Dennett 1978: 174]. This controversy, raging since the 1970's, has many philosophical precedents, ancient and modern,[4] but none so acute as that of Rene Descartes (1598-1650). Descartes, due in part to his discoveries spanning optics, meteorology and geometry collected in the *Discourse on Method* (1637), identified what has since come to be known as the homunculus fallacy, or "the fallacy of the little man in the head." As characterized by Alva Noe:

> It is incoherent to suppose that seeing an object depends on the resemblance between a picture in the eye and the object, for that presupposes that there is, as it were, someone inside the head who perceives the resemblance, this would lead to a regress, as there is no less difficulty explaining how the interior observer can see the interior picture.

Nexus Network Journal 12 (2010) 507–526 NEXUS NETWORK JOURNAL – VOL.12, No. 3, 2010 **507**
DOI 10.1007/s00004-010-0050-4; *published online* 16 September 2010
© 2010 Kim Williams Books, Turin

> The source of the fallacy of the little man in the head is the idea that the retinal picture functions as a picture, as something *perceived* [2004: 44].

Descartes's fundamental insight has been affirmed in many ways over the last 372 years and yet the introspective impression of mental manipulation of pictures in thought remains overwhelming – even as the controversy rages anew.[5] It is as if each new generation needs to learn again that there are no pictures in the brain.

Were I to characterize this dilemma with more nuance, I would say there is a disjunction between how I think I think and what I think I know. This essay aims to capture the interleaving of geometry and rhetoric in cognitive operations that fold perception into thought. Perhaps the place to begin is with a common misapprehension.

Mind and brain

An accepted initial distinction here is between what might be characterized as spiritual and material modes of interpretation at the seat of cognition, which I reject as a simple but pernicious distortion.[6] As Humberto Maturana and Francisco Varela observe, denying the homunculus fallacy engenders an "outlook which asserts that the only factors operating in the organization of living systems are physical factors, and that no non-material vital organizing force is necessary" [1980: 137]. This "biological" definition of mechanism, at the root of autopoiesis, is an originary principle of much current thinking about thinking, which I accept.[7]

What is necessary are ideas that respect hard-won introspective evidence while circumventing definitions that support vitalist or even idealistic debates. Here, Andy Clark's angle on "mind's-eye" and "brain's-eye" views, is promising. Why? Because Clark constructs a cognitive model on the basis of complementary mental processes. His distinction between mind and brain centers on tasks performed by deliberate mental effort and tasks that we perform quickly and fluently without conscious awareness. What is refreshing about Clark's argument is that he argues for the integration of mind and brain.

Just how does Clark manage this integration? The juice, of course, is in the argument but just the rhetoric is significant. There is a mind's-eye view of cognition – how we think we think – and there is a brain's-eye view – what we have learned about how we think, based on scientific evidence. Of course, it is not just about thinking. It is about perception and association and emotion. What is important is that we recognize the tangle of competing ideas: that what we think about how we think is not necessarily accurate; that just because thinking about thinking is often comically misguided, it does not follow that there is no place for what we conclude about how we think; that what we have come to accept as the way the brain works has very little to do with the introspective evidence of the mechanisms of thought; and, finally, that it is fitting that the mechanics of perceiving, thinking, feeling etc., are mostly unavailable to the organism performing these acts. In the beginning, just the recursiveness of these phrases explodes the dichotomy of mind/brain into a framework that recognizes the strengths and weaknesses of various forms of cognition and shifts the argument from objects – brains and minds – to networks of relations.

Mind's-eye view

The mind's-eye view is just what you think; it is the mind's own understanding of how it works. This comes in at least two flavors, the professionals' view of the matter and

a popular view. The professionals in this instance are philosophers, psychologists, and/or cognitive scientists – anybody whose job it is to figure out the how behind the why of mind. It seems that maybe a hundred years ago philosophers had a special purchase on these issues. That privileged position seemed to give way to psychology as standards of evidence took on an increasingly empirical flavor. Later still, as the purpose of the inquiry shifted from experimenting to modeling, those who in a different age might have been philosophers or psychologists came to call themselves cognitive scientists. All these professionals utilize different methods towards different ends but in broad strokes they share several common notions.

They share at this point in time what Clark calls as "classical cognitivism," which are characteristics that might be glossed as follows: 1) There is an individual and a world and though they may be related in any of a variety of ways they are distinct; 2) there is an algorithmic character to thinking – a language of thought – that is discoverable, verifiable and most importantly subject to modification from within the symbolic system.

Regarding the relationships of individuals and worlds, it makes no matter if one takes an idealist, a realist or even some scholastically nuanced position with regards to this association, it is always possible to draw a line between the world and the individual. The algorithmic character of thought breaks down into two sub-clauses: Thinking is a function and as a function it includes symbols yielding tangible structure that is often a literally physical pattern. Furthermore, the symbol structures are subject to instructions that are themselves expressible in symbols. Alan Newell and Herbert Simon assert, "the necessary and sufficient condition for a physical system to exhibit general intelligent action is that it be a physical *symbol* system" [Newell and Simon 1976, quoted in Clark 1989: 11, emphasis mine]. Elsewhere Simon goes so far as to identify information processing with physical dynamical theories expressed as sets of linked differential equations [Simon 1976].

The popular view of the matter is the impression that we direct the course of our own thoughts and that this intentionality is discoverable in words and deeds. The purpose of Clark's exposition of professional and popular views is to show that the popular view is not just a less competent version of the professional view but an approach to thinking about thinking that solves entirely different problems. What is important for the argument in this essay is that both approaches imply some executive function that directs thought and perception. The popular view of the matter posits, appropriately, a homuncular agent that has the "goal of making the behavior of others intelligible to us to just the degree necessary to plot their moves in relation to our needs and interests" [Clark 1989: 50]. The professional view, much more concerned with mechanisms of thought, has long suppressed the little man in the head but still needs an executive to direct the flow of thoughts, words and deeds. The homunculus-cum-ego preserves the executive without notions, discredited since Descartes, of representation and infinite regress, while at the same time allowing the machinations of minds their algorithmic character.[8]

Brain's-eye view

We might remember that the discussion in *Microcognition: Philosophy, Cognitive Science, and Parallel Distributed Processing* (1989) took place in the midst of a technological revolution: the application of previously undreamed of computing power being used to model brain functions. A concern with the modeling of cognition, dubbed artificial intelligence, had appeared at the heart of many disciplines – and for good reason (see [Miller 2003] and [Varela, Thompson and Rosch 1991]).

Early attempts to reproduce mental and perceptual processes using computers, drawing on philosophical models of symbolic processing in a classically cognitivist frame, tried to create general problem solving routines that reflected our "faith in the mind's own view of the mind" [Clark 1989: 4]. A specific example of this approach, drawn from robotics, concerns problems of navigation.

Initially, the design of navigation routines aimed at constructing representations of the spatial envelope – and the objects it contained – that a robot's central processor could draw on to move from one location to another. This approach is roughly consistent with the mechanism we think allows us to fetch a glass of water from the next room: grasp the glass, stand up by pushing back the chair so that it does not scrape the wall, move through the hall managing not to fall down the stair or trip on the carpet, negotiate the door frame, manipulate the faucet, fill the glass and then back, without spilling water or walking into walls. Conventional introspective evidence suggests that we manage such a feat because we have a mental map of spaces and obstacles that we negotiate in order to reach our goal. It turns out, however, that this does not work very well as a strategy for programming robots to move about.

Rodney Brooks, whose work at MIT in the 1980s helped explode the old paradigm, observes:

> [We] have built a series of autonomous mobile robots [and] we have reached an unexpected conclusion (C) and have a rather radical hypothesis (H).
>
> (C) When we examine very simple level intelligence we find that explicit representations and models of the world simply get in the way. It turns out to be better to use the world as its own model.
>
> (H) Representation is the wrong unit of abstraction in building the bulkiest parts of intelligent systems.[9]

These early robots did not so much navigate through a space as bump their way through an obstacle course on the basis of a series of local interactions and equally local course corrections. Stochastic as this navigational result appears to observers, it works as a strategy for moving from A to B. In the process Brooks claims to have discredited the notions of minds as general problem solvers and enfranchised brains as (albeit very complex) computational, nonrepresentational, problem solvers based on overwhelmingly local interactions.

The mechanism of such systems are often characterized as neural networks, and they offer progress modeling perceptual and sensorimotor tasks including real time sensory processing, the integration of input and output modes, the capability to deal with incomplete and/or inconsistent information, mechanisms of three dimensional ranging, to name a few of the kinds of problems on which researchers began to make progress. A general characterization of such competences is called pattern recognition (or pattern completion) and Herbert Dreyfus offers this description of how the simulated neural network mechanisms work:

> Fortunately, however, there are now models of what might be going on in the brain of an active perceiver ... that do not introduce brain representations. Such models are called simulated neural networks. Simulated neurons are generally called nodes. Networks consist of a layer

of input nodes, connected to a layer of output nodes by way of a number of intermediate nodes called hidden nodes. The simulated strengths of synaptic connection between neurons are called weights. The output of a neuron is called its activation. Running such a net means specifying the activations of the input neurons and then calculating the activation of the nodes connected to them using a formula involving the weights on these connections, and so on, until the activation of the output is calculated [Dreyfus 2005, 132-3].[10]

What these networks effectively explain, by modeling, is our ability to match patterns, learn and perform tasks requiring sensory information without explicitly formulated propositional rules. To understand why propositional encoding of a set of general rules does not work very well for modeling automatic (i.e. sensorimotor) tasks, take an example from the language of color. How do we know that emerald is a kind of green? According to propositional rules, for emerald to be a kind of green it is supposed to be some combination of yellow and blue. But, as Leonardo da Vinci (1452-1519) noted, there is no mixture of yellow and blue pigments which yields the particular visual characteristics ascribed to emerald. Therefore, in a propositional system one would need an exception to the rule that green is a species of color determined by the combination of yellow and blue. The result of this necessity, as observers become more attuned to the subtleties of color, is that there have to be more and more explicitly formulated exceptions in order to take into account effects that are, for one reason or another, ambiguous.

As another example, turquoise is either green or blue or neither of the two, depending on context. In a rules based system there would need to be several rules, each accounting for specific instances of the appearance of turquoise, i.e., as a kind of warm blue, a cool green, or perhaps neither, as its own particular color experience. Oddly, such a rules-based system could produce a program in which there are more rules than there are effects. On the other hand, neural network approaches (which Clark calls "connectionist") "buy you a profoundly holistic mode of data storage [and robust] hypotheses about the pattern of regularities in the domain." He calls this a superpositional storage of data and notes that as the system "learns about one thing, its knowledge of much else is automatically affected"; the system learns through pattern matching "gradually and widely" [Clark 1989: 111].

In other words, color in a connectionist model ceases to be a handful of primary colors arranged on a primitive geometric shape, the combination of which accounts for the gamut of color experience. There is no such thing as a primary color, or even a propositional systematization of the attributes of color perception such as hue, brightness and saturation (or their analogues from any system you prefer). Instead, colors in the visual field are superimposed with other visual effects to yield a range of optical experiences, inflected by color, through which we navigate our worlds. In such an environment, learning does not inscribe propositions, it matches patterns.

Mechanisms of robotic navigation, or what Clark calls three dimensional ranging and data retrieval through pattern completion, are among the exciting discoveries that neural networking or connectionist approaches yield.

In the connectionist approach ... the meaningful items are not symbols; they are complex patterns of activity among the numerous units that make up the network. ... In the connectionist approach ... meaning is not

located in particular symbols; it is a function of the global state of the system and is linked to the overall performance in some domain, such as recognition or learning

In other words, symbols are not taken at face value; they are seen as approximate macrolevel descriptions of operations whose governing principles reside at a subsymbolic-level [Varela, Thompson and Rosch 1991: 99-102].

What the word "subsymbolic" captures so well is that *how we think we think* is built on a neural substrate of which we have no experience and to which we have no access. What we are describing are the unconscious processes which ground symbolic cognitive operations but which, unlike the psycho-therapeutic unconscious, are operations to which we cannot have access (for implications and extensions, see [Varela, Thompson and Rosch 1991: 48ff]).

To summarize the brain's-eye view: thinking is continuous with perception, which is non-representational (neither propositional nor imagistic), built up from local interactions, which are aptly characterized as pattern matching and are, finally, overwhelmingly transparent to the organism.

Multiplex forms of explanation

In contrast to the neural networking approach, the mind's-eye view of thinking is a conscious and deliberate act, very much in the philosophical tradition characterized as "serial reasoning tasks of logical inference, temporal reasoning tasks of conscious planning" [Clark 1989: 127]. Euclidean geometry may be the most succinct example of the mind's-eye view of reasoning. There are collected in one place, the thirteen books of *The Elements*: five explicit assumptions (the common notions); twenty-three symbols (the definitions); five postulates (the rules) which together in various combinations are used to deduce 465 accurate conclusions (the propositions).[11]

Descriptions of such reasoning tasks are not well captured by connectionist, brain's-eye models. Rather than draw on Clark's examples of high-level symbolic characterizations (chess playing, the architecture of von Neuman machines, mathematical proofs, etc.), I will present examples related to the perception of space and the encoding of memories. The goal here is to maintain some symmetry with the examples discussed above. I draw these examples from literature on the role of perspective in the construction of space and from the "memory palace" tradition in rhetoric. These examples are not as "hard-core" as the classical conceptual-level representations favored in the literature of cognitive science, and they are tuned to the subject at hand, geometry and rhetoric. I select them because they provide excellent examples of processes in which there are both brain's-eye and mind's-eye descriptions of thinking about thinking, descriptions in which geometries play a central role.

The construction of depth through visual means, *perspective*, is an especially interesting case, partly because it is such a contentious domain in the history of art, philosophy and culture. For the discussion at hand, we can sidestep the bitter part of these disagreements by granting both biological and cultural components to the construction of space in representation. In fact, my argument hinges on the differentiation of symbolic and subsymbolic parts of the construction of space. As is so often the case in contentious domains, gradations of class membership complicate the argument. For instance, perspectival reproductions in painting, drawings and

photographs in which there is "a rigorous two-way, or reciprocal, metrical relationship between the shapes of objects as definitely located in space and their pictorial representations" [Ivins 1973: 9] may or may not be relevant to any one particular representation. At times, perspective is merely implicit, as in drawings where only the relative size of visual subjects is depicted, suggesting depth but not forcing a unified viewpoint. At others, perspective is purposely suspended to create representations for which there are multiple points of view as in synthetic cubism. Finally, and of course in many cases of visual art in the late twentieth century, it is not even warranted to speak of visual works as representations at all, since that implies a subject-object dichotomy, reinscribed in perspective, which is not at all germane.[12]

The point is, from a mind's-eye view and as mechanisms of symbolic processing, there are many different ways to characterize the point of view in images, some of which conflict to the point of being mutually exclusive. Perspective figures in some of these ways of thinking about representations but not in others, and the measure of just how conceptually bound by it we are can be taken by how radical one thinks Brooks thesis is in "Intelligence without representation."

For me, it changes everything. It is no longer appropriate to think of perceptual space as a continuous medium in which we are embedded. It is no longer possible to think of navigation as movement in reference to a mental map, however dynamically constructed. Corollary to these ideas for humans (but not necessarily relevant for robots) we can no longer build up our visions of the world from monocular or static points of view. These are all comments that are relevant to perspective as a symbolic system – a story many minds have made up to explain why we are susceptible to the illusion of depth in depthless representations.

Since Bishop Berkeley (1685-1753) we have known that depth is not given in the optic array. The easiest way to make this argument is to imagine a monocular, stationary viewpoint and grant a distinction between scenes and images. Under those conditions a point in the field of view may vary on x- and y-axes but its location on the z-axis (in depth) is "underdetermined."

> Scenes are three dimensional distributions of matter whereas images are only two dimensional distributions of gray tones. Thus images necessarily underdetermine scenes. For the remarkable Bishop Berkeley this was reason to draw the conclusion that it is impossible to see scenes. We deduce (representations of) scenes and we may be *wrong* in our deductions [Koenderink et al. 2000: 3].

Now allow the viewpoint to move. This turns the problem of deducing depth in scenes into a question of structure-from-motion. The details are technical and quite fascinating (see [Koenderink and van Dorn 1991]). The short version is that the visual system is adept at constructing depth, given a processing of only four points in three consecutive views.[13] In this scenario we construct depth from motion using mechanisms that are elemental and liable to connectionist modeling. Though the brain's-eye (subsymbolic) modes of visual perception are far from being worked out in detail such structure-from-motion modeling for depth perception suggests that what we call perspective is a symbolic (mind's-eye) manifestation of other, more elemental (brain's-eye) processes.[14]

Take another, more conjectural, example.[15] We have two eyes and yet the overwhelming impression is that we perceive scenes from a unified point of view, the so-called cyclopean eye.[16] Therefore, there must be some mechanism that combines views from two sensors into a single image. Furthermore this mechanism must be hardwired into visual perception in such a way that, though we are aware of the result of fusion, we are not aware of the mechanism. This mechanism would be accurately described as a geometrical transformation that represents a field with two foci as a field with one focus, fusing information from two eyes into a unified point of view.

The technical term for such a geometrical transformation is projection, in this case transforming ellipses into circles (transforming optical fields with two foci into perceptual fields with one focus). In other words, the cyclopean eye is the result of a fundamental perceptual competence that integrates binocular fields through projective transformations analogous to the way that projective geometry is the general case and perspective the special case.[17] Our susceptibility to the impression of depth in perspective representations with vanishing points (a mind's-eye view) becomes the unintended consequence of the process that fuses data from two sources (a brain's-eye view). In short, perspective is a symbolic level manifestation of a subsymbolic projective competence. Andy Clark's position – and this is the point of the exposition to date – is that we require both symbolic and subsymbolic paradigms to account for the richness of human cognition.

> Mixed models thus require multiplex forms of psychological or computational explanation. Not just different cognitive *tasks*, but different aspects of the same task now seem to need different kinds of algorithmic explanation. Since humans must frequently negotiate some truly rule-governed problem domains (e.g., chess, language, mathematics), some form of mixed model may well be the most effective explanation. ... A virtual symbol processor provides guidance and rigor; the [connectionist] substrate provides the fluidity and inspiration without which symbol processing is but an empty shell. In words that Kant never used: subsymbolic processing without symbolic guidance is blind; symbolic processing without subsymbolic support is empty [1980, 174-5].

I turn now to a mixed model that requires "multiplex forms of psychological *and* computational explanation" on the way to suggesting the lamination of geometry in mind and brain.

A mind's-eye view of geometry and rhetoric

A mind's-eye view of rhetoric (thinking about thinking as a conscious and deliberate act) is perfectly captured in the tradition of the arts of memory, a family of strategies for mnemonic storage and recall developed in ancient Greece, and codified in the second-century A.D. pseudo-Ciceronian treatise *Rhetorica ad Herennium*.[18] These practices, which included the technique of *imagines et loci* (images and locations, involved a kind of mapping where the text to be remembered is superimposed on (usually) architectural elements and committed to memory as an ordered whole. The sequence of textual images, often structured by the topography of a building, facilitates recollection. As recounted by Frances Yates [1966], elements of the art include rules for places (*loci*) and rules for images (*forma*), followed by a discussion of memory for things and memory for words. *Loci* are the placeholders, usually an architectural ornament or structure, which are committed to memory in a sequential fashion. *Loci* are as detailed as possible, for example, neither too large nor too small, neither too bright nor too dim, neither overly

ornamented nor too plain. *Forma* are images applied to *loci*. The *forma* must be as vivid as possible: active not vague, exceptional in some way (grotesque, comic, or beautiful), and revisited often.

There is a bifurcation in the rules for images, between memory for things (*res*) and memory for words (*verba*). Memory for words (*verba*) concerns the memorization and recitation of lengthy discursive and poetic works. In this situation, a practitioner of the memory art walks mentally through the *loci*, "reading" off the text to be performed. Rules for things (*res*) promotes a more associative, less literal, ordering of what is to be remembered, offering a method of ordering and accessing discrete yet related chunks of information.

The obvious and often-voiced criticism of this particular memory art is that a practitioner must commit to memory more than is actually being recalled (recall the propositional, symbolic, thinking about thinking discussed above). Not just one datum needs to be encoded but three (or more) data have to be committed for each word or thing to be recalled. This suggests something interesting about human information processing and, by extension, the wisdom built into mnemonics: there is no "grandmother cell" – no specific location in the brain where individual memories are stored. Where the literal application of the "memory palace" technique may be preoccupied with the careful selection and placement of *res* or *verba* to facilitate recollection, a more process-oriented interpretor will note that the practice also (and perhaps more importantly) supports dynamic recall by its linked trail of visual and rhetorical associations. This is plausibly the story a mind would tell itself about the way thinking transpires.

As with all thinking, good memory practice is cultivated and, as Umberto Eco observes, corruptions of memory are resisted with strategies that are constantly reengaged by new technologies that are remarkably constant across technological divides [Eco 2004]. According to tradition, upon hearing of the invention of writing the Pharaoh Thamus observed that the written word is not an aid for memory but a tool for forgetting. He recognized that writing allows us to forget by allowing us to ignore what is known. Quite literally, out of sight, out of mind. What the Pharoah failed to foresee is that we still need a memory for things written, if only to find where that which was forgotten has been stored. And so it goes – wax tablets give way to parchment, which in turn give way to printing from movable type, etc. In each circumstance humans require a strategy for remembering. More importantly, at each technological divide the art of memory is recreated with more elaborate techniques; by the Renaissance it had become permissable to express anything in terms of everything.

Again, this dance plays out at the technological divide between print and electronic media. The literal strategy of encoding *res* and *verba* on storage media is remarkably similar to the strategy of the memory palace: The data to be recalled are located at specific locations on a very long sequential medium (disk drive, CD, DVD, etc.). It is also consistent with the history of the memory tradition that the rules governing the encoding are ever more elaborate (i.e., abstract), requiring a file allocation table (an intermediate and gigantic *loci*) to reassemble *res* and *verba* into recognizable *forma*. Perhaps the most telling argument is the standardization of desktop computer architectures around serial processing (so-called von Neumann machines). There are many reasons for this, one of them being the historical prejudice for serial processing and sequential storage, as embedded in the literal version of the memory arts tradition.

To summarize the mind's-eye view, by analogy to memory: there exist symbolic representations – *res* and *verba*; structural relations – rules for *loci* and *forma*; and operations that arrange and rearrange symbols on mental structures – the memory arts. One interpretation, the literal one, supports sequential processing of symbolic content, similar to the way we think we think. Another interpretation suggests how, as in the case of perspective, a mind's-eye process is actually the result of a more elemental operation evolved to support an entirely different process, as in a model of mental operations that is subsymbolic.

Geometry and Rhetoric in the mind's eye

I confess to being utterly fascinated by Giordano Bruno's (1548-1600) geometry of thought as interpreted by Arielle Saiber in *Giordano Bruno and the Geometry of Language*. Saiber sensibly contextualizes such a move this way:

> A geometric reading of literature is not meant to replace other forms of textual analysis, as it does not claim to be a master key that unlocks all of a text's meaning and value. Its aim is to uncover important links between philosophical, aesthetic, or scientific notions of space and language's explicit and implicit demonstrations of these notions. The ways the geometry of space and form reveal itself in literature does, in fact, suggest much about how the imagination—individual and societal—orients and locates itself [2005: 26].

How the imagination orients itself is particularly suggestive in Bruno on two accounts; in Bruno's memory theatre and in the transmutation of geometric figures and rhetorical figuratives.

Bruno's mnemonics graduate from memory system to memory palace on the authority of Frances Yates, who concludes that in Bruno, the memory theatre was understood to be a method for printing "archetypal images on the memory, with the cosmic order itself as the 'place' system, a kind of inner way of knowing the universe" [1964: 191].

Yates' interpretation has been challenged, by Saiber on whether or not Bruno was a magus (Saiber holds not, see [2005: 92]), and by Rita Sturlese on whether letters recall images (Yates) or images recall syllables [Sturlese 1991 and Eco 2004]. While these details are significant they do not really alter the fact that Bruno was seeking "to establish within, in the psyche, the return to unity through the organization of significant images" [Yates 1966: 228]. In Bruno's words, by the act of imprintation "you may gain possession of a figurative art which will assist, not only memory, but all the powers of the soul" and "you will arrive from the confused plurality of things at the underlying unity" [Yates 1964: 199]. That this underlying unity is accomplished through figuration, has inspired a whole generation of hypermedia theorists.

Saiber elucidates Bruno's art in a manner that I see as complementary to Yates through a geometric analysis of Bruno's rhetoric. It is an inspired performance.

> Bruno saw geometry's figures as equivalent to language's figuratives, and he used both kinds of figurations to signify, refer to one another, and indicate an integrated vision of the universe and all that is in it. In his writing, geometric space/form and verbal space/form were used together to strengthen one another. As such, they worked together to fulfill a task of

extreme importance to the Brunian world view—demonstrating the interconnectedness of the celestial, terrestrial, and human worlds, and the importance of not breaking these divine bonds [2005: 17].

Saiber's exposition is organized as a progression of increasingly perfect geometric forms: lines, angles, curves.[19] These geometric figures are juxtaposed in analogy to rhetorical figures: brachylogia, systrophe and hyperbaton (lines); syneciosis, chiasmus, traductio (angles) and hyperbole, ellipsis, circumlocution (curves). I find these most satisfying analogies. Significantly, geometry and rhetoric are presented on par with each other. This is markedly different from the work of Leon Battista Alberti (1404-1474) who, for instance, insisted in his exposition of perspective, "I beg you to consider me not as a mathematician..." [Alberti 1976: 43]. Bruno would not have written such a thing for he believed above all in mathesis, "[a] symbolic ordering system that is not a mere mental abstraction, but a fusion of perception (thoughts) and the perceived (things in the world)" [Saiber 2005:52]. Furthermore, if Rensselaer Lee is correct in *Ut Pictura Poesis*, Alberti devised the categories of his theory of art by adapting rhetorical categories to painting.[20] I have always suspected that such an interpretation reflects a logocentric bias but this is not the place to argue this point. What is important for this argument, and for Bruno, is that "mathematics is more of an 'existential problem' than an 'abstract intellectual exercise'" (Hilary Gatti, in [Saiber 2005: 46]). Such an attitude allows Bruno latitude that is both breathtaking and confusing.

The idea that figures of geometry and figurations of rhetoric are reciprocal is confusing to minds whose habit is disciplinary. Rhetoric as geometry violates our contemporary sense of the order of things. Disciplines were not proprietary for Bruno as they are for us and Saiber's exposition brings this home:

> The trope of hyperbaton reverberates through the *Candelaio* as a device to illuminate the intimate workings of rectilinearity by inverting and diverting order. Rectilinearity is problematic when it is rigid and closed— when it is unidirectional. It is useful to the philosopher, on the other hand, when it allows for aperture and fluidity. As Bruno envisioned a universe in which space and thought are elastic, he created a language that exhibits such a trait. There is a plasticity to Bruno's writing, to his way of extending a discourse into a 'formless' format or, rather, into a linear format with multiple directionality implicit within it. Whether he is using brachylogia, systrophe, hyperbaton, or other devices to create a sense of exaggerated accumulation or diversion, his syntax and semantics both imply a sort of 'hyper-linearity.' The one-directional-sentence-on-the-page bursts into radiating vectors of potential and possible knowledge [2005: 86].

Bruno's "plasticity" is not just a matter of expression but a habit of mind, one we can better appreciate the more we cultivate the reciprocity of rhetoric and geometry.

That which is confusing is also, always, a source for that which may be breathtaking or revelatory. Geometry is conventionally thought of as the paradigm of deductive logic by reference to Euclid's *Elements*, wherein an edifice built of 465 true propositions has stood the test of time. That geometry is the model of reasoning—from a few general, self-evident propositions to the ensuing conclusions—is obviously important in the history of thinking about thinking. We must also, however, consider the flip side of the geometric coin. Working one's way through a proof where the result is not initially obvious, there is

often a moment before which nothing makes sense and after which the conclusion is perfectly obvious. This "eureka" moment is more or less intense depending on the magnitude of our initial confusion. What I would suggest is that in the eureka moment we find a twin to the "geometry as logic" model, which might be called "geometry of revelation." This eureka paradigm is an important model for thinking about thinking because it is the face of geometry that encodes methods and processes for dependably reproducing revelatory experiences.[21] Giordano Bruno exists squarely in a tradition where geometry and rhetoric are reciprocal, often revelatory means of expression. Saiber's exposition of the spatiality of his rhetoric and Yates's exposition of the language-like geometry of his memory theatre demonstrate this, but at the end of the day Bruno's geometry is a story minds tell themselves about the ways they work.

Multiplex forms of computational explanation: a gloss on geometry and meaning

Recently, Dominic Widdows has addressed how thinking in discursive frames may be expressed in geometric terms, how search engines work, and the ways that words may be said to be similar [2004]. As a software engineer for Google[TM], Widdows is well-positioned to explain the mechanics of search engines: *Geometry and Meaning* centers on the "union of geometry and logic in natural language processing" [2004: vvii], signaling something not unlike the union of geometry and analysis in analytic geometry. Meanwhile, "natural language processing" is what it says – the algorithmic expression of the ways humans intuitively use language. Like Saiber, Widdows is concerned with the spatiality of language, which is implicit in the main body of the text and wonderfully glossed in a series of asides that appear as "threads of supplementary material." At the heart of his presentation is an exposition of similarity,[22] which has a strong geometric flavor.

Like equality, similarity is a relationship between two (or more) things, although it expresses a looser, fuzzier, reckoning than direct equivalence. Geometrically speaking, similarities are qualitative relations consisting of translations, rotations and/or scaling operations. In natural language processing, similarity is a rather more sophisticated operation, if only because a relationship in one domain (language) is expressed as a quantifiable ratio in another domain (mathematics). What is merely implicit in Euclidean geometry (the idea of length) must be made explicit as the geometry of language is rendered progressively more analytical.

A rigorous definition of measurable distance must be established in order for a concept of linguistic similarity to even exist. Trading on the notion that "similar" words are in some sense "closer" than others, Widdows turns to Felix Hausdorff's (1868-1942) elucidation of the conditions necessary for metric spaces to give similarity an algorithmic basis. Given a collection of things (a set) and a collection of numbers (real numbers) one can map a set onto the reals in such a way that there is a measurable distance between all members, if the following conditions are met:

1. The distance between two members of a set (in geometric terms two points) is expressible as a non-negative real number.
2. Distance between two points is zero, if and only if the two points are equal (coincide).
3. The distance between point a and point b is the same as the distance between b and a.
4. For three objects included in the set, the distance from a to b plus the distance

from b to c has to be greater than or equal to the distance from a to c.

The first two conditions above are usually combined into the first "rule," known as the identity axiom for distance in a metric space. The third is the axiom of symmetry, and the fourth is referred to as the "triangle inequality." When all of these conditions are met, then and only then is it possible to measure length in some space.[23] What is most interesting are the techniques developed in natural language processing to preserve metric space while adapting it to the ways humans process relations among collections of things, words, and ideas.[24]

What we must come to terms with are the ways human information processing is *not* metrical. Regarding the identity axiom, it is quite common that humans confuse or misattribute identical things. The perception of color is a case in point. Everyone knows the degree to which colors are dependent on their environments and how easy it is to misidentify identical colors under different conditions, belying the applicability of the identity axiom. To take another simple example, consider the interaction of time and distance. We often perceive the outbound leg of a trip to differ in subjective duration from the homeward bound leg, even when the paths taken are identical. In this case our introspective evidence violates symmetry. To understand the way triangle inequality is relaxed in the space of human cognitive processing requires a short digression.

Widdows relates the triangle inequality axiom to transitivity. As Euclid wrote "things equal to the same thing are equal to one another" (first common notion). In the context of similarity, however, matters are somewhat different. For example, a door handle is related to a door and a door is taken to be part of a room, but we would not typically say a door handle is part of a room. In other words, door handle is proximal to door and door is proximal to room in ways that things-one-grabs are not necessarily related to envelopes or locations.[25]

Although these examples of violations of metric space in human mental processing are all too brief (and consequently subject to quibbling) the general point is obvious. Human information processing is not intrinsically metrical. What is of importance are the ways computational linguistics preserve metric spaces while adapting them to decidedly non-metric human information processing. Let us consider only one case; the manner in which distance is adapted to actual numeric measurement of similarity. Remember that similarity is a relationship between two or more things and that distance and similarity are converse (i.e., words close together are more similar and words further apart are less similar). Widdows expresses this as a ratio: the similarity between a and b is equal to one, divided by the distance from a to b. The potential problem with this expression is that it would be possible for the distance between a and b to be zero (if a and b are identical), which would be undefined in a mathematical sense.[26] It is better in this circumstance to tweak the similarity measure by adding one to distance between a and b in the denominator. Similarity is thus simply expressed as:

$$\text{sim}(a,b) = \frac{1}{1 - d(a,b)} \tag{4.8}$$

Which would ensure that sim(a,a) = 1 and that for any other object b, sim (a,b) < 1. If desirable, this may allow us to interpret sim (a,b) as the probability that a and b are interchangeable [Widdows 2005: 103].[27]

Note the functionality effected by this simple expediency in the denominator. Given the relationship between two members of a set (words, concepts), what is a plane space in geometric terms becomes rather more conceivable as ratio ranging between one and zero. There is no real mathematical difference because, as we know from Georg Cantor (1845-1918), there is exactly as much space between one and zero as there is in an unbounded plane. Jumping among mathematical domains to solve specific problems is a characteristic of Widdows' book *Geometry and Meaning* and, more generally, of some kinds of mathematical innovation.[28] Such techniques allow Widdows to migrate to whichever domain facilitates solution of the problem at hand, preserving the expediency of a field of words while implementing analytic solutions as probabilities.

After developing the concept of similarity through a series of more sophisticated geometrical images and numerical expressions, Widdows offers the most radical part of *Geometry and Meaning*. Using a toolbox of techniques (including the definition of metric space and several measures of similarity) and a group of processes for deducing and creating, relationships among collections of words, documents and concepts, he demonstrates how (quantum) logic can be used to extend the range of standard (Boolean) logic. Building on the notion of similarity and adding word vectors, normalization, clustering and vector negation he establishes the following:

> In Grassmann's algebra of conceptual structures in higher and higher dimensions, spaces of different dimensions are nested inside one another in a kind of lattice. This enables us to use lower-dimensional subspaces representing more specific concepts to be contained in higher-dimensional subspaces representing more general concepts. This brings some of the benefits of taxonomic classification, and it is a lot more flexible—whereas a node in a taxonomic tree has a unique path to the root, subspaces in vector spaces can trace their lineage via many different routes. For example, a line is contained in infinitely many different planes—thus, each of these planes could potentially be regarded as a 'parent concept' for the line. Grassmannian geometry naturally enables concepts to be cross-referenced [Widdows 2005: 236].

This cross referencing of concepts is easily distinguished through quantum logic where an ambiguous word (suit as in clothing, suit as in legal action) can be divided into constituent parts, any shading of which can be subtracted from a solution set to yield the most relevant match. What is radical is the concatenation of individual points into lines, planes and *spaces*, and their subtraction from even higher dimensional spaces. Expressed in linguistic terms, individual words are combined into very large fields (which in effect are isomorphic with concepts) that are cluttered with misspellings, related ideas, blended terms; in short, myriad ambiguities. It is a fundamental human competence to be able to quickly tease out of this soup a particular meaning relevant to the search (or conversation) at hand. Automating this competence with a nuance that even approaches

what we manage intuitively is very difficult. It turns out that vector negation, in the context of quantum logic, is a promising means of mathematical approximation for what we accomplish naïvely.

This brief gloss on Widdows' work is intended to suggest how a fundamental human competence with language, which at another time would have been considered rhetorical, is adapted to mathematics in general and to geometry in particular. The notion that a rhetorical competence in separating figure and ground in world fields is expressible in rigorously mathematical terms is not really provable in a theoretical frame without the mathematical apparatus that Widdows presents so admirably. What might constitute a demonstration is a working model that accurately deduces the objective of my query, effectively eliminating 98.9% of irrelevant matches while offering 99.8% of all relevant matches. The closest example of this, in contemporary terms, is a good search engine, and what is remarkable is not how relatively poorly they currently function, but that they work at all. I for one am wildly happy to have the web at my fingertips, and *Geometry and Meaning* offers, among other things, a very useful briefing on the current state of the art, its mathematical basis and potential evolution. Meanwhile, we are left with continuous (quantum) and discrete (Boolean) logics, illustrated in geometric terms, which help very dumb machines respond to very sloppy rhetorics.

In conclusion, I suggest there are geometries that function from a brain's-eye point of view in rhetoric that are analogous to geometries that function in the visual perception of space; i.e. adapting a qualitative geometric measure (in this case similarity) to a quantitative purpose, disambiguating words, concepts and languages. While it is remarkable that geometry and rhetoric are commensurable in both mind's-eye and brain's-eye frames, it is even more remarkable that we are so good at performing such translations and transliterations. Even though we may not be consciously aware of the mechanisms we apply in everyday tasks, all of us utilize geometry with remarkable sophistication.

Finally, I suggest that it is brain's-eye geometries that constitute thinking in pictures and that although the stories I may tell myself about the ways I think with images are more or less plausible fictions, the conviction that there is a non-propositional, non-textual, non-representational substratum to the ways we cope with the world, persists. Exactly what that looks like and precisely how it works are matters of ongoing research – in built works as well as in theory. Meanwhile, how I think we think is changing based on what I think we know in experience.

Notes

1. The most obvious confusion of this kind is the misplaced metaphor of the eye as a camera. Eyes do not work like cameras in any important way and the fact that they both share lenses has proved to be most misleading.
2. I am aware of the low repute with which introspection is regarded in psychological literature and, frankly I do not agree. What I take to be introspection is a blend of nuanced observation of our own processes in perception and experimental evidence from psychology, neurobiology and other cognitive sciences. This kind of awareness is a necessity component of the recursiveness fundamental to thinking about thinking. Francisco Varela, Evan Thompson and Eleanor Rosch capture it well:

 > In this paragraph, we see again how the fundamental circularity with which we began this book comes to the fore. To explain cognition, we turn to investigate our structure – understood in the present context as our computational mind. But since it is also cognition as experience that we wish to explain, we must turn

back and attend to the kinds of distinctions we draw in experience – the phenomenological mind. Having attended to experience in this way, we can then turn back to enrich and revise our computational theory, and so on. Our point is not at all that this circle is vicious. Rather, our point is that we cannot situate ourselves properly within this circle without a disciplined and open-ended approach from the side of experience [Varela, Thompson and Rosch 1991: 54].

3. We might agree to characterize the reductive scientist as one who insists mental capacities are not real until they can be computationally modeled and that only things that are susceptible to such modeling are to be taken seriously. We might agree to characterize humanists who only consider irrational motivations for human action or theorists blind to everything but talk of desire as "mystical humanists." The twin unreasonableness of "purely reductive scientists and mystical humanists" is itself a reductive obfuscation and yet, it remains a touchstone of my thinking that both extremes are equally non-productive.

4. In ancient philosophy Plato's allegory of the cave may be taken as the myth of origination. A modern incarnation is Arthur I. Miller's *Imagery in Scientific Thought* [1986], which is good evidence that the contemporary imagistic controversy owes a great deal to the epistemological reflections of modern physicists. Here is a sample from Albert Einstein (1879-1955):

 What, precisely, is "thinking"? When, at the reception of sense-impressions, memory-pictures emerge, this is not yet "thinking." And when such pictures form series, each member of which calls forth another, this too is not yet "thinking." When, however, a certain picture turns up in many such series, then—precisely through such return—it becomes an ordering element for such series, in that it connects series which in themselves are unconnected. Such an element becomes an instrument, a concept [Miller 1986: 43-4].

5. I take Barbara Maria Stafford's work to be a particularly good guide to the varieties of embodied seeing in the context of contemporary cognitive science and art making.

 What specifically interests me is how the brain-mind opportunistically seizes the structures it encounters, and how the surroundings, in turn, are repercussive, reflecting back the patterns the viewer seeks. ... nature and mind dynamically operate on one another. [They are] embedded in a mutual sentience [2007: 95].

6. Sadly, the dualism creeps back in at the "seat of cognition" phrase. In fact, I am not at all convinced that the mind/brain is the seat—but that is a different essay.

7. I do not believe this definition is reductive because of the feat of balance between consciousness and cognition managed in *The Embodied Mind* [Varela, Thompson and Rosch 1991].

8. For a developed version of this idea, see [Varela, Thompson and Rosch 1991], especially chapter 4.

9. [Brooks 1991, 3]; see also [Varela, Thompson and Rosch 1991: 208].

10. There is a good alternate description in Smolensky:

 In the von Neumann machine, memory storage is a primitive operation (you give a location and a contents, and it gets stored); memory retrieval is also a primitive operation. In subsymbolic systems these processes are quite involved: they're not primitive operations at all. When a memory is retrieved, it's a content-addressed memory: part of a previously instantiated activation pattern is put into one part of the network by another part of the network, and the connections fill out the rest of that previously present pattern. This is a much more involved process than a simple "memory fetch." Memories are stored in subsymbolic systems by adjusting connection strengths so that the retrieval process will actually work: this is no simple matter [1987: 5].

11. The edifice of Euclidean geometry is an impressive accomplishment and justifiably the standard against which all logical argument was compared, up until the nineteenth century when David Hilbert found some critical logical flaws in the assumptions, the symbols, and the rules. See [Reid 1970] for an expert exposition of this story.

12. What used to be called craft also falls into this domain (see [Paz 1974]). Further, these are but

two of the catalog of thirteen perspective effects given in the work of J. J. Gibson [1950], summarized by Edward T. Hall in his excellent book on social space [1966: 178-182].

13. This excerpt from "Affine structure from motion" gives a sense of a few of the necessary qualifications involved:

It is assumed that you: 1) can identify any given fiducial point in the different views and thus that a correspondence has been established. 2) have access to the full apparatus of spherical trigonometry: you may measure the angles between pairs of visual rays (apparent size) as well as the dihedral angles defined by triples of visual rays. 3) know a priori that the spatial configuration of the fiducial points is rigid. That is, you may assume that the mutual distances between arbitrary pairs of fiducial points in three-dimensional space are equal in the case of all N views. ... Then the problem is to find the spatial configuration of the M points (the shape) as well as the position of the vantage point relative to that configuration for the N views [Koenderink and van Dorn 1991: 377].

14. [Marr 1982] is relevant to this subject.

15. The conjecture alluded to depends on modifications and extensions of Kubovy's argument [1988]. If warranted they could be subjected to experimental falsification.

16. Evidence for such was discovered by Bela Julesz and reported in *Foundations of Cyclopean Perception* [1971].

17. Nicely captured in the familiar dictum: all perspectives are projective but not all projectivities are perspectival.

18. This quote from Eric Auerbach gives a nice sense of the central importance of this treatise:

The art of the hinting, insinuating, obscuring, circumlocution, calculated to ornament a statement or to make it more forceful or mordant, had achieved a versatility and perfection that strike us as strange, if not absurd. These turns of speech were called *figurae*. The Middle Ages and the Renaissance, as we know, still attached a good deal of importance to the science of figures of speech. For the theorists of style of the twelfth and thirteenth century the *Ad Herennium* was the main source of wisdom [1973: 27].

19. "A note about the progression of the chapters from 'lines' to 'angles' to 'curves' is due. The order is an allusion to the widely held Renaissance belief that the circle (or, in three-dimensions, the sphere) was the most perfect of forms, and that all other figures were inevitably deficient in comparison. A straight line was less perfect than a triangle, a triangle less perfect than a square, a square less perfect than a pentagon, a pentagon less perfect than a hexagon, and so on until a figure reached '-gon-less' perfection—in other words, it had become a circle" [Saiber 2005: 4].

20. The long quote from Lee is as follows:

Professor Panofsky has called to my attention the fact that Alberti's threefold division of painting represents an indirect adaptation, long before Dolce's direct adaption, of the rhetoricians' *inventio, dispositio,* and *elocutio*: *inventio* being partly included by Alberti under *compositione* (where he speaks of arrangement, decorum, etc.) and mentioned once, in its own name, at the end of his book in connection with his advice concerning literary knowledge; *dispositio,* the preliminary outline of the orator's discourse, being represented also by compositione ... [and] also by *circonscriptione,* the outline drawing through which the disposition of figures in a sketch would chiefly be made; and *elocutio*, the actual performance of the oration, by *receptione di lumi,* the rendering of the picture [1940: 71].

21. It is understandable why mathematicians and philosophers of science are shy of treating geometry as the technology of revelation – it undermines their professional status as hard nosed realists – and it is necessary, in my estimation, to acknowledge the ration of geometry that does not fit. Talk of the eureka moment has been current in the literature for decades, should it not be realized for what it is – a way of dependably reproducing revelatory experiences?

22. With apologies to Dominic Widdows for the unauthorized revision of his chapter heads: Chapter one is about the similarity of numbers and sets; chapter two the similarities among words; chapter three the similarities in taxonomies; chapter four, measuring similarity. Chapters five and six are about the similarities between vector spaces and word fields; chapter seven, discrete and continuous logics; chapter eight, ordered sets and concept lattices.

23. As it appears in Widdows [2004: 100]:

> **Definition 6** Let A be a set and let $d: A \times A \rightarrow \mathbb{R}$. The function d is a metric on A if and only if the following axioms hold.
>
> 1. $d(a,b) \geq 0$ for all a, $b \in A$, and $d(a,b) = 0$ if and only if $a = b$.
> 2. $d(a,b) = d(b,a)$ for all a, $b \in A$. (So d is symmetric.)
> 3. For all a, b, $c \in M$, $d(a,c) \leq d(a,b) + d(b,c)$.
>
> In this case d is called a metric on A and (A , d) is called a metric space.
>
> ... The three metric space axioms, and the term 'metric space' (*Metrischer Raum*) itself, were introduced by Felix Hausdorff (1914, Ch 6), ...

24. For a philosophical argument drawing on similar ideas in the context of *image schema* ("a recurring, dynamic pattern of our perceptual interactions and motor programs that gives coherence and structure to our experience"); see [Johnson 1987: 39ff].

25. For a more nuanced discussion, see [Widdows 2004: 114ff].

26. In a linguistic context, this would mean that there is such a thing as infinite similarity, which there may be, but it is difficult to handle mathematically.

27. It should be noted that there are many measures of similarity and that even the practical utility of similarity has been attacked; see [Gärdenfors 2000: 109ff]. Yet the notion that, for instance, yellow and orange are similar by some measure that yellow and black are not, intuitively captures something about the ways we use language that is worth preserving.

28. For Descartes's jumping between geometry and analysis, see Felix Klein (1849-1925) [1893]; for jumping among different kinds of geometries, see [Rees 2005].

References

ALBERTI, Leon Battista. 1976. *On Painting.* Cecil Grayson, trans. New Haven: Yale University Press, 1976..

AUERBACH, Erich. 1973. Figura. Pp. 11-71 in *Scenes from the Drama of European Literature: Six Essays*, Ralph Manheim, ed. and trans. Gloucester, MA: Peter Smith.

BERKELEY, George. 1972. *A New Theory of Vision and Other Writings.* London: Dent and New York: Dutton.

BROOKS, Rodney A. 1991. Intelligence without representation. *Artificial Intelligence* 47: 139-159.

CAPLAN, Harry, ed. 1954. *Rhetorica ad Herennium.* Cambridge, MA: Harvard University Press.

CLARK, Andy. 1989. *Microcognition: Philosophy, Cognitive Science, and Parallel Distributed Processing.* Cambridge, MA: MIT Press.

DENNETT, Daniel Clement. 1978. *Brainstorms: Philosophical Essays on Mind and Psychology.* Montgomery, VT: Bradford Books.

DREYFUS, Hubert L. 2005. Merleau-Ponty and recent cognitive science. Pp. 129-150 in *The Cambridge Companion to Merleau-Ponty*, T. Carman and M.B.N. Hansen, eds. Cambridge, UK: Cambridge University Press.

ECO, Umberto. 2004. Remembering Mnemonics. In *The Art of Memory, Catalogue 1322.* London: B. Quaritch.

EMPSON, William. 1930. *Seven Types of Ambiguity.* London UK: Chatto and Windus.

GÄRDENFORS, Peter. 2000. *Conceptual Spaces: The Geometry of Thought.* Cambridge, MA: MIT Press.

GARDNER, Howard. 1997. Thinking about thinking. *New York Review of Books* 44,15 (October 9, 1997): 24-25.

GATTI, Hilary. 1999. *Giordano Bruno and Renaissance Science.* Ithaca, NY: Cornell University Press.

GIBSON, James J. 1977. *The Perception of the Visual World.* Westport CT: Greenwood Press.

HARRIES, Karsten. 2001. *Infinity and Perspective*. Cambridge, MA: MIT Press.

HALL, Edward T. 1966. *The Hidden Dimension*. Garden City NY: Doubleday.

HEIDER, Eleanor Rosch, and Donald C. OLIVER. 1972. The structure of the color space in naming and memory for two languages. *Cognitive Psychology* 3: 337-354.

IVINS, William Mills, Jr. 1973. On the rationalization of sight. Pp. 7-13 in *On the Rationalization of Sight with an Examination of Three Renaissance Texts on Perspective*. New York: Da Capo Press.

JOHNSON, Mark. 1987. *The Body in the Mind: The Bodily Basis of Meaning, Imagination, and Reason*. Chicago: University of Chicago Press.

JULESZ, Bela. 1971. *Foundations of Cyclopean Perception*. Chicago: University of Chicago Press.

KLEIN, Felix. 1893. A comparative review of recent researches in geometry. *Bulletin of the New York Mathematical Society* 2 (July 1893): 215-249.

KOENDERINK, Jan J. 1986. Optic Flow. *Vision Research* 26, 1: 161-179.

———. 1990. The brain a geometry engine. *Psychological Research* 52, no. 2-3 (1990): 122-127.

KOENDERINK, Jan J., and Andrea J. VAN DOORN. 1991. Affine structure from motion. *Journal of the Optical Society of America A: Optics and Image Science* 8, 2: 377-385.

KOENDERINK, Jan J., and Andrea J. VAN DOORN, A. M. L. KAPPERS, and J. T. TODD. 2000. Directing the mental eye in pictorial perception. Vol. V, pp. 2-13 in *Human Vision and Electronic Imaging*, Bernice Ellen Rogowitz and Thrasyvoulos N. Pappas, eds. Bellingham, WA: SPIE.

KUBOVY, Michael. 1988. *The Psychology of Perspective and Renaissance Art*. 2nd ed. Cambridge UK: Cambridge University Press.

LAKOFF, George. 1987. *Women, Fire, and Dangerous Things: What Categories Reveal About the Mind*. Chicago: University of Chicago Press.

LEE, W. Rensselaer. 1940. *Ut Pictura Poesis: The Humanistic Theory of Painting*. New York: Norton.

LEYTON, Michael. 2006. *Shape as Memory: A Geometric Theory of Architecture*. Boston: Birkhäuser.

MARR, David. 1982. *Vision: A Computational Investigation into the Human Representation and Processing of Visual Information*. San Francisco: W. H. Freeman and Company.

MATURANA, Humberto R., and Francisco J. VARELA. 1980. *Autopoicsis and Cognition: The Realization of the Living*. Dordrecht, Holland ; Boston: D. Reidel Pub. Co.

MERLEAU-PONTY, Maurice. 1971. *Sense and Non-Sense*. Evanston IL: Northwestern University Press.

———. 1974. *Phenomenology of Perception*. London: Routledge & Kegan Paul.

MILLER, Arthur I. 1986. *Imagery in Scientific Thought: Creating the 20th-Century Physics*. Cambridge MA: MIT Press.

MILLER, George A. 2003. The cognitive revolution: a historical perspective. *Trends in Cognative Sciences* 7, 3: 141-144.

MOORE, Donlyn Lyndon and Charles Willard MOORE. 1994. *Chambers for a Memory Palace*. Cambridge MA: MIT Press.

NEWELL, Allen, and Herbert SIMON. 1976. Computer science as empirical inquiry: symbols and search. *Communications of the ACM* 19, 3: 113-126. (Rpt. in *Mind Design II*, ed. John Haugeland,. Cambridge, MA: MIT Press, 1997, pp. 81-110).

NOË, Alva. 2004. *Action in Perception*. Cambridge, MA: MIT Press.

PANOFSKY, Erwin. 1991. *Perspective as Symbolic Form*. New York: Zone Books.

PAZ, Octavio. 1974. *In Praise of Hands: Contemporary Crafts of the World*. Greenwich CT: New York Graphic Society.

REES, J. M. 2005. Teaching geometry to artists. *Nexus Network Journal* 7, 1: 86-98.

REID, Constance. 1970. *Hilbert*. New York: Springer-Verlag

SAIBER, Arielle. 2005. *Giordano Bruno and the Geometry of Language*. Burlington, VT: Ashgate.

SCHACTER, Daniel L. 2001. *The Seven Sins of Memory: How the Mind Forgets and Remembers*. Boston: Houghton Mifflin.

SIMON, Herbert. 1970. Appendix: Computer programs as theories. Pp. 272-273 in *Perspectives on the computer revolution*, Z. W. Pylyshyn, ed. Englewood Cliffs NJ: Prentice-Hall.

SMOLENSKY, Paul. 1987. Connectionist AI, and the brain. *Artificial Intelligence Review* 1: 95-109.

STAFFORD, Barbara Maria. 2007. *Echo Objects: The Cognitive Work of Images.* Chicago: University of Chicago Press.

TODD, James T. 1994. On the optic sphere theory and the nature of visual information. Pp. 471-478 in *Perceiving Events and Objects*, Gunnar Jansson, et al. eds. Hillsdale, NJ: L. Erlbaum Associates.

VARELA, Francisco J., Evan THOMPSON, and Eleanor ROSCH. 1991. *The Embodied Mind: Cognitive Science and Human Experience.* Cambridge, MA: MIT Press.

WIDDOWS, Dominic. 2004. *Geometry and Meaning.* Stanford, CA: Center for the Study of Language and Information Publications.

YATES, Frances. 1964. *Giordano Bruno and the Hermetic tradition.* Chicago: University of Chicago Press.

———. 1966. *The Art of Memory.* Chicago: University of Chicago Press.

———. 1969. *The Theatre of the World.* Chicago: Chicago University Press.

About the author

Heir to the oldest design firm in Kansas City in continuous operation, Jack Rees Interiors, the work of J. M. Rees is currently mostly architectural. He collaborates with clients and contractors to create and/or revise the architectural envelope, detail the interior and exterior surfaces, and design woodwork and casework in structures old and new. Rees holds a Master of Science degree in Architectural Studies from the University of Texas. As a reader, he is especially interested in history of geometry, the perceptual construction of space, and the phenomenon of color. As a writer he is interested in collaborations between the visual and verbal, as in the book *The Sixth Surface: Steven Holl Lights the Nelson-Atkins Museum.* He was Guest Editor for the *Nexus Network Journal* vol. 12 no. 2 (Summer 2010) dedicated to Eero Saarinen on the centennial of his birth.

Book Review

Cornelie Leopold

Geometrische Grundlagen der Architekturdarstellung

3rd ed.
Stuttgart: Kohlhammer, 2009

Reviewed by Bettina Marten

Steedener Hauptstr. 58
D-65594 Runkel-Steeden GERMANY
bettina.marten@t-online.de

Keywords : Cornelie Leopold,
geometry and architecture,
geometric constructions,
architectural design

Deinde graphidis sientiam habere, quo facilius exemplaribus pictis quam velit operis
speciem deformare valeat.
Vitruv, *De architectura libri decem*, Bk. I, ch. 1, 4

The visualisation in perspective of buildings and other three-dimensional objects in two-dimensional construction drawings, which can convey a realistic picture of a structure to build, is one of the most important tasks and therefore a special challenge for architects, engineers, designers etc., because of its significance in explaining their ideas and projects to their clients. Admittedly, nowadays these tasks are made easier by CAD software, but nevertheless the drawing made by hand is still part of the basis of competence of any architect etc. The purpose of the book reviewed is to instruct students – of architecture, building engineering, city and environmental planning and related fields – in this discipline and to deepen their knowledge, as the author explains in her preface:

> Die hier vorgestellten geometrischen Grundlagen haben einen universellen Anspruch der Anwendbarkeit und werden in diesem Buch exemplarisch an der Architektur aufgezeigt.(...) Die Kenntnisse der geometrischen Grundlagen sowie die räumliche Vorstellungsfähigkeit sind insbesondere bedeutend für computergestütztes Zeichnen und Visualisieren (p. 9).

In her introduction the author points out the significance of drawings in perspective and three-dimensional models as media of communication throughout the whole process of building, starting with the first sketches and ending with the realisation. But while the drawing is needed to show all the details, the model as a three-dimensional object is meant to make the planned object visible at smaller scales and is reduced to the most important parts. The task of geometry here is to provide the language of form that can be understood by all involved persons.

The functions of geometry, important for training the imagination and the intellectual capacity for understanding of space, are defined by the author as follows: 1) as understanding and description of geometric forms, which can be integrated into some system of order created by man: "Geometrie ist ein vom Menschen geschaffenes

Ordnungssystem, um Formen begreifbar und erfassbar zu machen" (p. 12); thus geometry takes over the position of a sensory factor of order; 2) to create methods for the illustration of spatial objects on the level of drawing, for example in perspective drawings such as central and parallel projections, etc.; 3) the reconstruction of geometric properties taken from the picture of the object by methods, which enable the unambiguous conversion from the drawing; 4) as execution of geometric construction of space on the level of drawing; and 5) as method to train spatial imagination and thinking.

In the first part of the textbook the author points out the importance of the drawing as a medium of communication between architects and engineers etc. on one side and their clients on the other side. Especially during the planning process, geometric sketches and drawings enable all those involved to follow all changes and developments, alternatives and details in the designs and drafts. During the process of planning the act of seeing is of crucial importance. The explanations that follow provide a historic retrospective of the developement of the medium of drawing from its beginnings. The focus is on the importance of drawings as basis of the planning process, but it is at the same time a historical view onto the development and history of geometry and its methods themselves. The Egyptians were the first to use geometric methods to measure their fields every year after the flood of the Nile or the geometry of space to calculate cylindrical container. From the sixth century B.C. onwards, the Greeks started the scientific survey of geometry – the phrase *geometry* means literally "measurement of the earth". The author also points out the developement of visual perception of space during the various periods of childhood, explains the physical process of seeing in the eye and the origin and meaning of the imagination of space. The first part also involves short explanations of the development of the graphic sign system, which serves as vocabulary for understanding geometrical drawings, and the representation of dots, lines and sides.

Part 2 is divided into several chapters according to the various methods of illustration, starting with the different kinds of projections, like the classical central perspective, and ending with the navigation of a three-dimensional computer model. All the subjects discussed are explained in depth. The clear chapters, which follow each other in relation to their content, make it possible to look quickly and purposefully at each single method, so the reader is quickly informed about geometric constructions such as axonometry, construction of ellipses and polyhedrons, curved surfaces and solid bodies, constructions of silhouettes, encoded projections, and the transferral of these methods into CAD-software programms. The author also points out explicitly that the use of CAD processes cannot possibly be managed without the knowledge of the classic methods of drawing and illustration – an appeal to the beginning students to study this discipline intensively.

The explanations are supported visually by many detailed and clear drawings made by Andreas Matievits. Other illustrations, such as fotographs of contemporary built architecture (by Zamp Kelb, Mario Botta, Renzo Piano, Frank O. Gehry, etc.), incunabulums of architecture (New York, Guggenheim Museum by Frank Lloyd Wright; Marseille, Unité d'Habitation by Le Corbusier; Wichita, Wichita-House and Montreal, USA-Pavillon both by Richard Buckminster Fuller; Sidney, Opera by Jørn Utzorn, etc.) and architectural drawings (Philibert de l'Orme, Daniel Libeskind, Gerrit Rietfeld, Tadao Ando, etc.) show the wide range of use and provide a vivid presentation of the complex matter. Geometric theorems are marked by exclamation marks and therefore easy to find in case of urgent need.

In the appendix basic geometric constructions are explained and visualised in drawings. The book concludes with a glossary of the conventional sign system, bibliography and index. To sum up: Following the first part with an introduction on the complex social-cultural context of geometry, in circa 250 pages even complicated geometric constructions are explained clearly to students of architecture, engineering and design etc. and help to train spatial sight. Easy to handle – absolutely recommendable as textbook!

About the reviewer

Bettina Marten is an art historian with a special interest on the mutual relationships between art, architecture and mathematics. She was the organizer of the symposium "Fortificacion in focus – Mathematical Methods in Military Architecture of the 16th and 17th Centuries and Their Sublimation in Civil Architecture", which took place in Dresden 2008. She teaches at the universities of Dresden and Frankfurt am Main.

Book Review

Volker Hoffmann

Der geometrische Entwurf der Hagia Sophia in Istanbul. Bilder einer Ausstellung

Bern: Peter Lang, 2005

Reviewed by Rudolf H. W. Stichel

Technische Universität Darmstadt
GERMANY
stichel@klarch.tu-darmstadt.de

Keywords: Volker Hoffmann, Hagia Sophia, Byzantine architecture, geometric constructions, squaring the circle

The publication reviewed here is only a slim volume and yet one experiences high expectations when picking it up. After all, it deals with an extraordinary architectural monument, and attempts to explain its technical and theoretic origins and background, which have often enough appeared to be veiled in mystery.

The Hagia Sophia in Istanbul is undisputedly one of the few outstanding masterworks of world architecture. Built in the sixth century A.D. by the Roman emperor Justinian, it still counts as one of the boldest human constructions to date. Although it has suffered repeated and sometimes serious damage, and its use has been modified frequently, it has still survived to this date with all its essential elements intact. Its broad, high-ceilinged interior space, which is roofed by seemingly weightless domes and vaults, never fails to make a striking impression on every visitor. However, it isn't easy to make the relation between the structural and design principles of this unique architectural system accessible, even to an expert. This effect was observed soon after completion of the church, and might even have been intended by the architects and their patron.

Volker Hoffmann has worked towards understanding the building principles and design processes of the Hagia Sophia throughout his long scientific career. An acknowledged scientist, Hoffmann taught history of art at the University of Bern up to 2005. With this publication he tries to illustrate how the architects of the sixth century geometrically developed the ground plan as well as the elevation of Hagia Sophia out of a single design figure. Hoffmann's theses, hailed as breaking discoveries (see, for example, [Staudacher 2004]), have been published elsewhere in parts [Hoffmann and Theocharis 2002] but, sadly, remain difficult for even specialists to comprehend. This publication, an exhibition catalogue and companion book in one, presents Hoffmann's positions to a broader public in a simpler, more understandable form and also augments them with general observations. This alone deserves our unreserved gratitude.

The book is a collection, in reduced format, of all the plates of an exhibition that first took place in 2005 in the Hagia Sophia in Istanbul and later in Berlin in the Kunstbibliothek der Staatlichen Museen. The forty-two plates, which are always positioned on the right hand pages, offer multiple pictures as well as short texts in German and Turkish. On the left side, translations of these texts in the English and

French language have been added. The fact that these pictures are only included on the first pages and not repeated on the second, resulting in large blank above the English and French translations, is confusing only at first glance.

The introductory section of the publication (pl. 01-03) includes a report on how the exhibition was created, a list of all participating institutions and a short historical summary of the structure in question. Four thematic blocks follow to illustrate different aspects of the Hagia Sophia. The first block (pl. 04-15) collects some illustrations of the building under the title "Illustrations – Images". It includes a wide range of images, from the oldest, schematic illustrations of the tenth century to modern photographs and architectural surveys. The texts include the attempt to characterise the various ways of representing the structure, which Hoffmann had already presented elsewhere in greater detail [Hoffmann 1999]. Thus the emphasis in these texts is placed on older architectural survey material (pl. 08-13). On the other hand, the second part, entitled "Design – Groundwork" (pl. 16-33), is an extensive presentation of Hoffmann's theses on the geometric design of the Hagia Sophia. This constitutes the actual core of the publication. The third part focuses on "Construction and Deformation" (pl. 34-37) and illustrates some of the most important structural problems of the building. It also includes the various structural damage observed, as well as the corresponding repairs and modifications that have left visible marks on the building. The fourth and final part, entitled "Mathematics and Cosmology" (pl. 38-42), touches superficially on various aspects of intellectual history that supposedly support Hoffmann's theses.

The presentation seems befitting and entirely sufficient for the intended purpose of this exhibition. To a large extent, the text and illustrations appear well arranged and informative. To be sure, occasional mistakes show that not all aspects have been attended to with the necessary thoroughness. On pl. 08 for instance, the measurements from the drawings of Guillaume Joseph Grelot's 1670 survey are analysed, but the measurements used and discussed are not the ones found in the original 1680 edition cited but rather those found on the smaller illustration of the 1681 reprint, whose proportions have been extensively changed (cf. [Stichel 2008: 34-36, fig. 16. 21]. On pl. 35 "all the parts that were modified or added after 558" are presented in a clear and well-arranged manner. Yet this section contradicts the insights that Rowland Mainstone has offered the scientific world through his meticulous survey and its expert analysis ([Mainstone 1988]; cf. now [Duppel 2010]). On the same plate the suggestion by Henri Prost for the existence of three rows of windows, containing nineteen openings, on the walls between the main arches and the gallery of the Hagia Sophia is accepted. This blatantly contradicts the information handed to us by Paulus Silentiarius who, describing the building during Justinian's reign, clearly attests to eight windows without giving any information about the arrangement.

Nevertheless, the central thesis that was the reason for this exhibition is much more important than such smaller, diffuse details. Like others in the past, Hoffmann's design analysis also convincingly stems from the figure of a square (pl. 16-19) that lies almost completely hidden in the centre of the building between the main pillars, but has been laid out with great care and accuracy. This geometrical figure of a square is supplemented by "a circle inscribed in it and a circle circumscribed around it" (pl. 16), something Hoffmann calls an "analemma". Using the ratio of 100:106 the square is repeated slightly enlarged and the geometric system becomes a "double square with double circles" (pl. 16). This is Hoffmann's main design figure. Hoffmann then scales this "double-analemma" up and down by the factor $\sqrt{2}$ to describe the design processes (pl. 18). Based

on this construction and, with the help of selected circles, he defines the building lines (in this publication referred to as "vanishing lines") for the exterior walls (pl. 18-19). Up to this point Hoffmann's thesis is clear and comprehensible.

Yet, according to Hoffmann, "the double-analemma is not sufficient to define all the construction relevant points and vanishing lines in the design" (pl. 20). Therefore Hoffmann develops the geometric figure further, which he, in a contrived and outmoded fashion, calls a *Mutterriss*, "master plan" (pl. 20). It is unclear how the rectangle that marks the building lines of the church (E1-E4) is developed from this master plan. Furthermore, this rectangle fails to define the building lines accurately. The deviation is visible even in the strongly scaled down ground plan. Indeed, this figure is absolutely insufficient to allow the development of the Hagia Sophia ground plan. Hoffmann therefore connects further points of the "master plan" without any recognisable system, and elongates the resulting lines to bearing lines. Their points of intersection have no significance for the ground plan, yet they partly lie on lines that approximately define the structure. Such a practice contradicts every architectural tradition and is not supported by historical sources. In addition, it is obvious that only very inaccurate results may be achieved by such a practice. At any rate it would have been very difficult for the architects of the Hagia Sophia to define the intersection points of these bearing lines clearly, especially since they meet at an acute angle, and even more so in a building of this size.

Hoffmann uses the "double-analemma" at various scales to also explain the elevation of the Hagia Sophia. At first glance the circular arcs match elements of the structure quite well. However, what the planar projection doesn't reveal is that these circles are positioned on different levels, the only reason why this geometrical system manages to appear so intriguingly simple.

All necessary criticism aside, Hoffmann did succeed in noticing one essential property of this structure that lies hidden in the central double square. With little difficulty it becomes apparent that the two squares of the so-called analemma are intimately connected and defined by certain clear proportions (pl. 38). The length of the side of the larger square equals 3/4 of the diagonal of the smaller square, while the length of the side of the smaller square equals 2/3 of the diagonal of the larger square. Hoffmann's postulate that the architects of the Hagia Sophia knew about "circling the square", i.e., the reversal of squaring the circle, should be read in a similar context. To this end, Moritz Cantor is cited but apparently only superficially so. Otherwise it should have become clear to Hoffmann that, in the field of applied mathematics of antiquity, irrational values were usually approximated by integer values whenever possible. As has recently been demonstrated, such approximations may be used successfully to explain the design of the Hagia Sophia in concordance to contemporary mathematics and philosophy [Svenshon and Stichel 2006; Svenshon 2010].

By choosing the ancient Greek "analemma" to describe his geometric figure, Hoffmann suggests that his method is based on ancient practice. This is highly misleading, since the actual analemma, especially as described by Vitruvius and Ptolemaeus, is a geometric figure with a significantly different form, as can easily be observed [Hübner 1996]. The weaknesses of the last part of the book seem to be of a similar nature. There Hoffmann tries suggestively to frame the design system against a larger humanities-related background. Aside from inaccuracies (pl. 40: an octagram is not a cube), statements that are simply false appear in this section. Hoffman claims that:

in Greek and Roman culture, as well in the 6th century in general, we find two notions of the Cosmos, which either compete with or supplement each other: cube and sphere. … Sphere and cube, combined to one world model, symbolizing both world shape and world order, form the central design model of the Hagia Sophia" (pl. 40).

Of course it is correct that the ancients understood Earth and the Universe as spheres and that competing models for the cosmos existed. Yet the cube has never played a role as a cosmic symbol. Might it be that in this instance Hoffmann's terminology is confounded? At any rate, some theories of the time describe the physical form of the earth as "tetragonos". Yet this never suggests an actual square but rather an oblong form. It is also a completely different matter when Plato uses the cube as a symbol but not as an actual physical image of the element of Earth, while he appoints other regular geometric bodies to the elements of Fire, Water and Air. Hoffmann mentions the writings of Kosmas Indikopleustes, but does so selectively; Kosmas Indikopleustes aggressively accuses the spherical model of the Cosmos of being a pagan theory and decides therefore that it is a false model. On the other hand John Philiponos, one of the most essential scientists of the sixth century A.D., adopts exactly what Indikopleustes declines and confirms it through biblical arguments, something that Hoffmann seems to ignore.

In conclusion, one has no choice but to feel disappointed by the highly acclaimed results of Hoffmann's research. "The secret of the design principle used in the Hagia Sophia" has by no means been "uncovered" as previous enthusiastic commentators have claimed [Staudacher 2004]. Factual errors and insufficient research characterise essentially every thematic section with an intensity that undermines the scientific value of this publication in its entirety (as previously noted by Felix [2006]).

In the overall assessment it should not be overlooked that Hoffmann has achieved an exact survey of the Hagia Sophia using a Leica Scanner Cyrax 2000. Thankfully, the modern method attests to the "extraordinary exactness" of Robert Van Nice's survey, carried out using traditional methods and published some decades ago [Van Nice 1965–1986]. The irregularity of the ground plan in the area of the north-east conch that Hoffmann believed to have found in an older contribution [Hoffmann and Theocharis 2002: 419, fig. 23] proves therefore to be groundless. It is understandable that only small parts of this important survey, which offers the opportunity to describe every point in this structure with exact coordinates, may be included in this publication (pl. 14-15). It would of course be very helpful if the data of this undertaking could be made available in an appropriate form for the scientific community dealing with the Hagia Sophia. If this were done, the merits of Hoffmann's work, for which he has undoubtedly deserves credit, might also receive the wider attention they deserve.

English translation from German by Dr.-Ing. D. Boussios

References

DUPPEL, C. 2010. *Ingenieurwissenschaftliche Untersuchungen an der Hauptkuppel und an den Hauptpfeilern der Hagia Sophia in Istanbul.* Karlsruhe.

FELIX, R. 2006. Review of: V. Hoffmann, *Der geometrische Entwurf der Hagia Sophia in Istanbul,* Bern. *tec* 21: 26.

HOFFMANN, V. 1999. *Die Hagia Sophia in Istanbul. 'Bilder aus sechs Jahrhunderten' und Gaspare Fossatis Restaurierung der Jahre 1847-49.* Bern.

HOFFMANN, V., N. Theocharis. 2002. Der geometrische Entwurf der Hagia Sophia in Istanbul, erster Teil. *Istanbuler Mitteilungen* 52: 393-428.

HÜBNER, W. 1996. Analemma. In: *Der Neue Pauly: Encyclopädie der Antike I* (Stuttgart), 650.
MAINSTONE, R. J. 1988. *Hagia Sophia: Architecture, Structure and Liturgy of Justinian's Great Church.* London - New York.
STAUDACHER, F. 2004. Deciphering the 'Eighth Wonder of the World', *Reporter 52, The Magazine of Leica Geosystems* (2004): 10-13.
URL: http://www.geoservice.si/uporabno/Reporter52.pdf (accessed 10 July 2010).
STICHEL, R. H. W. 2008. *Einblicke in den virtuellen Himmel: Neue und alte Bilder vom Inneren der Hagia Sophia in Istanbul.* Tübingen.
SVENSHON, H. 2010. Das Bauwerk als 'aistheton soma'. Eine Neuinterpretation der Hagia Sophia im Spiegel antiker Vermessungslehre und angewandter Mathematik. In: *Das Römische Reich im Mittelalter. Studien zum Leben in Byzanz.* F. Daim and J. Drauschke, eds. Monographien des Römisch-Germanischen Zentralmuseums, 84 (Mainz 2010), vol. 2,1: 59-95.
SVENSHON, H. and R. H. W. STICHEL. 2006. 'Systems of Monads' as Design Principle in the Hagia Sophia: Neo-Platonic Mathematics in the Architecture of Late Antiquity. In *Nexus VI: Architecture and Mathematics,* Kim Williams, ed. Torino, pp. 111-120.
VAN NICE, R. L. 1965–1986. *Saint Sophia in Istanbul. An architectural survey.* 2 vols. Washington D.C.

About the reviewer

Rudolf H.W. Stichel is "Außerplanmäßiger Professor" at the Technische Universität Darmstadt, where he teaches Classical Archaeology. His research focusses especially on the art of Late Antiquity and the transition to the Byzantine Middle Ages.